LEE MILLER PHOTOGRAPHER

JANE LIVINGSTON

THAMES AND HUDSON

Cover: Lee Miller, Self Portrait, 1932.
Lee Miller Archives

Following pages: p. 3 Erik Miller, Lee Miller and Aunt Kate,
New York, 1932. Lee Miller Archives

p. 4 Man Ray, Lee Miller and her Father,
Theodore, on his visit to Paris (set of four
original prints), January 1931.
Lee Miller Archives

p. 5 Theodore Miller, Stereoscopic Nude Study
of Lee, Poughkeepsie, New York, 1928.
Lee Miller Archives

p. 6 George Hoyningen-Huene, Erik Miller
and Lee Miller, Paris, 1930. Lee Miller Archives

p. 7 Man Ray, Lee Miller, c. 1930.
Lee Miller Archives

p. 8 Man Ray, "Neck," a portrait of Lee
Miller which Man Ray later used as
inspiration for his painting "Le Logis de
l'Artist," 1929. Lee Miller Archives

p. 9 Man Ray, Suicide, 1930 (signed and dated
on reverse). Lee Miller Archives

p. 10 Man Ray, Lee Miller, by the light of a
Sunray Lamp, Paris, c. 1929.
Lee Miller Archives

p. 11 Attributed to Man Ray, Lee Miller with
Soap Bubble, c. 1928. Lee Miller Archives

p. 12 George Hoyningen-Huene, Lee Miller,
Paris, c. 1930. Lee Miller Archives

p. 13 Man Ray, Lee Miller: Set of Two
Portraits, c. 1931. Lee Miller Archives

p. 14 Horst P. Horst, Lee Miller, Paris,
c. 1930. Lee Miller Archives

p. 15 Man Ray, La Dormeuse (Lee Miller),
c. 1930. Lee Miller Archives

p. 16 Edward Steichen, Lee Miller, Fashion
Portrait, New York, c. 1928. Lee Miller Archives

p. 17 Man Ray, Lee Miller — Fashion Portrait,
Paris, c. 1930. Lee Miller Archives

p. 18 Arnold Genthe, Lee Miller, New York,
c. 1927. Lee Miller Archives

p. 19 Arnold Genthe, Lee Miller, New York,
c. 1927. Lee Miller Archives

p. 21 Photographer Unknown, Lee Miller and
Man Ray, inscribed on reverse "For Lee
— this souvenir — hoping we shall
always see eye to eye. Love, Man,"
c. 1930. Lee Miller Archives

Copyright © 1989 by the California/International Arts Foundation
Text copyright © 1989 by Jane Livingston
Photographs copyright © 1989 by the Lee Miller Archives

First published in the USA in 1989 by The California/International
Arts Foundation and Thames and Hudson Inc.,
500 Fifth Avenue, New York, New York 10110
First published in Great Britain by Thames and Hudson Ltd, London

Library of Congress Catalog Card Number 88-062708
ISBN No. 0-917571-07-X (hardcover)
ISBN No. 0-917571-06-1 (softcover)

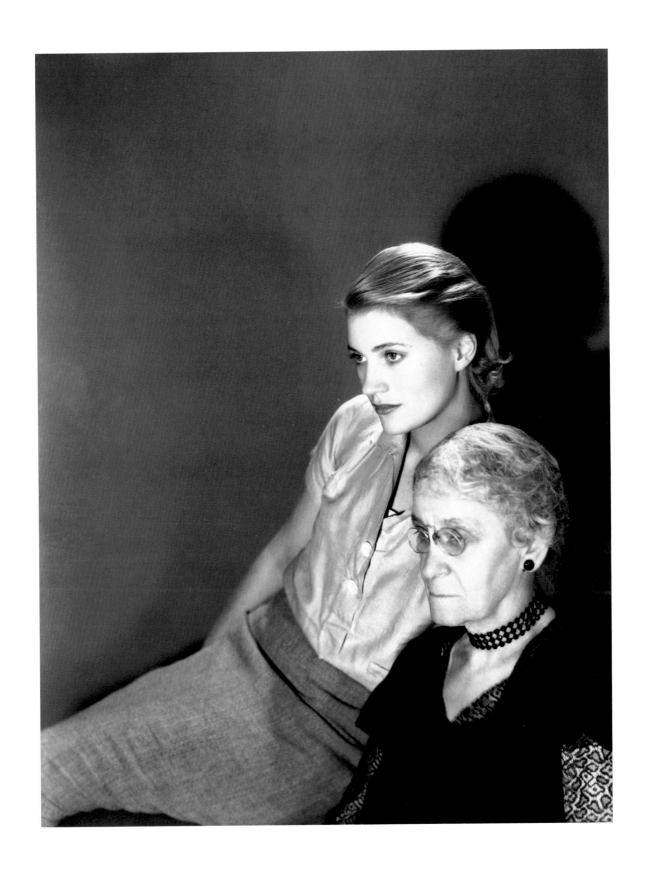

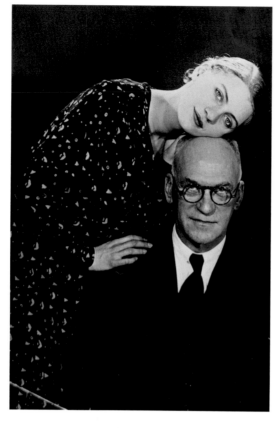
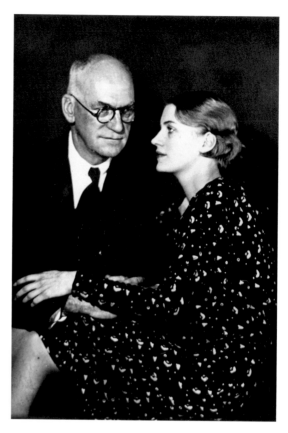
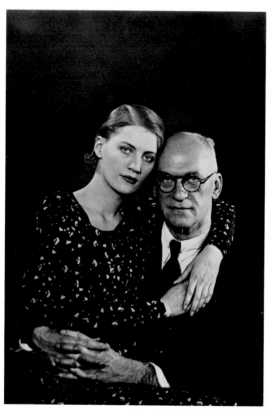
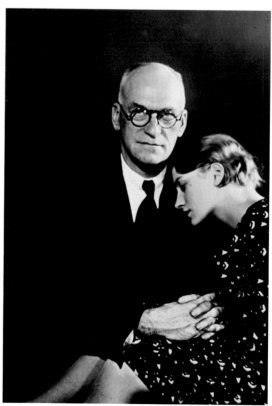

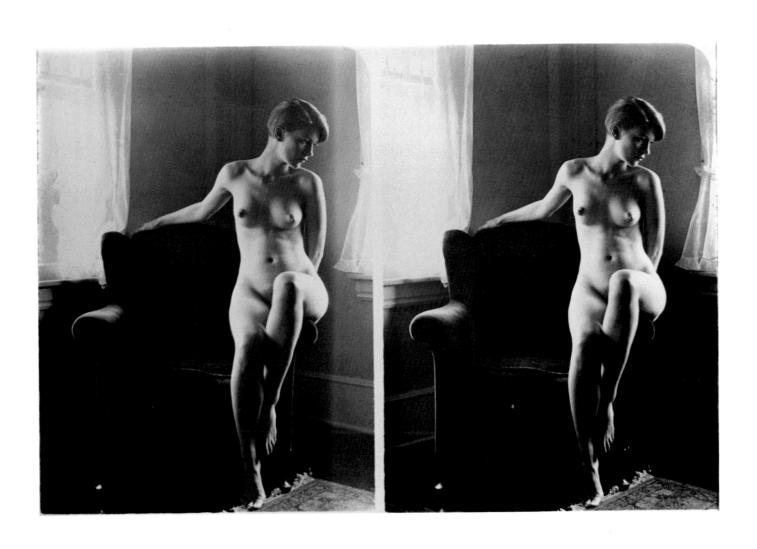

5

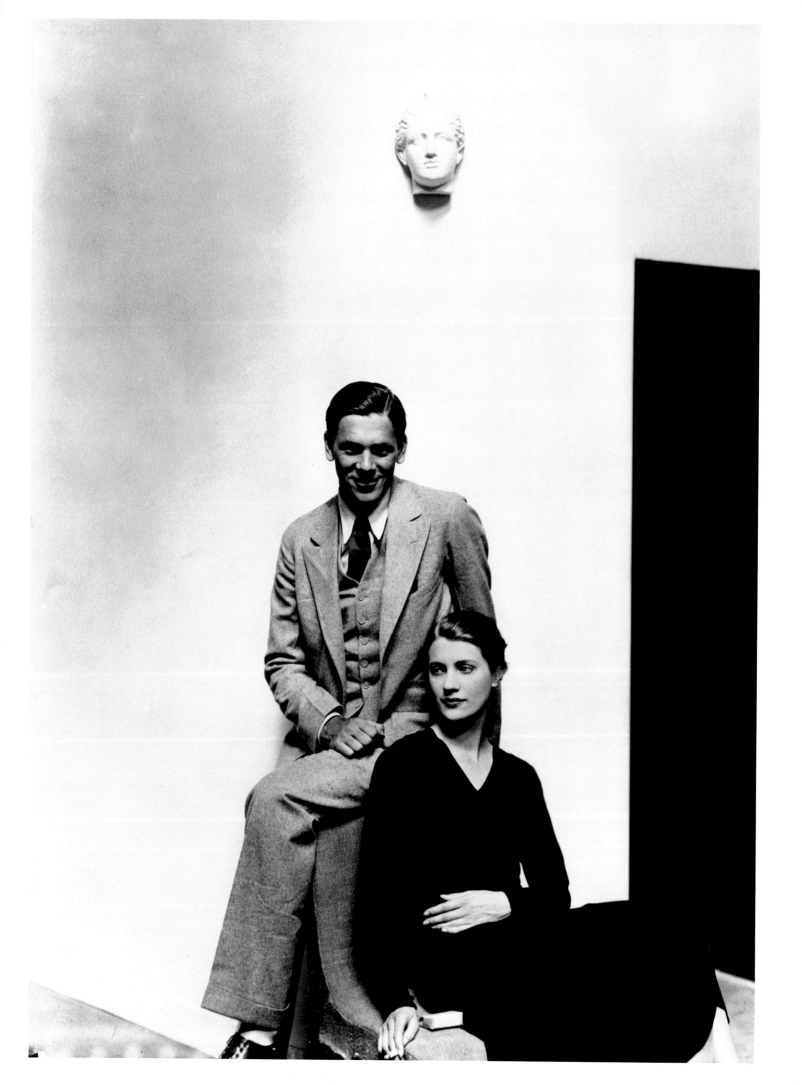

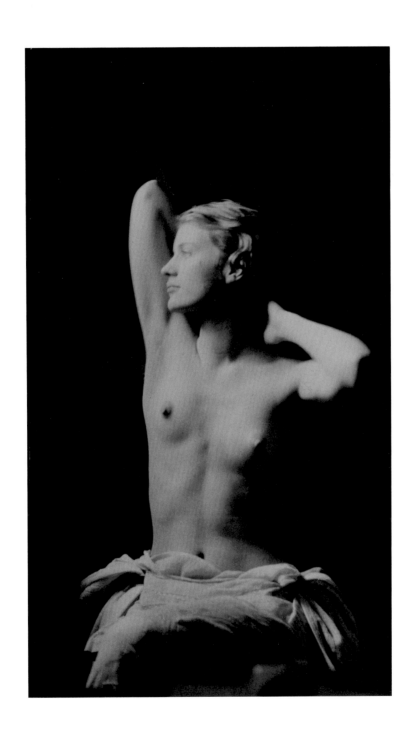

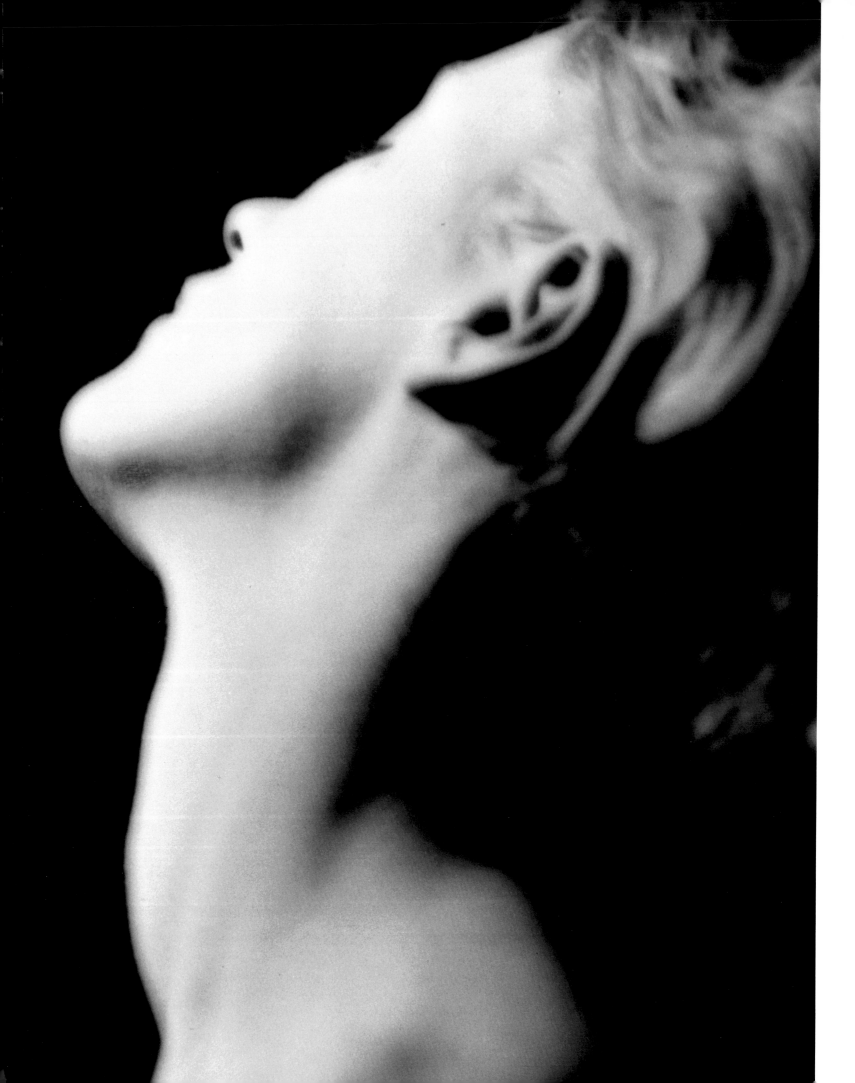

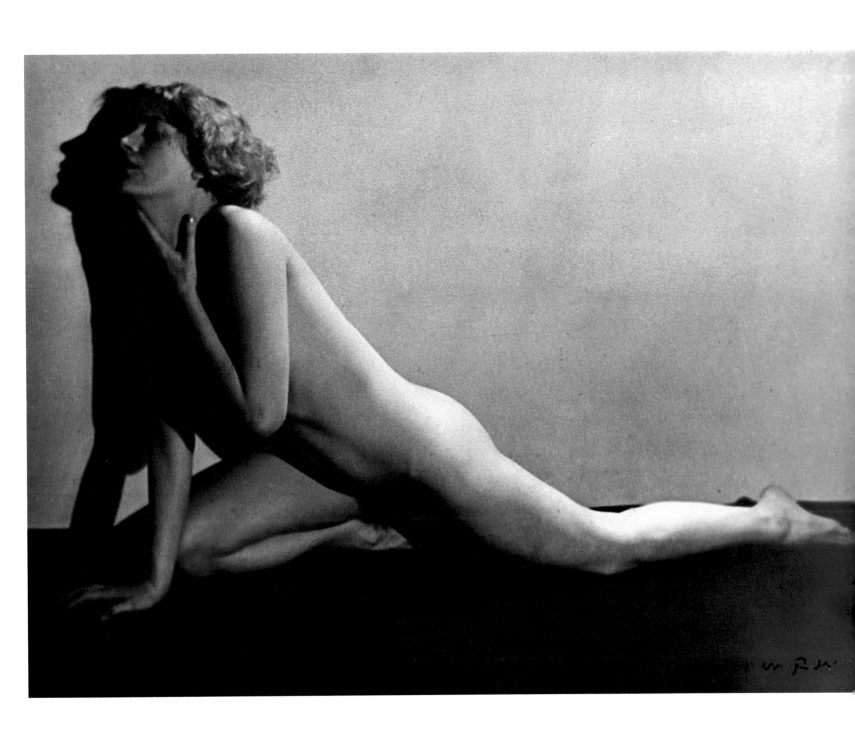

9

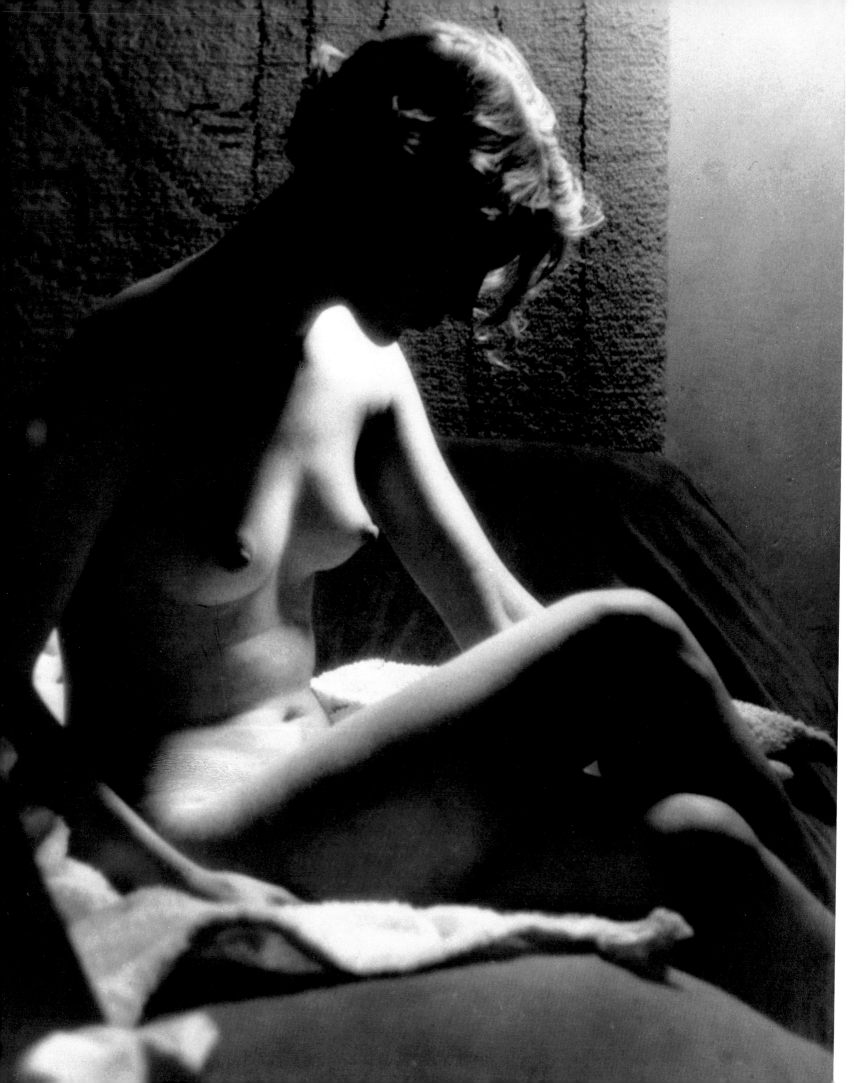

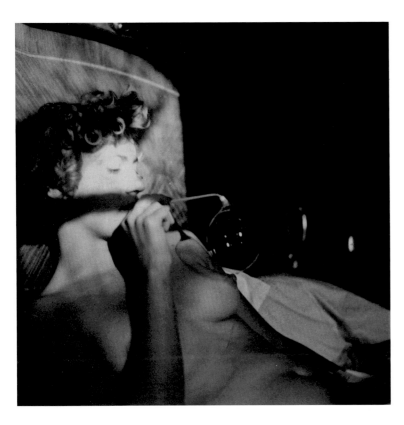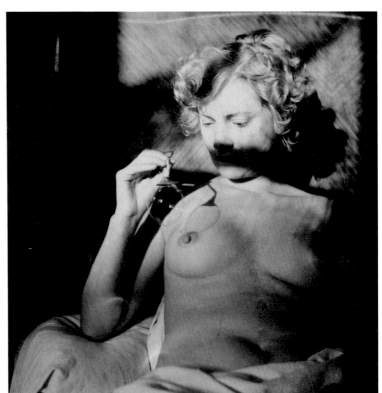

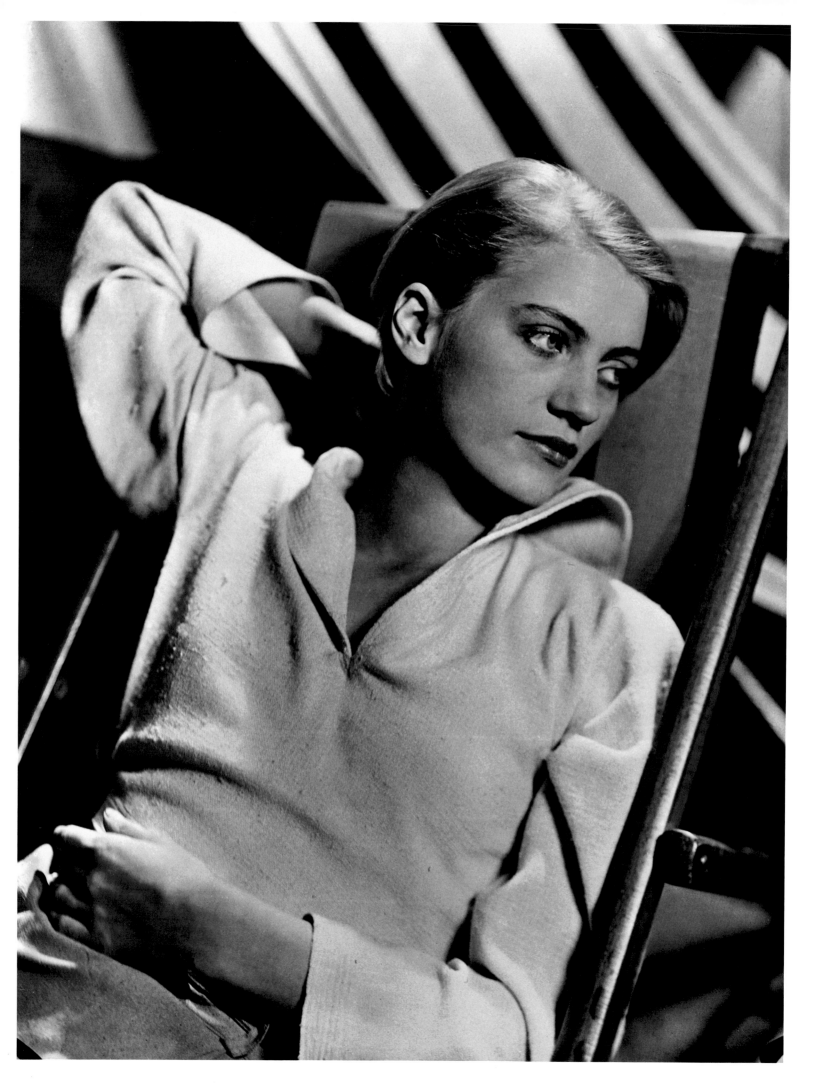

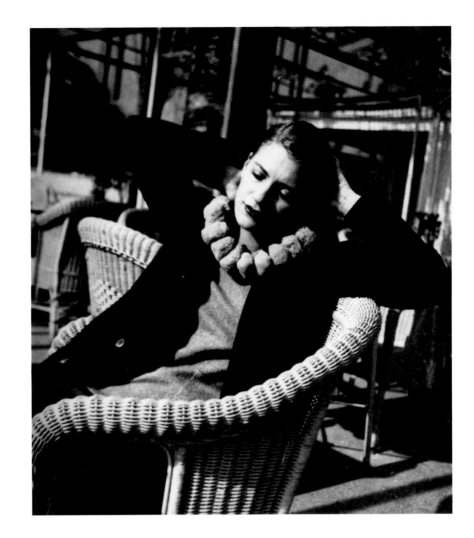

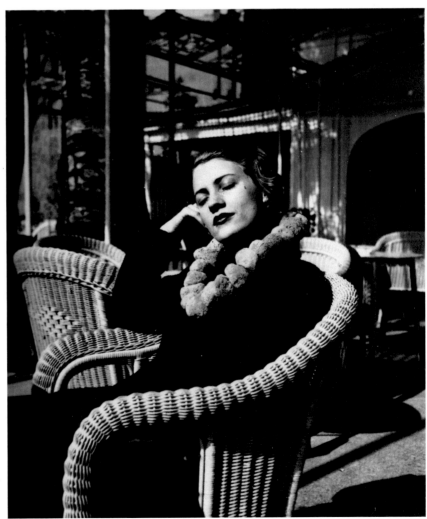

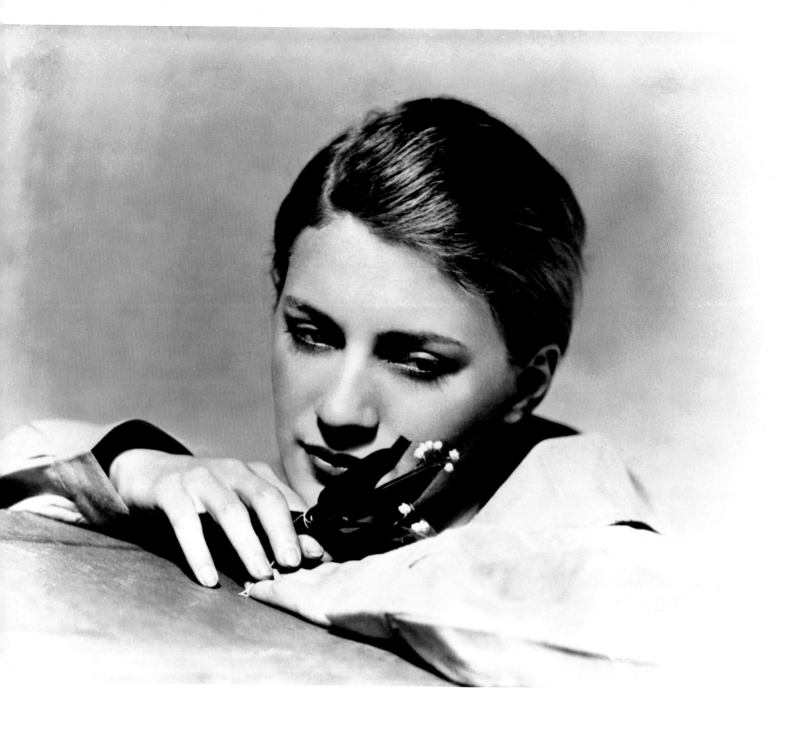

14

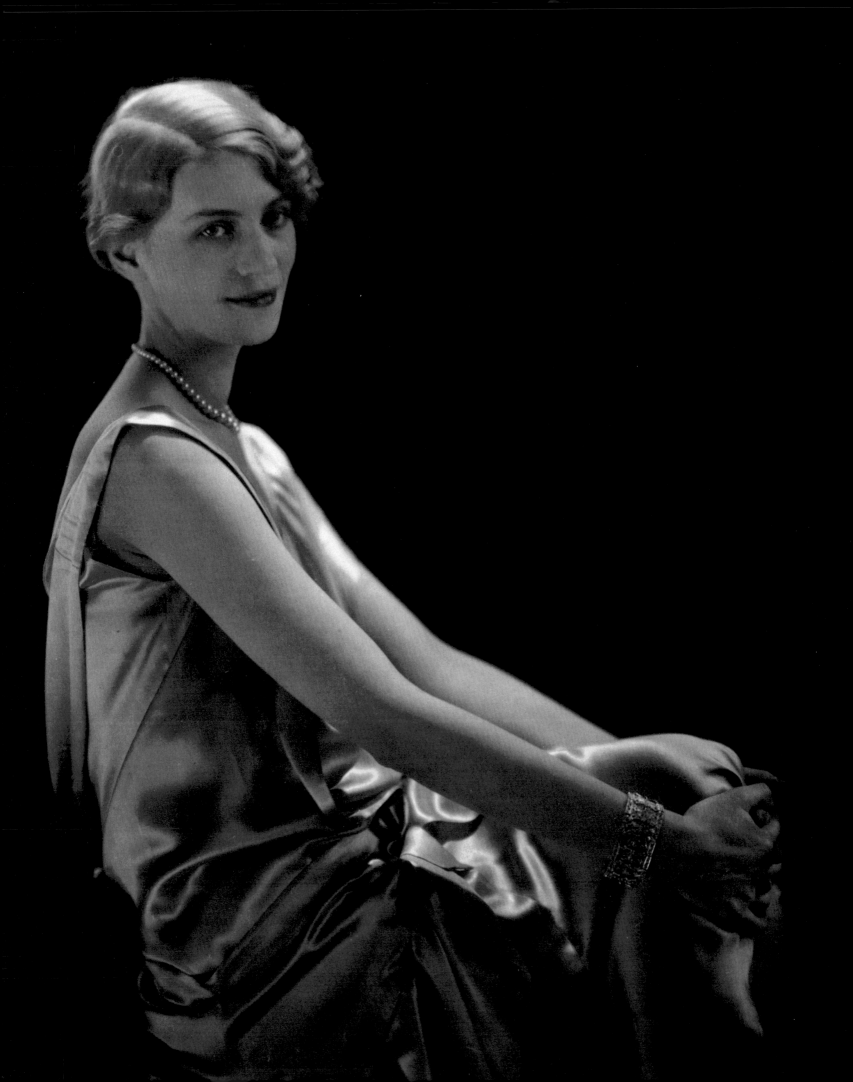

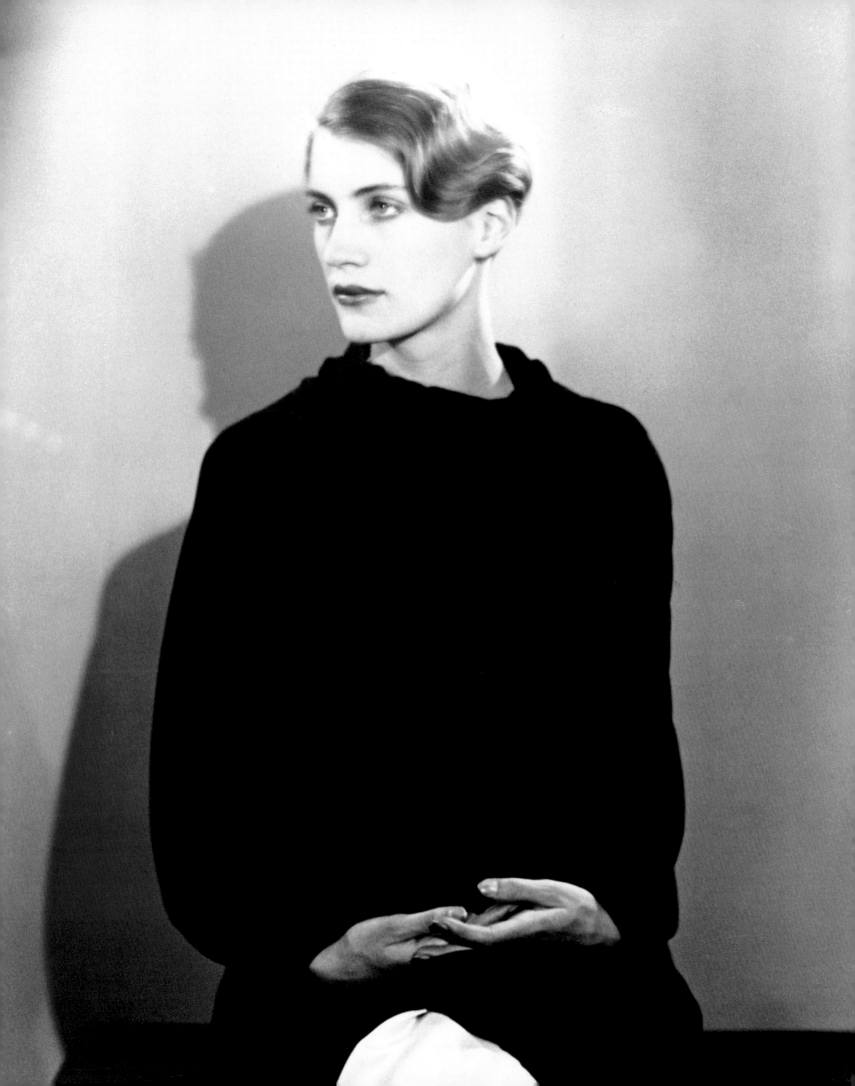

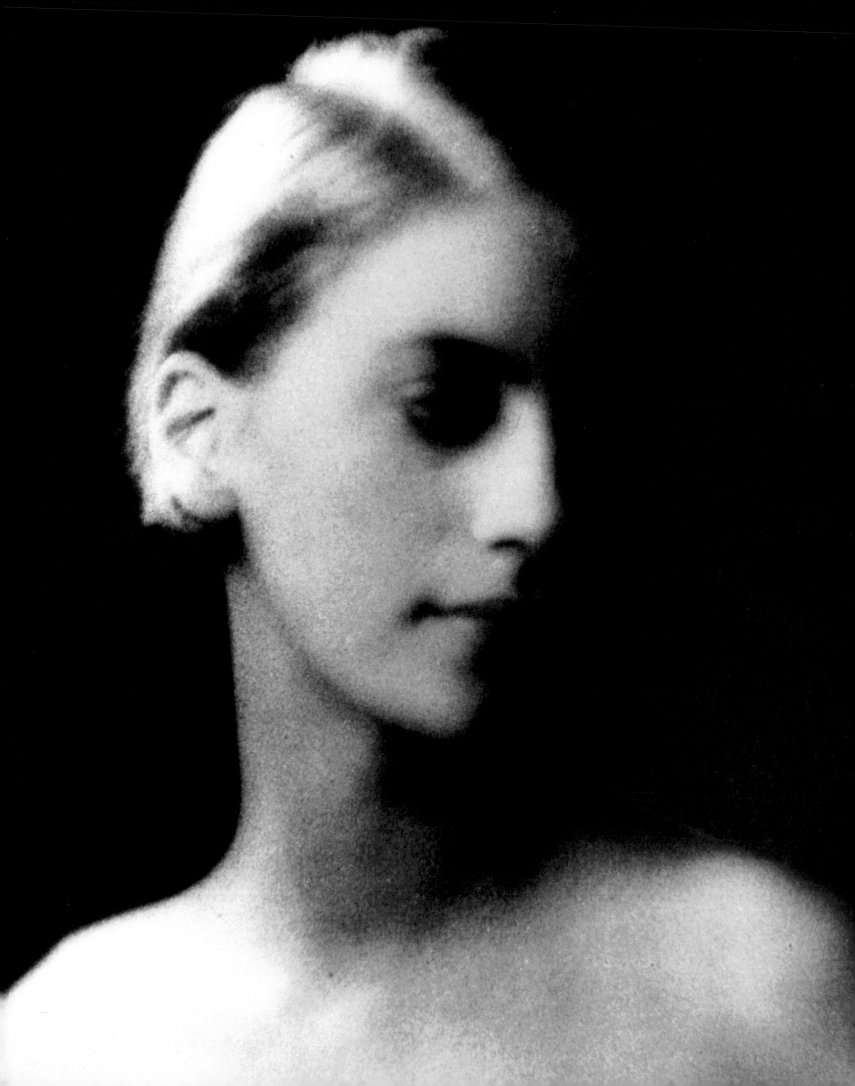

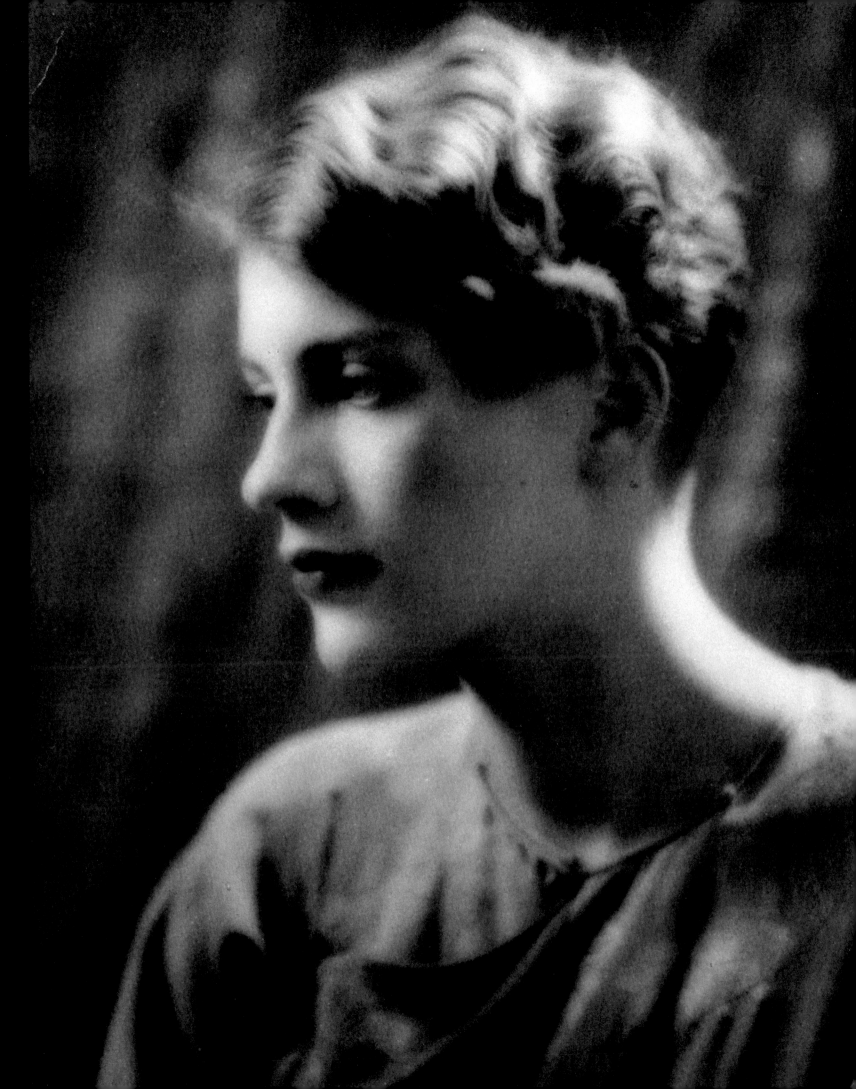

JANE LIVINGSTON

THAMES AND HUDSON

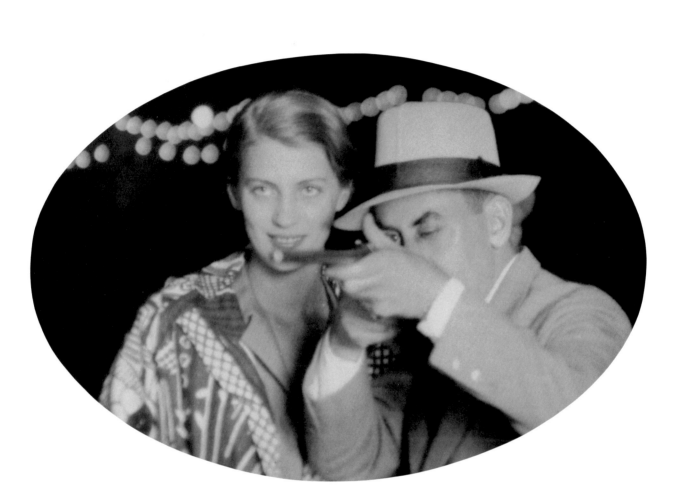

LEE MILLER PHOTOGRAPHER

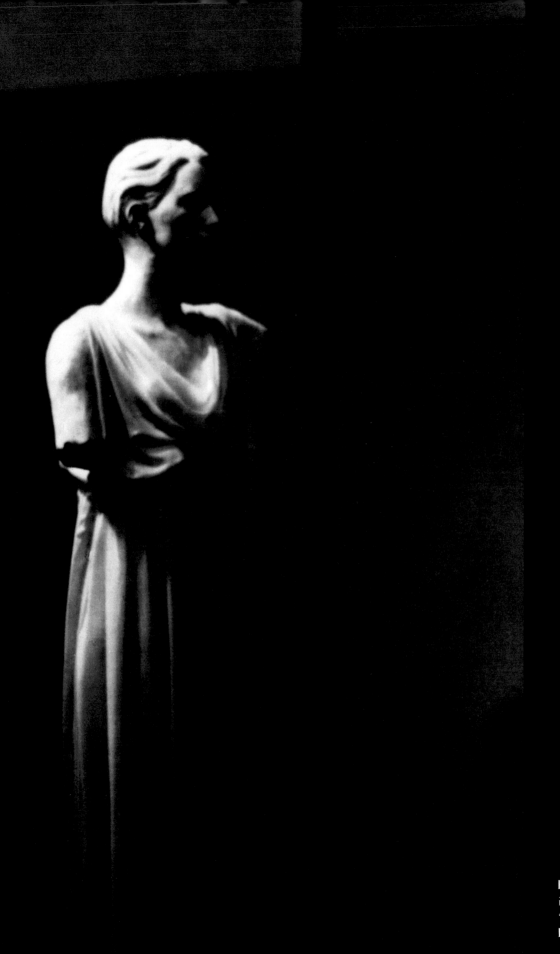

Photographer Unknown, Lee Miller
in her Role in Cocteau's Film
"Blood of a Poet," 1930.
Lee Miller Archives

Lee Miller, Sculpture in Window,
Paris, c. 1929.
The Art Institute of Chicago;
The Julien Levy Collection

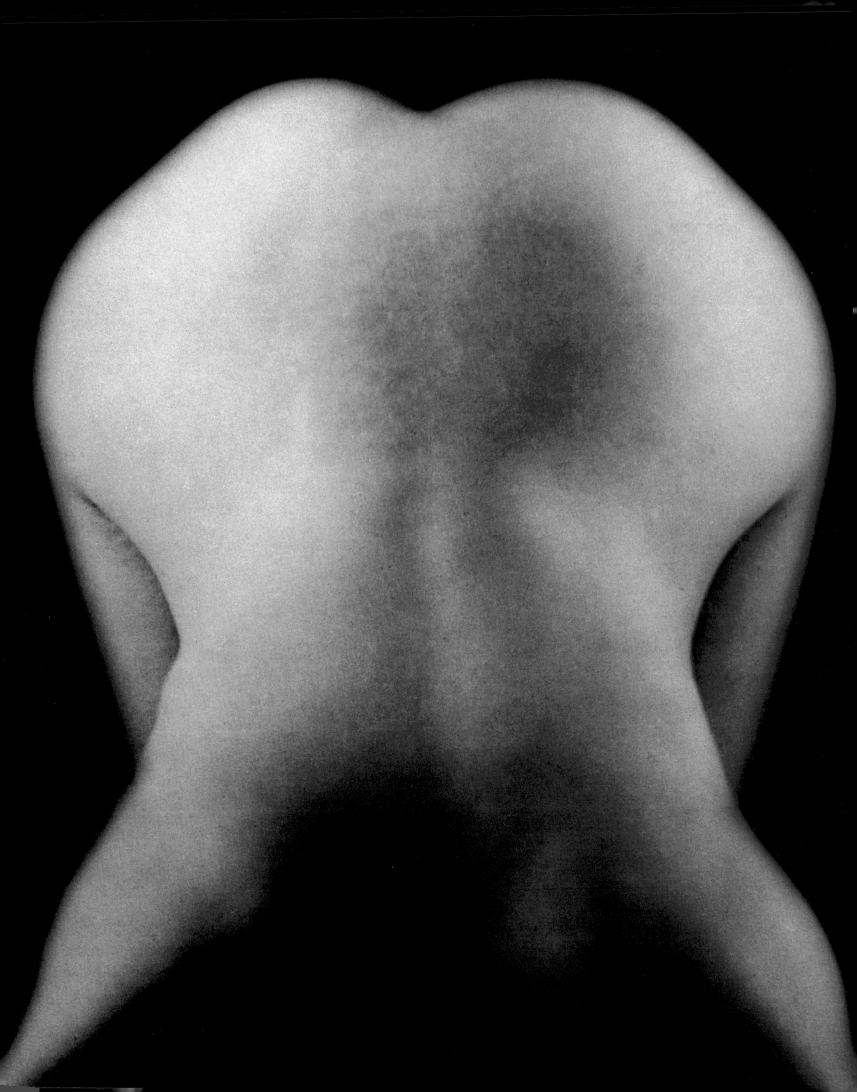

Lee Miller's name, when it is known to the contemporary audience, is associated primarily with her status in any of three roles. She may be remembered as one of the great beauties of the European-American social and artistic scene of the 1920s and 30s; as Man Ray's model, lover and photographic collaborator in Surrealist Paris; or, finally, as Lady Penrose, the illustrious wife of Sir Roland. She was all of these things. But perhaps more important for her, and for us, she was herself an artist. Indeed, it is not too much to say that Lee Miller was one of the most distinctive and accomplished photographers of her generation.

That Lee Miller's photographic legacy, which spans more than twenty years and falls into a number of separate geographic and stylistic episodes, should be so little known to the sophisticated contemporary art public, is perhaps in part accounted for by her own nature. During most of her artistically productive years, Lee Miller lived a formidable paradox: she was at once a willing object of others' aesthetic desire, and a passionate, disciplined and self-abnegating creator of subjectively true images. Like any artist, she sought, sometimes ruthlessly, to engage a reality outside herself through her own work.

In photography, there seems to be no such thing as a typical, or classic, pattern of an artist's development. Great photographers seem to forge strikingly distinctive paths

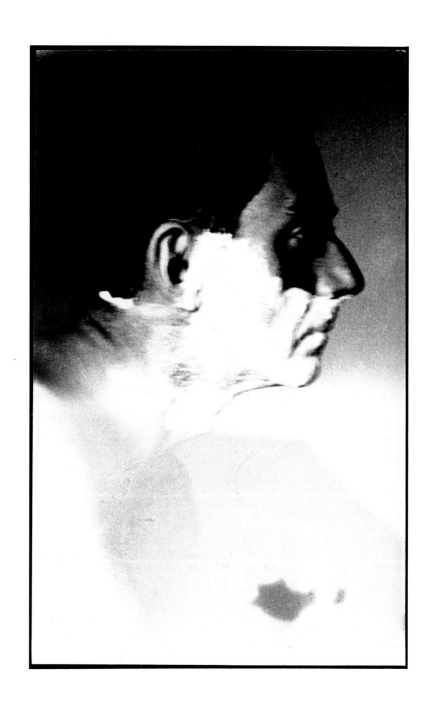

in their pursuit of a life's productivity: no prescribed training ground unites successful artist photographers; no special career trajectory is given by custom or necessity in this field of artistic endeavor. Some, like the classic instance of Lartigue, bloom early and wither; most others develop gradually, and flourish cyclically over a long lifetime.

Yet certain temperamental characteristics seem common to many extraordinary photographers in the last few generations. First is a restless curiosity, often bordering on obsessive adventurism; second, a mechanical or scientific bent; and third, an innately *aesthetic* vision, a way of seeing the world that is automatically selective, framing, discerning.

Lee Miller fully embodies all these tendencies. She happened to be an artist who blossomed early, developed sporadically, and ceased to contend in the photographic arena long before her vital decline. But her life as a photographer reflects two additional qualities that give her oeuvre its sharp singularity. First, Miller was, all her working life, an artist who functioned through intense spurts of activity, alternating with sometimes prolonged intervals of either painful lassitude, or self-imposed separation from the camera. She went at her craft with all her attention, with every possible resource of technical concentration and visual acuity — or she dropped it, sometimes for months on end. This pattern is only vaguely discernible at the beginning of her professional career, in the crucial years in Paris and New York; but it becomes increasingly more pronounced during her years in Egypt (as the wife of Aziz Eloui Bey), and later, during the World War II and the post-War years.

The second distinguishing attribute we come to understand in studying Lee Miller as a photographer also relates to her abruptly episodic working rhythm — but it is a different thing. It has to do with her unusual role as subject for others' aesthetic delectation. The evidence suggests that this physically ravishing young woman, photographed widely by the likes of Edward Steichen, Arnold Genthe, George Hoyningen-Huene, Horst P. Horst, and coveted by many extraordinary men, seems to have used her camera as a defense against the potentially crushing force of the narcissism pressed upon her. She combined a drive for recognition—whether through her looks, her wit, or her talent — with a periodic fierce determination to somehow *get outside herself,* to forget, or better, to lose herself in a vision operating *through* her, rather than one reflecting back from her.

It is clear from all that is known about Lee Miller in her formative years that her father, Theodore, exerted a powerful and lifelong influence on her. He was a gifted engineer, an inventor, an avid photographer; she was his only daughter. Lee must have internalized from her earliest consciousness Theodore Miller's fascination with inventive technique; certainly she inherited his facility. And the two of them remained close throughout their lives. But she may also have had a troubled relationship with him — while he was a direct source of strength and a powerful mentor, he became for a time a somewhat obsessed photographer of her, and she a compliant model. The closeness between them especially when Lee was in her early twenties, may have bordered on an unhealthy intimacy. In any event, Lee Miller would always have difficulty in establishing long-term relationships with other men. Her photographic work served as the steadiest commitment in her life until she gave it up for good in the 1950s — interestingly, at a time when she finally made marriage, to Roland Penrose, and a relatively settled domicile, the primary conditions of her life.

Lee Miller's first mature period as an artist came about as a result of leaving her father (and mother and two brothers), leaving her home in Poughkeepsie, New York, to

Lee Miller, Man Ray Shaving, c. 1929.
Lee Miller Archives

live in Paris. She had first visited Paris in 1925, when she was eighteen, and had glimpsed an artistic world astonishing in its breadth and audacity, but one that at that time apparently seemed to her dominated by Andre Breton's Surrealism. Certainly she became aware of Breton, the poets Guillaume Apollinaire and Paul Eluard, Jean Cocteau, and the artists Marcel Duchamp, Max Ernst, René Magritte, and of course, Pablo Picasso, Georges Braque, Fernand Leger, Joan Miro. She would later come to know them all. But it seems to have been the iconoclastic American painter and assemblagist and photographer Man Ray whose presence in Paris most captured her imagination.

Lee Miller returned to her parents' rural New York home in 1926, but she began to spend more and more time in New York City, enrolling in the Art Students League, to study theatrical lighting and design. On weekends, she often worked with her father on his photographic projects: one of their favorite devices at this time was a stereoscopic camera involving simultaneous exposures and a prismatic lens viewing apparatus endowing the contact prints with the illusion of three-dimensionality.

One day in late 1926, Lee Miller was literally rescued from being hit by an automobile in mid-town Manhattan by a stranger who turned out to be the magazine publisher, Condé Nast. He immediately saw her potential as a successful model, and she soon began appearing in the pages of *Vogue*. Lee Miller was photographed in this period by Edward Steichen and Arnold Genthe — and met the highpowered world of New York fashion and publishing. She became close, for instance, to *Vanity Fair's* Frank Crowninshield, and formed an enduring friendship with a beautiful Norwegian fellow art student, Tanja Ramm.

In 1929, Lee Miller with Tanja Ramm sailed on the *Comte de Grasse* for Paris, where she would stay for three years and produce her first body of photographic work, an episode that we may now judge to be among the most arresting and creative, if not the most mature, of her artistic life. If one counts the Paris years, 1929-1931, and the ensuing years from 1932 to 1934 when she and her brother Erik Miller had their own photographic studio in New York, as one extended episode in her stylistic develop-ment, this half-decade can be argued to be one of the two great periods in Lee Miller's work, only comparable to the years from about 1940-1945, when she was photographing in Britain and Europe during the height and aftermath of World War II.

In Paris, Miller was able porously to absorb, and almost uncannily assimilate, the artistic values around her. She actually came to *her* Paris, however, in a slightly circuitous way, once she and Tanja Ramm arrived in 1929. She almost immediately went on to Florence, Italy, on an informal fashion assignment for a *Vogue* designer which required her to make detailed drawings of Renaissance costume ornaments found in paintings of the period. Apparently Lee Miller began to experiment with a camera to record these elements, rather than tediously drawing them. With a folding Kodak and a portable tripod, using only available light, and relatively slow film, she successfully completed her assignment.[1]

From Rome she returned to Paris with the newly formed idea of becoming a professional photographer. She went immediately to Man Ray's studio in the Rue Campagne Première, and found Man Ray, not at home but at the nearby cafe, Bateau Ivres. According to her own account,

> He kind of rose up through the floor at the top of a circular staircase. He looked like
> a bull, with an extraordinary torso and very dark eyebrows and dark hair. I told him
> boldly that I was his new student. He said he didn't take students, and anyway he

Lee Miller, Rat Tails, c. 1930.
Lee Miller Archives

Lee Miller, Carousel Cows, c. 1930.
Lee Miller Archives

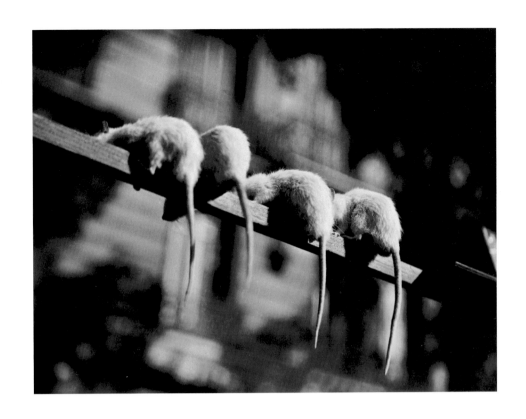

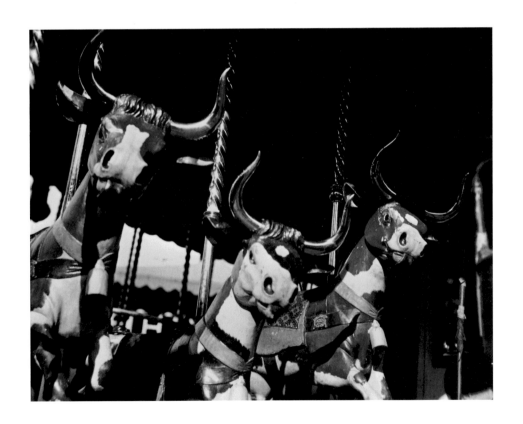

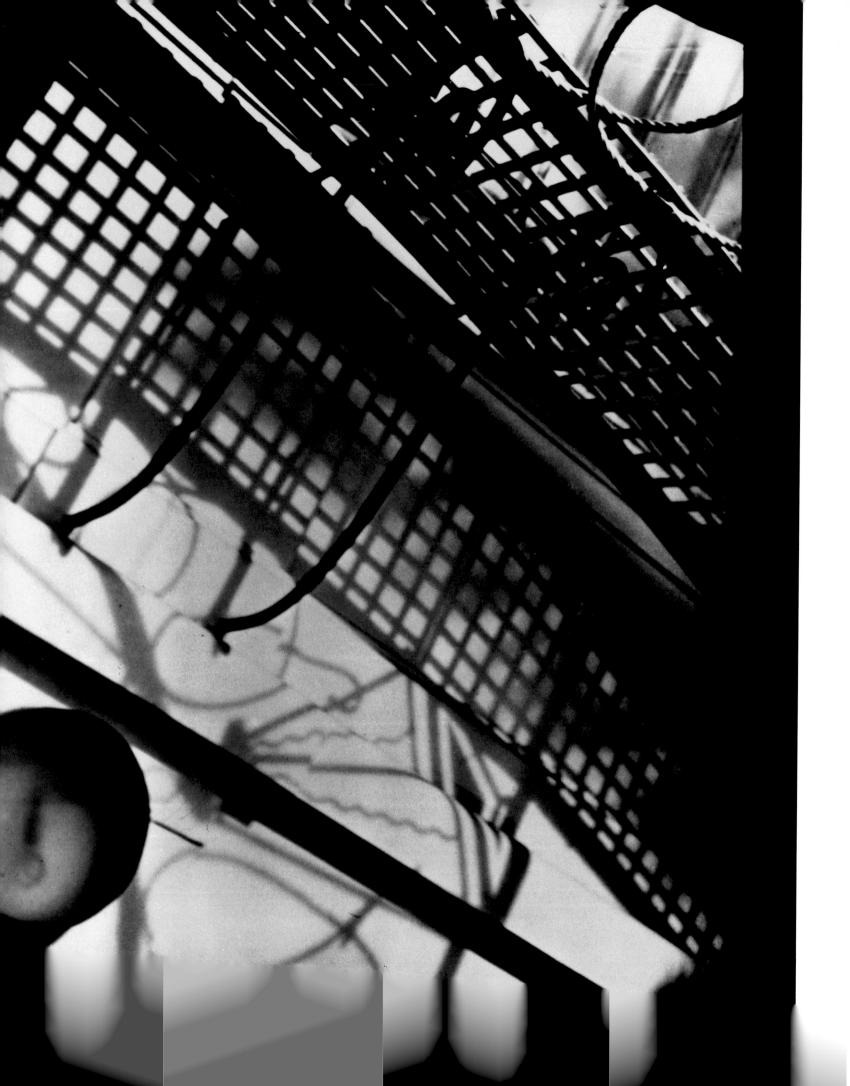

was leaving Paris for his holiday. I said, I know, I'm going with you — and I did. We lived together for three years. I was known as Madame Man Ray, because that's how they do things in France.[2]

In Paris, Lee Miller's work seemed instantly to assimilate many of the insights of Man Ray, Jacques-Henri Boiffard, Paul Eluard, Jean Cocteau — and, in the very next moment, to display her own mark. Miller's style in this first mature phase leapt to an unforced Surrealism, a sense of the startling, and the memorable, in the ordinary. She became a master of the unmanipulated Surrealist image. This achievement would stay with her for the rest of her artistic life; some of her much later photographs, done in Blitz-torn London, have now entered firmly into the Surrealist photography canon. Yet her first efforts from her Paris-in-the-20s years are astonishingly good, and just as maturely "Surrealist" as the wartime pictures that would be far more widely circulated. Lee Miller's ability in these Paris/New York studio years simply to inhale, suddenly to embody, the highest new sensibility around her, and make it her own, gives us an inkling of what phenomenal resources lay at her command in those times when she was geared up to live and work at full capacity.

The early Paris work, including such images as those on pages 23, 24, 26, 29, 30, 32, 33, and 34, amounts to an astonishingly coherent yet diverse body of images, each a kind of personally resonant, yet universally provocative statement, all made under the influence of French Surrealism. Lee Miller's Surrealism was seldom of the genre that is primarily characterized by absurdist juxtapositions, such as with Dali, Magritte, or Hugnet: nor was it quite like some of the intensely disturbing or displaced images of Jacques-Henri Boiffard or Hans Belmer. Rather, hers is a subtler manifestation of the Surrealist heightening, or deracinating, of an object or instant or detail. Miller's best photographs from this period often seem psychologically neutral in comparison to other Surrealist photographs, and are oddly humble in subject. Instead of affronting us, she would seem to want to look at the marginal, or the apparently inconsequential, and make these things evocative. What she often loved — in this early period as later — was simply to find the arresting in the ordinary. To her, the intensity she sought was sometimes to be found in a slightly subdramatic moment. Lee Miller appears never to have been seduced in her photography by the other ascendant styles of the time — whether the Pictorialism of Stieglitz, Steichen, Genthe, even Berenice Abbott — or the European Constructivist aesthetic practiced by Moholy-Nagy or Brugière. A specific combination of the pragmatic techniques of lighting and composition learned from commercial studio work, and the French Surrealist modality that wanted to jolt, to refresh and disturb, were habits of vision that Miller adopted and then tempered or modified for her own stylistic purposes.

Critical to understanding Lee Miller's fundamental vision as a photographer is to see that although she may be said to have been grounded in fashion photography and all that it implied, and though she gained a thorough understanding of this wily craft, she always chafed under its constraints. Indeed, she eventually rejected the possibility that any work done on strict commercial assignment, as its own end, could sustain her commitment to making transcendent pictures.

Miller's wholehearted adoption of Man Ray and his tutelage attests to a perhaps only half-conscious but powerful will even in her early twenties, to command alternative ways of being a photographer. She and Man Ray entered into an intimately symbiotic working relationship that may, for her, have been both formative in her growth as a photographer, and symbolic of a part of her nature that at once assisted and perhaps

Lee Miller, Ironwork, Paris, c. 1929.
The Art Institute of Chicago; The Julien Levy Collection

31

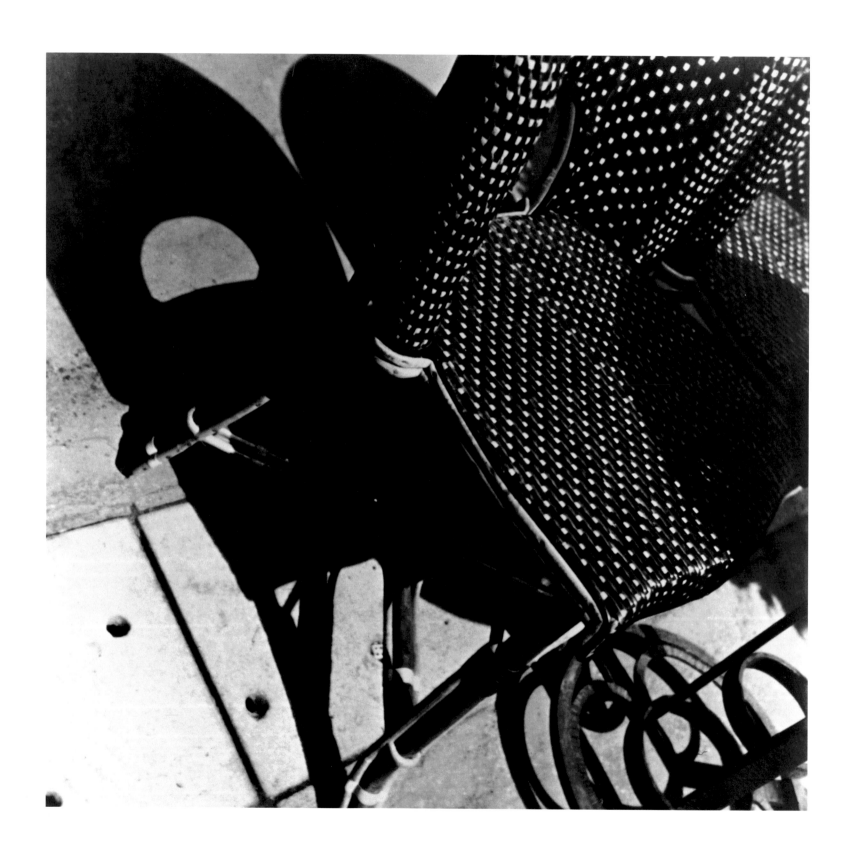

Lee Miller, Chairs, Paris, c. 1929.
The Art Institute of Chicago;
The Julien Levy Collection

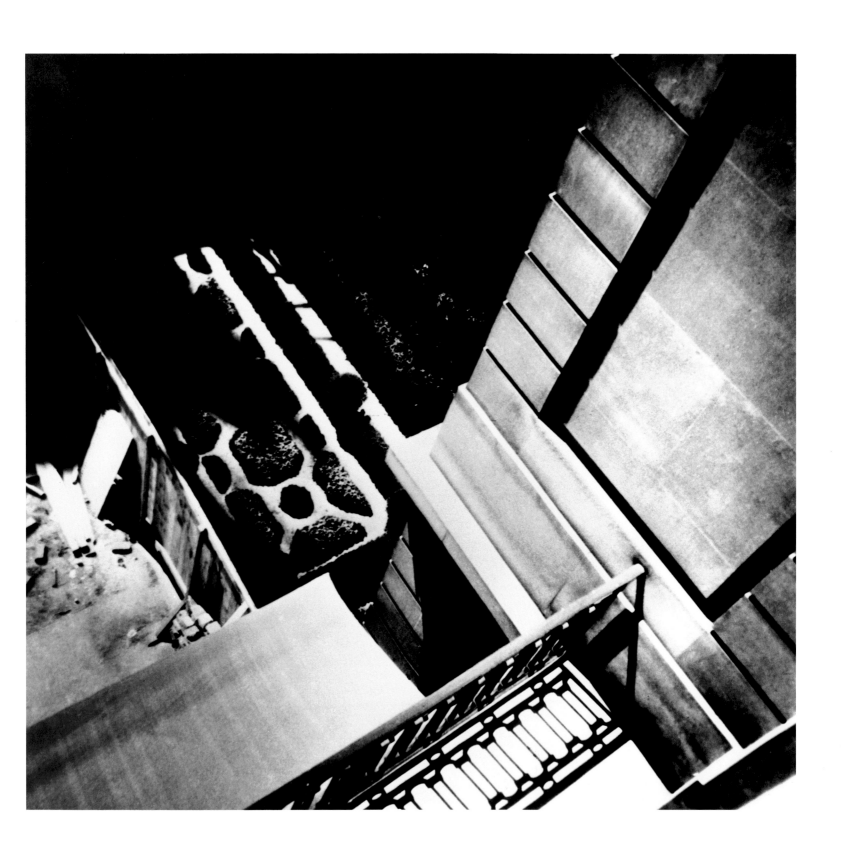

Lee Miller, Architectural View, Paris,
c. 1929. The Art Institute of Chicago;
The Julien Levy Collection

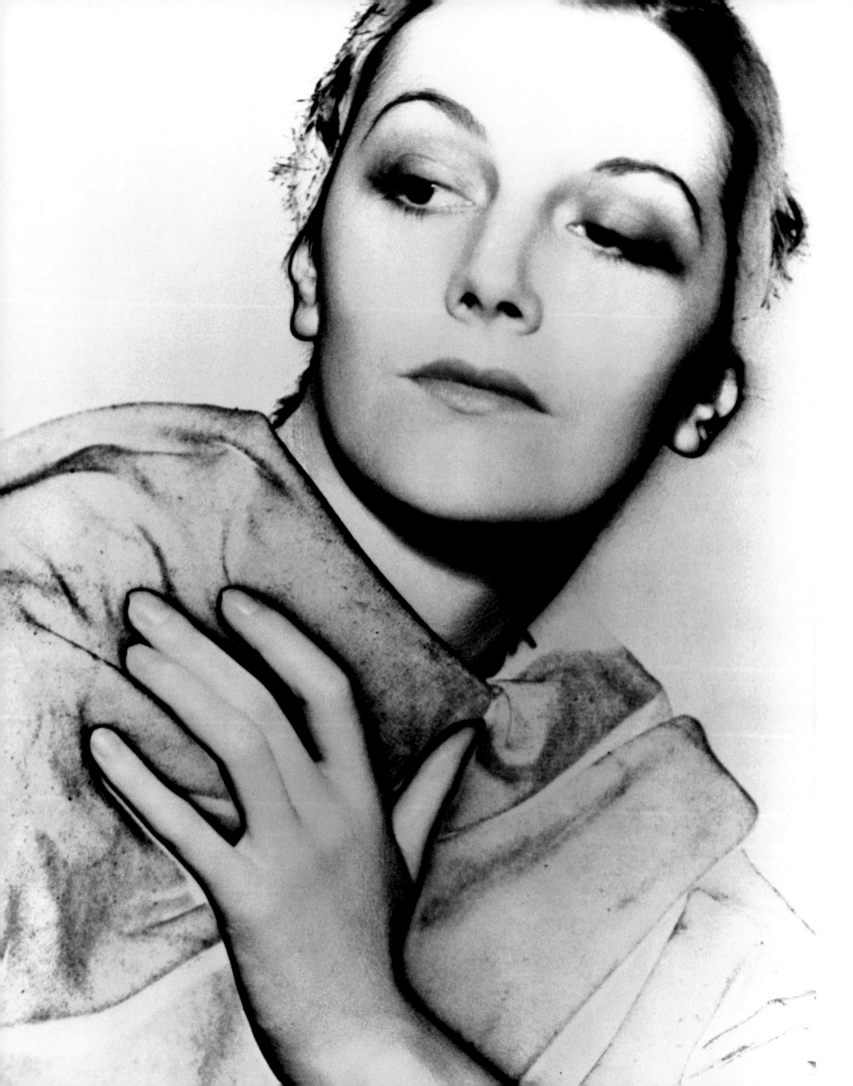

hindered her as an artist. For Lee Miller seemed always to have a restless, pragmatic, and almost *egoless* approach to her own style. She rarely promoted or even showed her photographic work to those who might help her in an artistic career. Antony Penrose notes that " . . . neither [she nor Man Ray] was seriously concerned when their credits were wrongly ascribed. Man Ray passed quite a lot of his own work over to Lee to free himself for painting . . . "[3]

There have probably been both early and later ascriptions of important images to Man Ray, that were actually by Lee Miller; there may always remain unknown misattributions. An image such as the now well-known *Nude*, c. 1934, [p. 24] is certainly one that could just as well have been taken by Man Ray. (That it is correctly ascribed now is probably due to its inclusion in Julien Levy's Lee Miller exhibition in 1932.) Moreover, many images of Lee by Man Ray, such as "*Neck*," 1929 [p. 8], or the solarized image of her called *La Dormeuse*, [p. 15] seem created through a process in which the model and photographer have collaborated fully as artists.

Lee Miller worked closely with Man Ray on such photographs as the ones forming the portfolio *Electricité*, 1931 (generally attributed solely to him), and probably others. What is, however, well known and incontrovertible is her direct involvement in the re-invention of the solarized photograph (Alfred Stieglitz had actually done it first), a technique Man Ray adopted that would be nearly as central to his own Surrealist production as the Rayograph. Lee Miller described the event to her brother, Erik, as follows:

> Something crawled across my foot in the darkroom and I let out a yell and turned on the light. I never did find out what it was, a mouse or what. Then I realized that the film was totally exposed: there in the development tanks, ready to be taken out, were a dozen practically fully developed negatives of a nude against a black background. Man Ray grabbed them, put them in the hypo and looked at them: the unexposed parts of the negative, which had been the black background, had been exposed by this sharp light that had been turned on and they had developed and came right up to the edge of the white nude body . . . It was all very well my making that one accidental discovery, but then Man had to set about how to control it and make it come out exactly the way he wanted to each time.[4]

The interesting thing about Miller's participation with Man Ray in this and other photographic developments is that in her own work, even at this time — 1929-1932 — she did *not* slavishly adopt either the new techniques or the basic stylistic vocabulary of her mentor. A few of her solarized images work beautifully [p. 34] and, though very similar to Man Ray's work, have her distinctive stamp. But most of the images from this first mature period are Lee Miller's own, characterized already by the use of relatively simple devices to create the Surrealist sense of surprise in a given image, Andre Breton's "convulsive beauty" residing in the accidental, or the decontextualized. Miller in this sense was instinctively a Surrealist in the manner of Boiffard, Hans Belmer, or Man Ray himself, all of whom in their best images preferred the "straight" to the montage-constructed or double exposed image. The Surrealist photograph that found in the ordinary its own quality of strangeness or contortion, rather than the one contrived by artful juxtaposition, was immediately more palatable to her. Lee Miller's natural way with the camera was to use its *framing capacity* itself as a powerful tool for isolating and re-presenting reality.[5] In images like those on pages 30, 32, 33, and 110, the *camera angle* — in each case deliberately canted in relation to the subject, trained diagonally up or down, or rotated left to right from a vertical axis — alone creates the

Lee Miller, Unknown Woman, Solarized Portrait, 1930. Lee Miller Archives

35

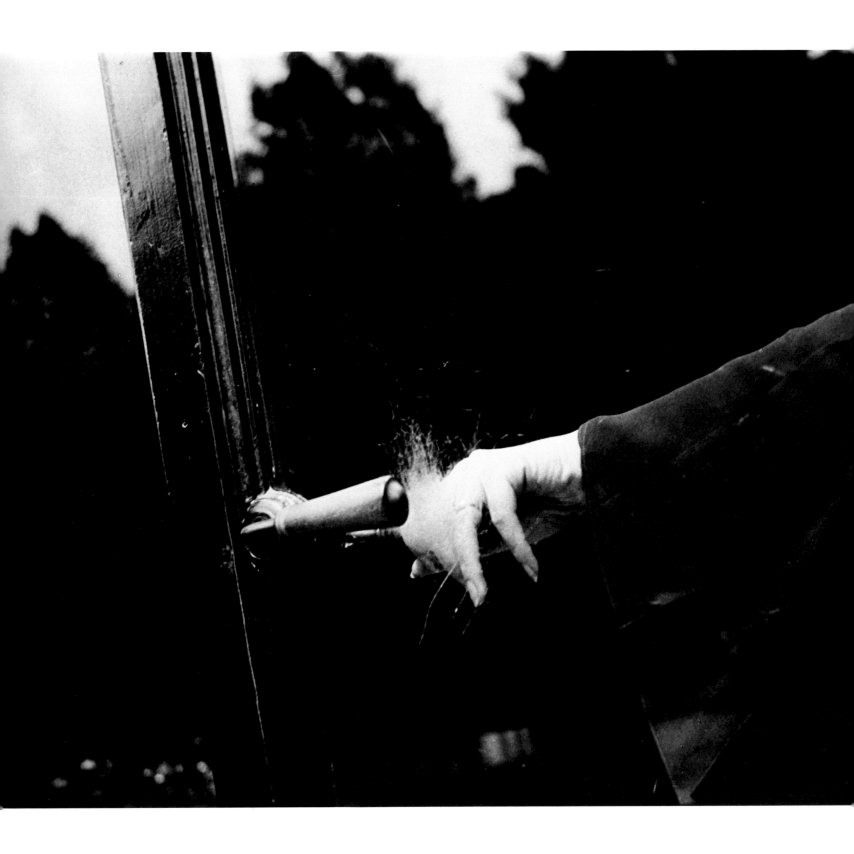

drama of the photograph. And in many of these early Surrealist images, she develops even more reductive means by which to produce "convulsive beauty."[6] Some of her photographs convey the quality Man Ray evinced with the caption *Explosante-Fixe* ("Exploding Still"). This evocative term was used to title his photograph of a momentarily stopped dancer whose full, layered skirts are still swirling around her like eddying water, or an unfolded rose. Lee Miller's "convulsive beauty" is of a quieter nature, as in the silhouette of a hand reaching toward an ambiguous grill work and fringed umbrella background [p. 111], or as in perhaps her most subtle and haunting Surrealist-inspired image [p. 36], the photograph of a woman's arm and hand reaching toward a glass door, not quite touching the protruding knob, seeming to be exploded, or erased, by the scratches in the glass etched by diamond rings.

Some of the photographs in this group were shown at the Julien Levy Gallery in New York from February 20 to March 11, 1932. Other photographers included in this exhibition of twenty Europeans were the Surrealists Maurice Tabard, Roger Parry, Umbo, and Man Ray, as well as the Constructivist or Bauhaus-associated artists Moholy-Nagy, Helmar Lerski, Walter Hege and Walter Peterhans. Just under a year later, December 30 to January 25, Julien Levy showed a larger body of her work in its own space at his gallery. Like other Surrealist and modernist photographs of the time, hers failed to sell well — one consequence of which was to allow much of the great Julien Levy Collection of photography from the 1930s to find its way into the collection of the Chicago Art Institute. (Today, aside from the extraordinarily complete, well preserved and thoroughly documented collection of her work in the Lee Miller Archives in Sussex, the only slightly significant repository of the artist's vintage prints remains in the Art Institute's Julien Levy bequest.)

During Lee Miller's years in Paris in the late 1920s and early 30s she was photographed often, and by some superb photographers. She became close to a few of them — particularly George Hoyningen-Huene. She also did her own fashion photography for some of the great couturiers, among them Chanel, Schiaparelli, and Patou. And she set up shop as a portrait artist. Her portraits of Inez Duthie, Man Ray, and the anonymous solarized portraits [pp. 108, 41, and 34] are among the most beautiful she ever made — though her portrait photography would more fully develop and mature later; in the 1940s and 50s she had far more ability to capture a subject in an informal and psychologically telling spirit than seemed possible for her in this period.

Both through Man Ray and by her own magnetic and curious nature, Lee Miller met and befriended most of the influential members of the Surrealist circle in Paris. She of course knew André Breton and Marcel Duchamp, and her friendship with Paul Eluard and his wife, Nusch, would last a lifetime. One of her more direct roles in the Surrealist episode was her casting by Jean Cocteau as the female lead in his film, *Sang de Poete* (Blood of the Poet), 1930. In this part she was costumed and made up as an armless, draped statue — it is this image of her that remains, for most who have viewed it, the memorable aspect of her cinematic presence [p. 22]. But the film required more of her than inhabiting this frozen, visually electrifying form, and she performed in it well and to critical acclaim. Nevertheless, this was to be her only film role: "I just can't act," she said.[7]

The Paris years laid the groundwork for Lee Miller's future life, in many different ways. She met people who remained in her life to its end, Pablo Picasso and Max Ernst among them; she fell in and out of love, as she would continue to do. These years were especially critical in terms of the development of her central being as an artist. The

Lee Miller, "Exploding Hand," c. 1930.
Lee Miller Archives

37

best photographs she produced during this period, as is evident from the twenty-two images here, are among the peak achievements of her artistic production. This work does not yet evince the psychological range that some of her great war photographs would do — from depths of empathic understanding and flexibility, to steely rage — and yet here already she has accomplished an enormous feat as a photographer. She proved herself by the early 1930s to be patently endowed with natural talent; she seems to have been stimulated by her environment to try anything, and to work persistently.

In hindsight, viewing Lee Miller's overall photographic career, one might wonder why she did not develop as an artist toward evermore "pure" and radical work, as did most of her artist friends in Paris in the late twenties — why her direction became more apparently documentary and less deliberately "artistic" as she matured.

It is possible that one of the key factors in her resistance to the seductions of self-conscious art photography, even though she was fascinated by the Surrealists and their many inventions, was the continuing influence throughout the 1930s of the world of fashion photography to which she still belonged. George Hoyningen-Huene was a consummate master of studio photography; Lee Miller learned virtually all her lighting technique from him. As Antony Penrose says, " . . . [Lee Miller's] modelling sessions with Hoyningen-Huene were rather like a privileged tutorial, allowing Lee to work on both sides of the camera at the same time."[8] It is fair to say that Lee Miller never gave her best efforts to fashion photography, as much as she practiced it over the years and as often as its professional availability sustained her career. A few of her *Vogue* assignments during the war elicited some marvelous images — generally under circumstances that made exacting studio technique impossible; for the rest, Miller's many fashion trade images simply hold their own in the commercial genre.

In 1931, Lee Miller met a wealthy, older Egyptian who lived in Paris, Aziz Eloui Bey; he was married to a beautiful and much photographed woman named Nimet; Lee Miller was gradually moving away from Man Ray, who pursued her more and more desperately. Miller and Eloui Bey became mutually infatuated; within months Nimet committed suicide and Man Ray threatened to do the same. It was evident to Miller that she had to make a major change, much as she may have wanted to remain in Paris. In any event, at the end of 1932 she shut down her Paris studio and returned to New York.

Lee Miller was able to establish a new business in New York City during the depths of the Great Depression because of the extraordinary network of connections she had built up in merely a few years. She obtained financial backing for her photographic studio from two wealthy and socially prominent businessmen: Christian Holmes, a Wall Street broker who was heir to the Fleischmann Yeast fortune, and Cliff Smith, an inheritor of the Western Union fortune. With her brother Erik as her assistant, she established Lee Miller Studios in two adjoining apartments at 8 East 48th Street.

Erik Miller designed and built the darkrooms, installing cypress wood tanks large enough to accommodate the 8 × 10" plates they generally used. The studio was equipped with concealed cables and remote controlled lights, which, in Antony Penrose's words, constituted

> no mean achievement when the dictates of large format cameras with slow film speeds called for enormous lights and fat cables. There was a practical reason for the concealment, as a lot of Lee's work was portraiture. She was always keen to have her sitters appear as natural and relaxed as possible, and despite her love of her technology, she was aware that gadgets and equipment could be distracting and intimidating. Perhaps it was for the same reason that she 'decorated the windows

Lee Miller, Scent Bottles, New York, 1933. Lee Miller Archives

Following pages:

Man Ray, Eye of Lee Miller with inscription on reverse, October 11, 1932 (signed and dated). Lee Miller Archives

Lee Miller, Man Ray, 1931. Lee Miller Archives

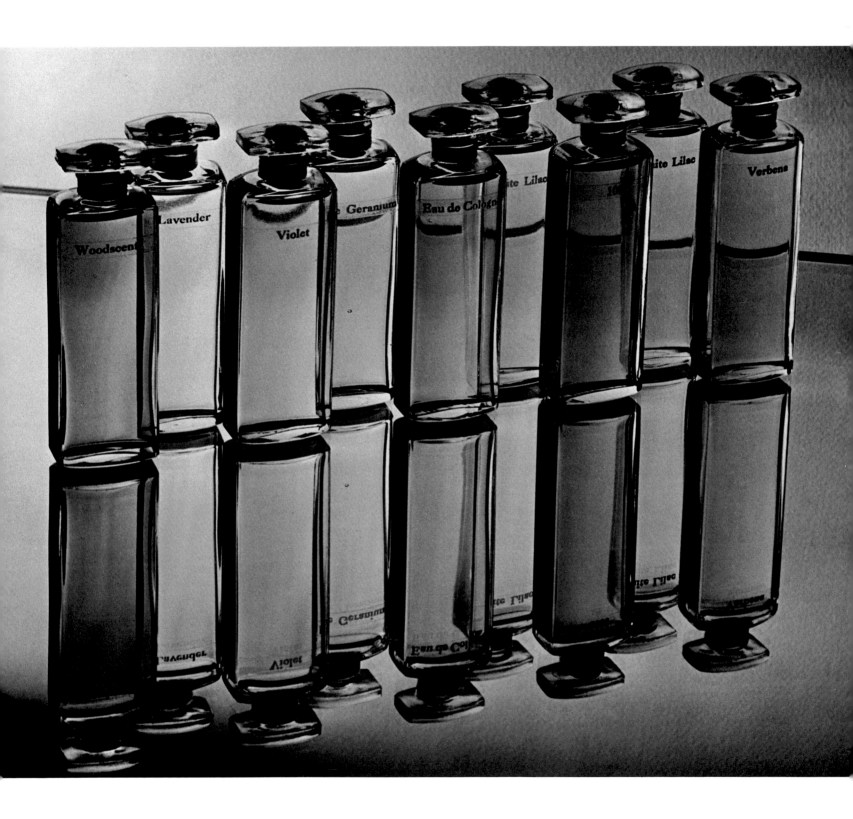

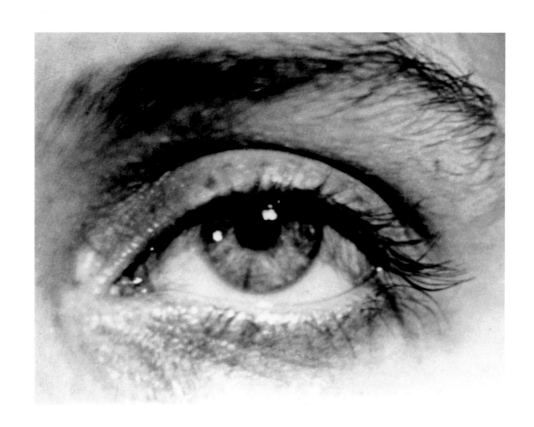

Postscript: Oct. 11, 1932:

With an eye always in reserve
material indestructible
Forever being put away
Taken for a ride
Put on the spot
The racket must go on —
I am always in reserve.

MR

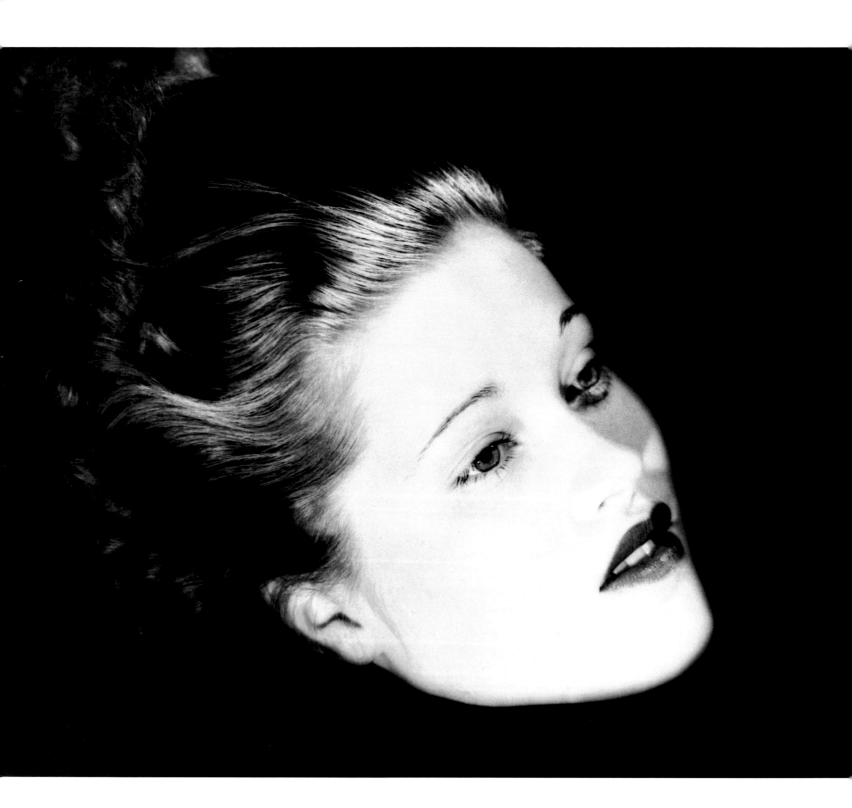

with tubes of chiffon in the shades of the spectrum, like a row of Christmas stockings. The French doors [were] treated with the same tints in flat curtains."[9]

Erik Miller did much of the printing under Lee's supervision. He has recalled that

> It was tough at first, because Lee was being insistent on getting the highest quality. She would come into the darkroom to examine the prints and she would grab hold of any that were even slightly defective and tear the corners off. I always used to marvel at the way she could pick out what was wrong with a print, maybe something that had completely escaped my notice, but when it was put right the whole print would be greatly improved. It was never a case of delicately dabbling away with print forceps. We always used to plunge right in, rubbing the surface of the print with our fingertips and sometimes blowing on it so the warmth would enhance the tone in a specific area. . . . [10]

In a sense, the two-year interval Lee Miller spent working as a full-time self-employed professional photographer in New York was the true training ground for the rest of her life as a photographer — and was in itself the closest she came, in a sustained way, to being a fully disciplined darkroom craftsman in her medium, an artist who worked in a conventionally disciplined, and somewhat formularized, manner. The photographs from this period show a compositional formality which extends some of the preceding Paris work, and, at the same time, appears divorced from it. One is subtly aware, in studying the New York studio images, particularly the portraits, of her wanting to "make a living at this thing" — of striving to compete in the professional environment of the best commercial photography.

But a few of the New York images rise above even the highest level of studio portraiture or the fashion photography of the era, to take their place among Lee Miller's strongest work. Her patently "interpretive" series of portraits of the eccentric American Surrealist artist, Joseph Cornell [p. 116]; the pristinely elegant yet daringly composed image called "Floating Head" [p. 42]; the relatively "straight" yet magnificently elegant and character-filled portraits of two friends, each a stunning beauty, Dorothy Hill and Tanja Ramm [pp. 44, 45 and 109] — all these images hold their own among the greatest studio portraiture. And even some of the product shots, most notably the composition made with scent bottles lined up on a slight diagonal and reflected in the mirror on which they sit, endure in Lee Miller's photographic *oeuvre* [p. 39].

Lee Miller photographed several eminent theatrical and artistic figures in her New York studio, among them Clare Boothe Luce, and the actresses Lillian Harvey and Gertrude Lawrence [p. 119], with whom she remained friends for the rest of her life. John Houseman, during this period when he first came to know Lee, invited her to photograph the cast of his 1933 production of Gertrude Stein and Virgil Thompson's *Four Saints in Three Acts*. Her portrait of Thompson stands out among the many posed portraits of this era [p. 118].

Although Lee Miller, working closely with Erik Miller, took on many challenging commercial assignments, including some requiring color photography using three separation negatives, it was simply not a way of working that would sustain her interest for very long. Although, according to Erik Miller, " . . . when the chips were down, she just would not quit," she could also be "intolerably lazy when she wanted."[11] Eventually Miller became, once again, restless and impatient to move on.

In the overall context of Lee Miller's stylistic development, it is perhaps appropriate to think of the Paris and New York studio production — the work done in the years

Lee Miller, Floating Head, Portrait of Mary Taylor, New York, 1933.
Lee Miller Archives

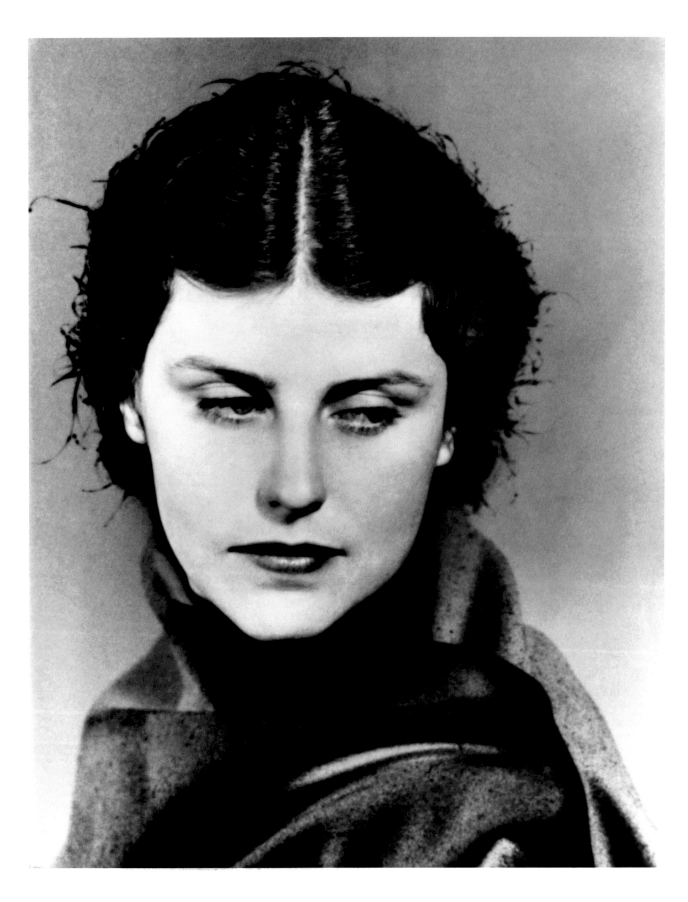

Lee Miller, Dorothy Hill, Solarized Portrait,
New York, 1933. Lee Miller Archives

Lee Miller, Tanja Ramm, Paris, 1931.
Lee Miller Archives

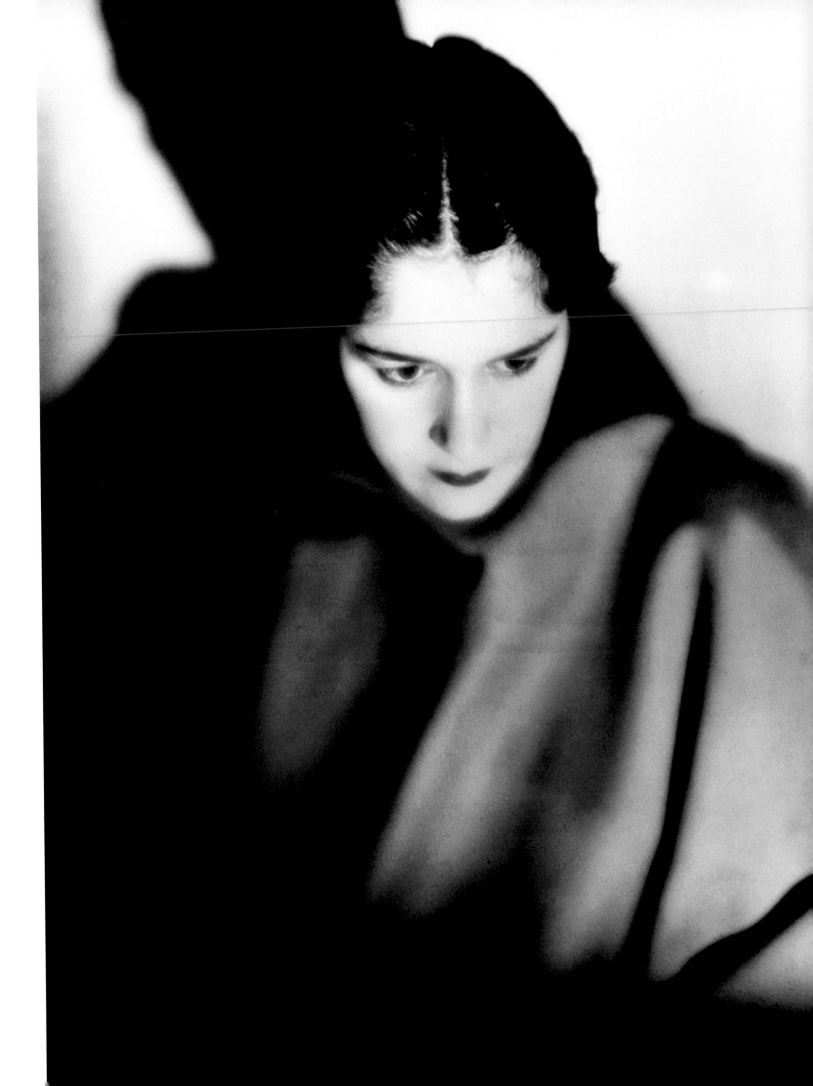

1929-1934 — as basically a single, sustained episode in the artist's development. One overriding hallmark of this diverse body of work is its quality of *precision*, or formal deliberateness. These images balance an almost muscular strength with a quality of lyrical delicacy. Their author is plainly endowed with an acute visual sensibility. One recognizes a drive to locate the aesthetic center of any given event or subject, and to express that core, that essence, through a lens that singles out the innately artful rather than imposing it.

Oddly, and even inexplicably, Lee Miller would soon leave behind many of the stylistic characteristics she so laboriously honed in these early years. From 1935 on her work shifted dramatically, when the circumstances of her life took her away permanently, as it would turn out, from the luxury (or the discipline, or encumbrance) of an elaborately equipped studio and darkroom. The changes in her stylistic approach certainly to some extent reflect the increased reliance on more and more portable equipment, as she roamed the world and often relied on make-shift printing facilities. But there is a deeper need one senses in her development as a photographer from now on — a desire increasingly to engage the world on its own terms, to clear away her own powerfully if subtly mediating taste, to allow her subjects to present themselves as their nature made them. It was almost as though, in the mid 1930s, she began again to learn to be a photographer. This new quest culminated in perhaps the greatest pictures she ever took, some of those done in the heat and squalid aftermath of the great world war in Europe, in 1944 and 1945.

The event in Lee Miller's life that precipitated this uprooting from, among other things, the physically elaborate technical environment she may have thought she needed to be a photographer, was the appearance of Aziz Eloui Bey in New York, to marry her and take her with him to Egypt.

Eloui Bey and Miller moved to Egypt in July 1934. Their official residence was a large Victorian house near Cairo, on the island of Giza, but they spent much of their time elsewhere in Egypt, often Alexandria. They visited Europe together, based in St. Moritz, where Aziz Eloui Bey owned a villa. Sometime in 1935 Lee Miller wrote a letter to Erik Miller, perhaps still feeling slightly guilty about having so precipitously abandoned her New York studio, and, in the process, left her brother unemployed. In it she said

> I don't know whether you are still interested in photography — or got the same loathing for it I had had. . . .
>
> Until Xmas time this year I hadn't taken even a roll of film — about three exposures I didn't bother to develop. But then I went to Jerusalem for a day and got sort of inspired and did about ten swell ones. . . . I've found a small shop to do my developing and printing to my satisfaction, so I'm taking an interest again.[12]

Photographer Unknown, Lee Miller and Aziz Eloui Bey, Egypt, c. 1935. Lee Miller Archives

Lee Miller's photographic activity during the first two years she was married to Aziz and living primarily in Egypt, was sporadic, though at moments intense. She seems to have been stimulated by travel, and she established a pattern of more and more frequently taking caravan driving trips into the desert with various groups of friends and usually without her husband. A few of her best Egyptian images from remote parts of the country in this period, and more particularly ones done a little later, such as those on pages 122, 123, and 125, combine a distinctive quality of lush atmospherism and a pungent sense of place that make them unique in her production. The strong light and shadow and a subtle compositional quirkiness give these pictures a feeling of calculated exoticism unusual in her work. And yet these images, more than most in her

46

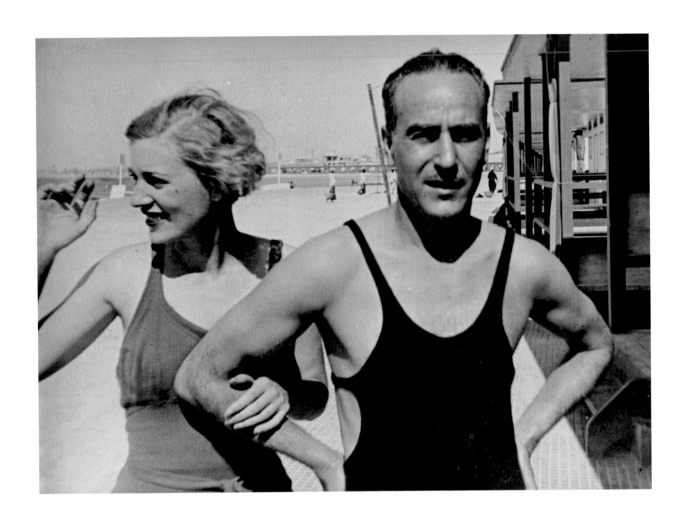

career, are fundamentally transparent, descriptive, strangely uneventful. Their special character derives either from some relatively simple yet crucial framing decision — the unobvious angle of view, for instance, as in the Cairo street scene shot from above, with strings of fluttering banners strung in a zig-zag pattern [p. 49] — or from a contrastingly large, theatrical gesture, as in the image showing the shadow cast by the Great Pyramid [p. 121]. These devices can of course be interpreted as resulting directly from her Surrealist indoctrination. But the Egyptian photographs are seldom demonstrably "Surrealist photographs," with the notable exception of the desert landscape shown through the torn screen of a tent [p. 52]. (This photograph is said to have inspired Magritte's painting *Le Baiser;* the Belgian painter is known to have seen it in London in 1938).[13]

Some of Lee Miller's strongest Egyptian pictures are a handful of rather static, even pensive still-lifes such as those of hotel interiors [pp. 50 and 51]. One of the striking aspects of the Egyptian photographs overall is the absence in them of native people, whether as portrait subjects or anonymous figures. A well known picture from Miller's years in Egypt is one of bales of cotton seen against a cloud-filled sky [p. 53]; the cotton bursting through the rounded burlap shapes becomes a kind of analog to the white clouds behind: the composition perfectly divides foreground and background into two realms, with a strong diagonal. The strange character of textural lushness here becomes the very subject, or raison d'être, of the image, signaling a renewed attention to *abstract* visual content as an end in itself.

In the summer of 1937 Lee Miller went by herself to visit Paris. Although she returned to Egypt and continued officially to live with Aziz Eloui Bey for another two years, this trip marked the beginning of a series of decisions she was perhaps half-consciously moving toward, to make Europe (and, ultimately, as it would turn out, England) her primary base for the rest of her life. Clearly she did not feel at home in Egypt — she was particularly bored by the stiffness and conventionality of well-to-do society there, what she called the "black satin and pearls set"[14] — but just as apparently, Miller must have felt alienated from the United States.

When she arrived in Paris in 1937 the first thing she did was to attend a Surrealist costume ball held by the Rochas sisters, daughters of a prominent industrialist, and attended by, among others, Man Ray, Max Ernst, Michel Leiris, Paul and Nusch Eluard, and Julien Levy. There, as related by Antony Penrose, she both "buried the hatchet" with Man Ray, and met the man she would later marry, Roland Penrose, the English Surrealist painter, writer, and founder of London's Institute of Contemporary Art. Lee Miller and Roland Penrose immediately took to each other, and spent several weeks together attending plays, exhibitions, Surrealist gatherings and parties;[15] when Penrose left Paris to install the Max Ernst exhibition at London's Mayor Gallery Lee Miller stayed in Paris and then went to England herself with Man Ray and his Martiniquaise girl friend, Ady. They met Roland Penrose in Plymouth and joined him for a month at "Lamb Creek," a beautiful Georgian house in Cornwall, owned by Penrose's brother Beacus. There they lived in hedonistic bliss with Max Ernst and Leonora Carrington, and Paul and Nusch Eluard, and were visited by the Surrealists Herbert Read, E. L. T. Mesens, and Eileen Agar. A little later, the same group reconvened at the Hôtel Vaste Horison at Mougins, France, where Pablo Picasso and Dora Maar had just arrived from Paris.

It was there that Lee Miller took the extraordinarily voluptuous and sly and narratively replete photograph of the Eluards, Man Ray and Ady, and Roland Penrose

Lee Miller, Street in Cairo, 1937.
Lee Miller Archives

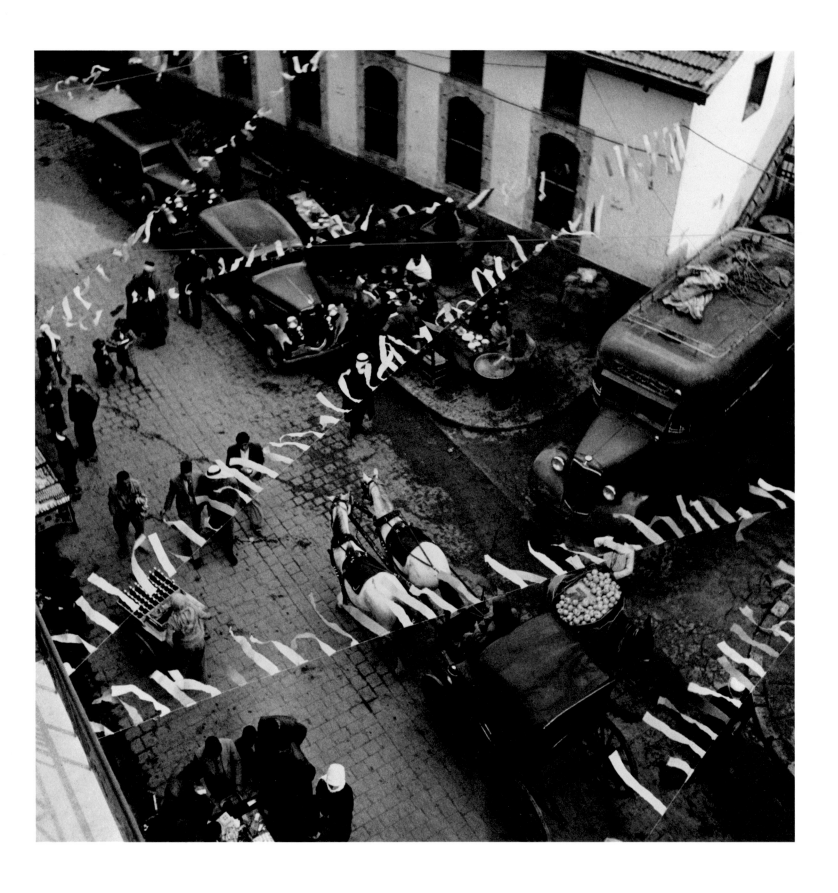

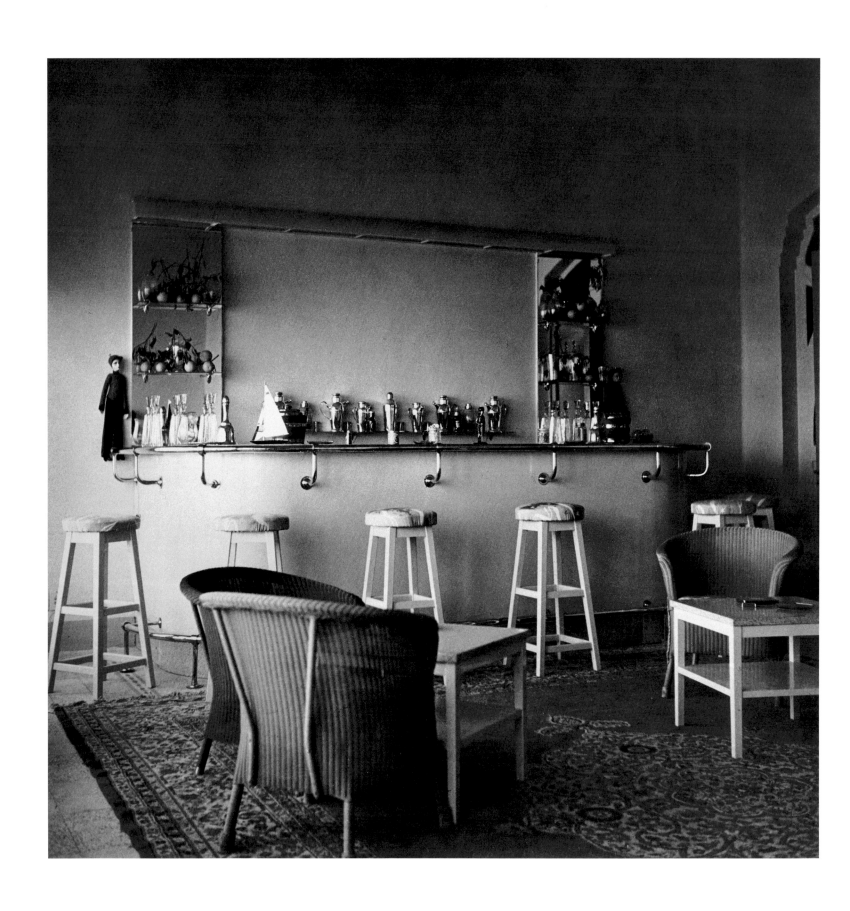

Lee Miller, The Estate House of Abboud Pasha,
Arcamant, Qena, Egypt, c. 1936. Lee Miller Archives

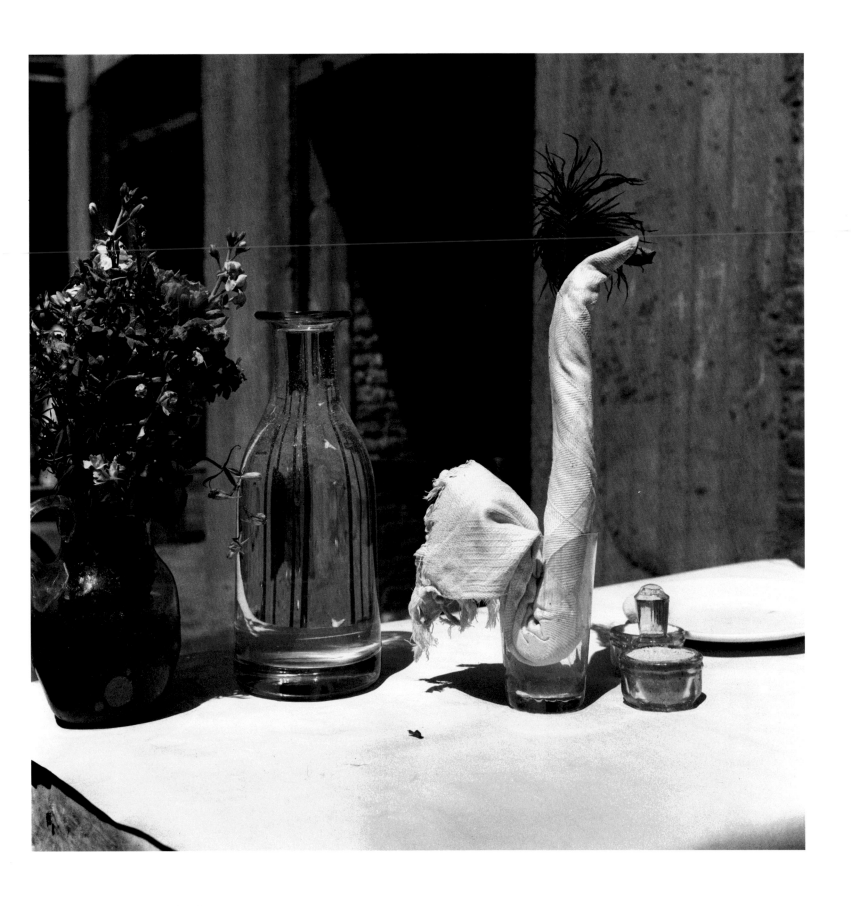

Lee Miller, Restaurant Table, Cairo,
c. 1936. Lee Miller Archives

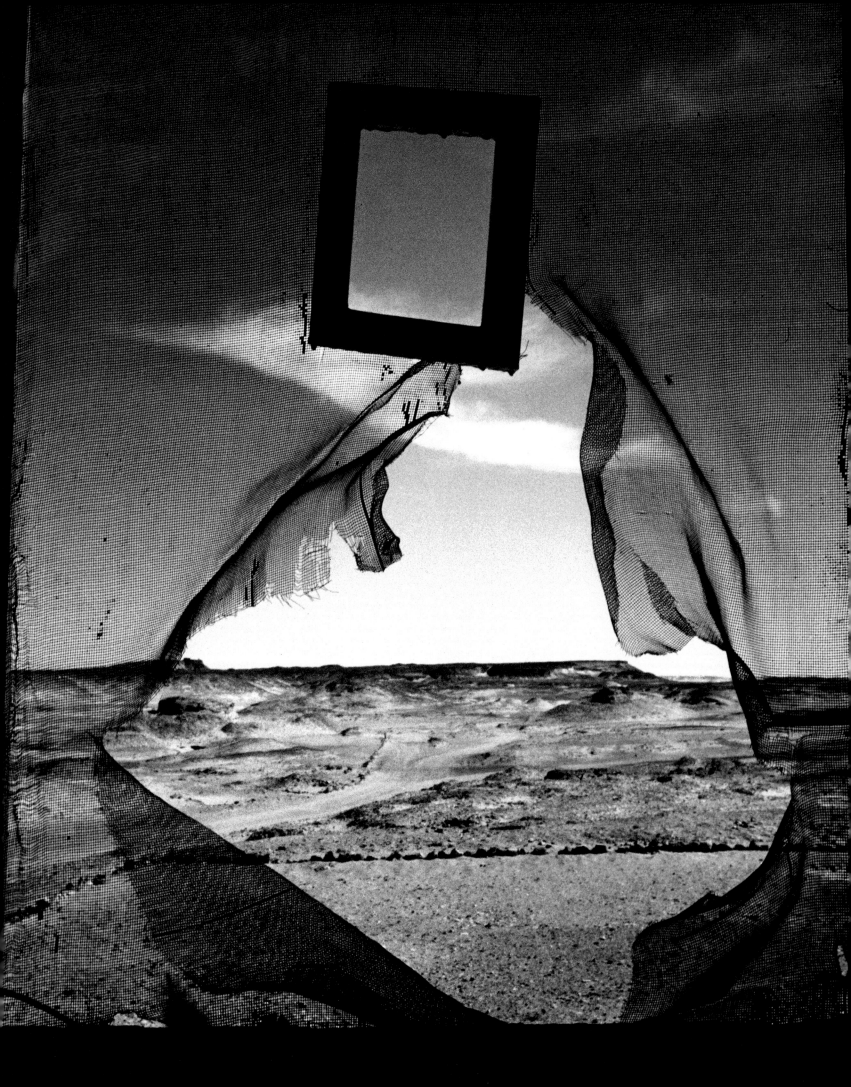

Lee Miller, Portrait of Space, near
Siwa, 1937. Lee Miller Archives

Lee Miller, Cotton Struggling to Escape
from Sacks to become Clouds, Asyut,
Egypt, 1936. Lee Miller Archives

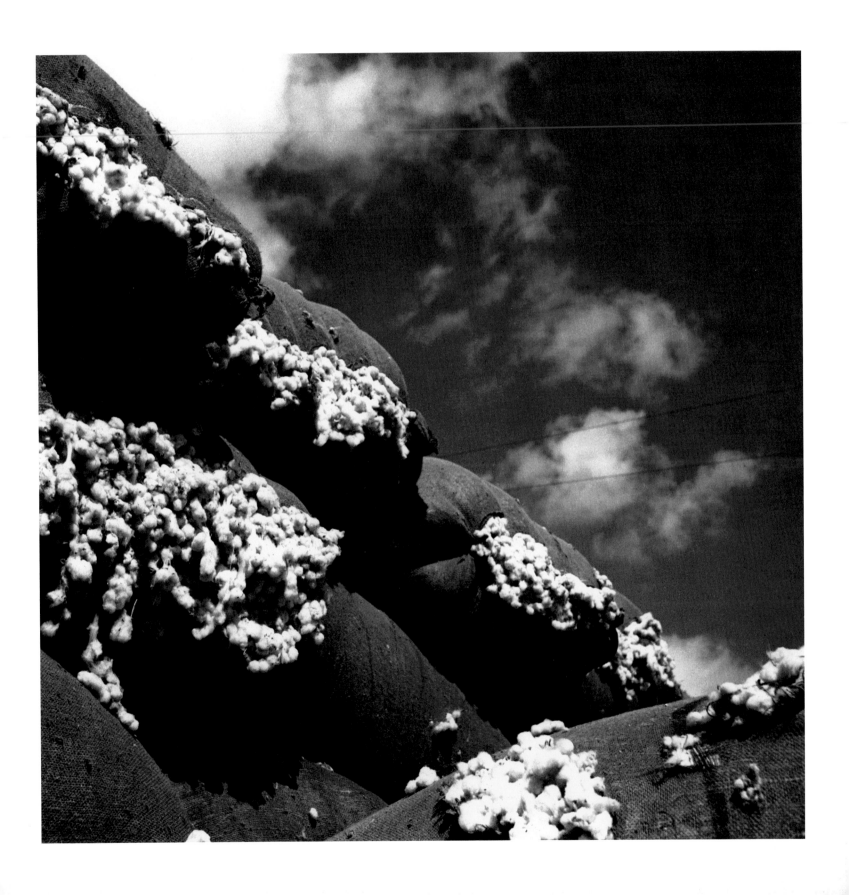

picnicking on the grass [p. 55]. This image portends a great change in Lee Miller's life and work. The contrast between its subject and framing and the ones made in Egypt, both before and after this moment, tells all one could want to know about Lee Miller's private feelings about her life in those years — and how, and where, she wished to live it.

Lee Miller sailed from Marseilles to Alexandria at the end of the idyllic summer; the next year was spent mostly in Egypt. This year of return was probably her most successful period there as a photographer — certainly she was more adapted to the country than before, and she now had her own automobile, a big, durable Packard, with which to take long excursions into the desert. In the Spring of 1938, Miller and her Packard boarded a ship headed for Athens, where she had arranged to meet Roland Penrose. From Greece, the two of them made a long driving trip through the Balkans, including Bulgaria and Romania. This journey is memorialized in Roland Penrose's small classic of Surrealist literature and photography, *The Road is Wider Than Long*. The imagery and style of some of these photographs, like some of Man Ray's in the late 1920s when he was living with Lee Miller, seem occasionally difficult to distinguish from hers.

In Bucharest, Roland Penrose and Lee Miller parted ways, he returning to England with Harry Brauner (brother of the Surrealist painter Victor), a musicologist and folklorist studying Romanian culture. Miller photographed consistently on this trip — but the work lacks either the emotional intensity or the compositional distinction of which she was so patently capable. Certainly it recedes when compared with what was to come in the next few years.

Lee Miller finally returned to Cairo via another adventure, this one in Lebanon and Syria with Bernard Burrows, a friend from the British Embassy. Once she was back in Egypt, facing the inevitable dissolution of her marriage to Aziz Eloui Bey, Roland Penrose appeared; the two of them, with George Hoyningen-Huene and Erik Miller's wife, Mafy, made a trip in Lee's Packard to the tribal oasis village of Siwa, Egypt. Finally, in June 1939, Lee Miller left Egypt for good, sailing from Port Said to Southampton, to be met by Roland Penrose.

On a short trip to the continent to visit Max Ernst and Leonora Carrington in their farm house in Saint-Martin d'Ardeche, Miller took some utterly "modernist" and very beautiful photographs of the farm walls Ernst had decorated [p. 56]; she and Penrose also visited Picasso and Dora Maar in Antibes. They were in the South of France when Hitler invaded Poland. Lee Miller decided to return to London with Penrose rather than return to America and risk missing the war.

Throughout the rest of 1939 Miller frequented the London office of *Vogue*. The studio was dominated at that time by Cecil Beaton, a personage with whom Lee Miller never had any particular rapport. Miller had been out of professional photography since she left New York in 1934, and competition at *Vogue* was stiff. Nevertheless, even with all this against her, she persisted in making herself useful and well-liked in the magazine offices, and by the beginning of 1940 she had secured a staff position. Her work for *Vogue* throughout 1940 was mostly standard fashion illustration, usually dealing, in that wartime climate, with practical items of clothing or promotional shots of accessories, with the occasional celebrity portrait. Her most valued working associate at this time, according to Antony Penrose, was Roland Haupt, a talented darkroom technician — particularly in the art of the fine print — with whom Lee Miller worked closely, and who himself became a noted fashion photographer.

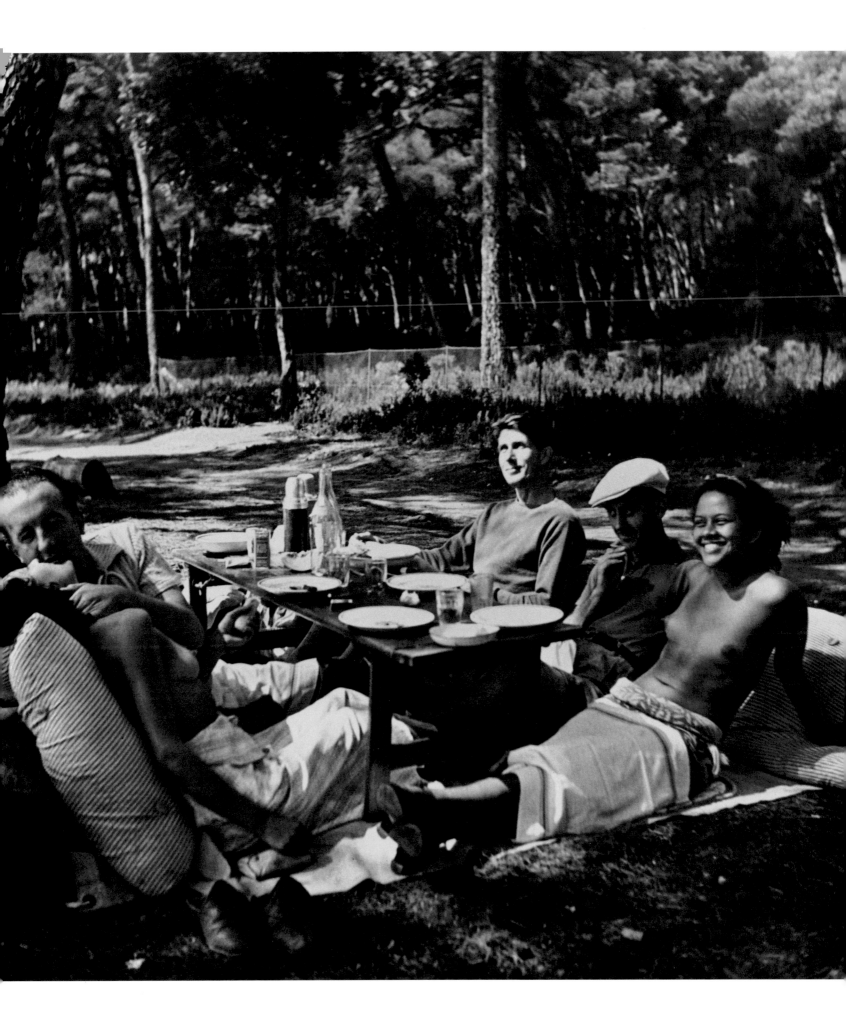

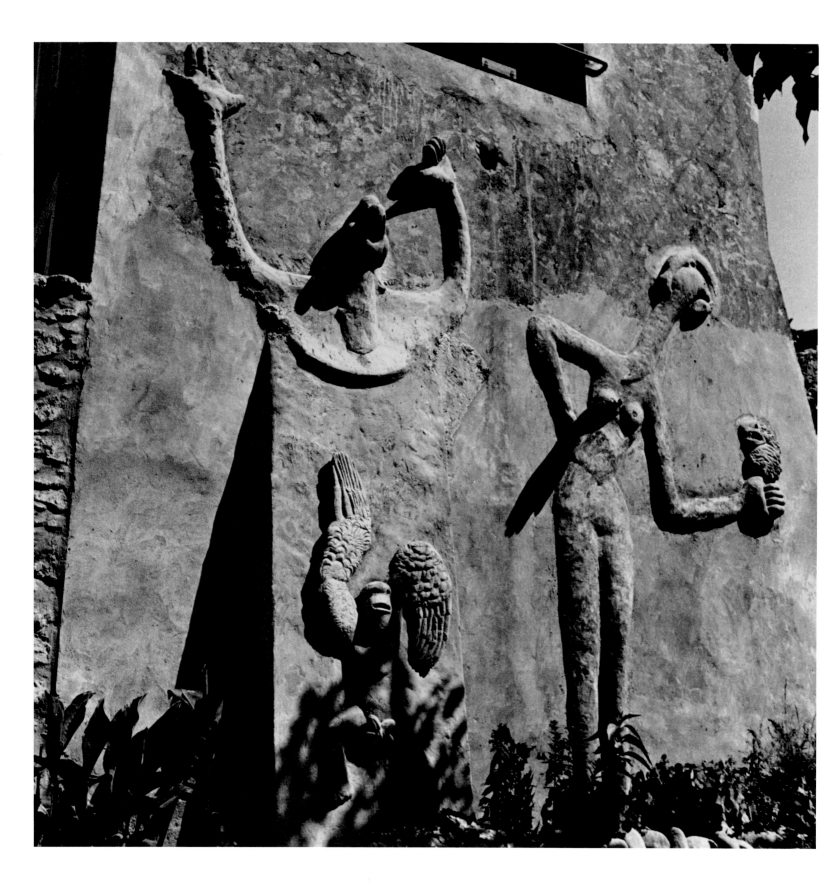

Lee Miller, Sculpture by Max Ernst on
the Wall of the House in St. Martin
d'Ardeche, 1939. Lee Miller Archives

Lee Miller, Man Ray and Ady, Mougins,
France, 1937. Lee Miller Archives

It was clear, both from the competent but slightly bloodless character of the photographs Miller did for *Vogue* in this period, and from her own testimony, that she was by this stage in her artistic development ready to leave commercial studio work behind — and, by implication, ready to move to a new creative level as a photographer. The project that in retrospect seems to have provided the catalyst into a new artistic maturity was the production of a book, inspired by and compiled from photographs Lee Miller had been making on her own, *Grim Glory: Pictures of Britain Under Fire*, edited by Ernestine Carter and written by Edward R. Murrow. It was distributed both in England and the United States (published by Scribners) as a vehicle for dramatizing the horrors of Blitz-torn London. As is clearly evident from the images from *Grim Glory* included here [pp. 59, 60, 61, 132, 133, and 136], Miller was making a huge stride in her work toward the boldly expansive compositions, the increasingly eccentric-and-yet-unaffected imagery, and the transcendent fearlessness in relation to her subject, that are the hallmarks of her work throughout the war years.

As Roland Penrose noted of Lee Miller's photographs for *Grim Glory*, "Her eye for a surrealist mixture of humour and horror was wide open . . ."[16] Penrose described his own, totally new experience in the face of the realities of the Blitz, which was to "learn that fear was a hideous reaction that could seize a person and make him crawl like an animal."[17] He recounts an incident showing the difference between his own response and Lee's: "One clear moonlight night which had been chosen for a heavy raid I . . . was on duty as a warden and, having returned home at midnight for the small packet of tasty refreshments that Lee systematically prepared for my patrol, I left her at the gate with her last words, 'Aren't you excited?' in my ears."[18]

Many of the best photographs Lee Miller made in wartime London and Continental Europe, whether they ended up as book projects (*Grim Glory* and *Wrens in Camera*) or as assignments for *Vogue*, have a distinctive combination of apparently contradictory qualities: on one hand, they are oddly *literary* in approach — ironic, allusive, multi-leveled. On the other hand, many of these images seem so immediate, so spontaneous and uncalculated, that their sheer *presentness* overshadows their literary, or ideological content. One of the images in *Grim Glory*, titled "Revenge on Culture" [p. 59], picturing the nude head and torso of a female statue half-buried under the rubble of some bomb explosion, was reproduced world-wide. Yet it is certainly far from the strongest picture of this period — others in *Grim Glory* are better, subtler [pp. 132, 133, and 136] — and as a group, these pictures are interesting as much for their preparing the way for what was to come soon afterward, as for their own quality.

It was in 1941 that Lee Miller met the American David E. Scherman, a *Life* magazine photographer assigned to the London bureau and part of a group of Americans who gathered frequently at Lee Miller's and Roland Penrose's Hampstead house. Miller and Scherman were to travel and photograph together on several important occasions throughout the war. Scherman, and other American journalistic photographers, by example, may have influenced Lee Miller increasingly to abandon the titling *double entendres* that crept into her work in the early war photographs. (Images from *Grim Glory* have recently entered into the Surrealist photography canon, notably, in *L'Amour Fou*.) In 1940 and 1941 Miller began to focus more clearly on the center of the narrative drama around her rather than the quirky peripheral scene that so often seduced her attention. Of course, it may have been simply the escalating intensity of Lee Miller's response to the war and its atrocities that pushed her into an ever more audacious and emotionally courageous mode of photography.

Lee Miller, Revenge on Culture, from *Grim Glory*, 1940. Lee Miller Archives

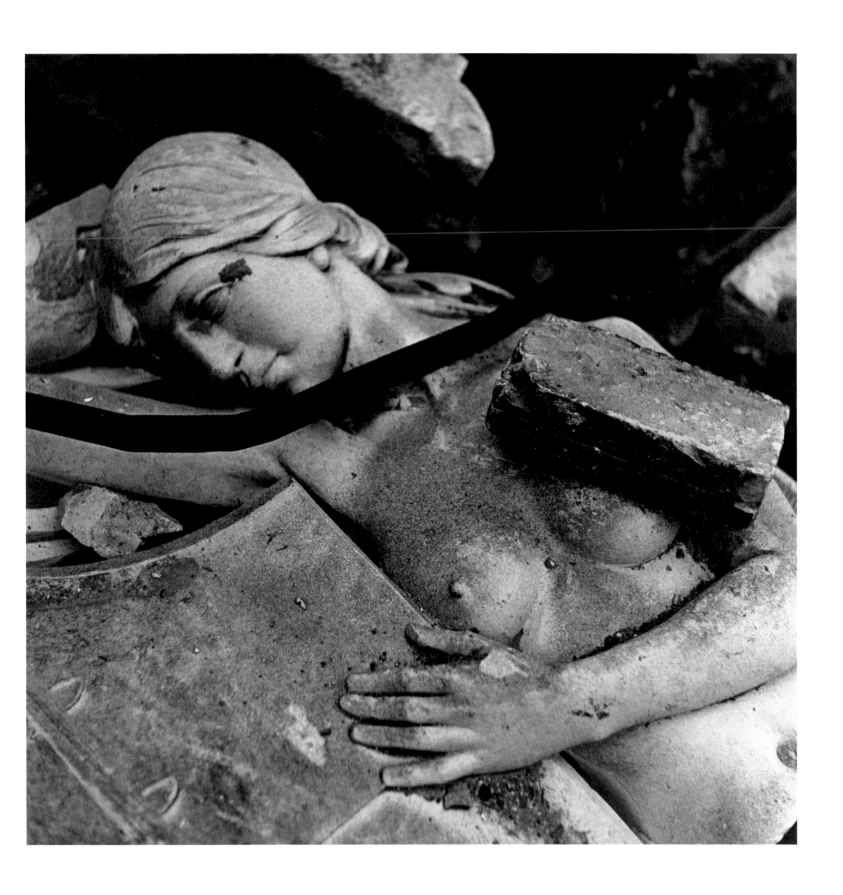

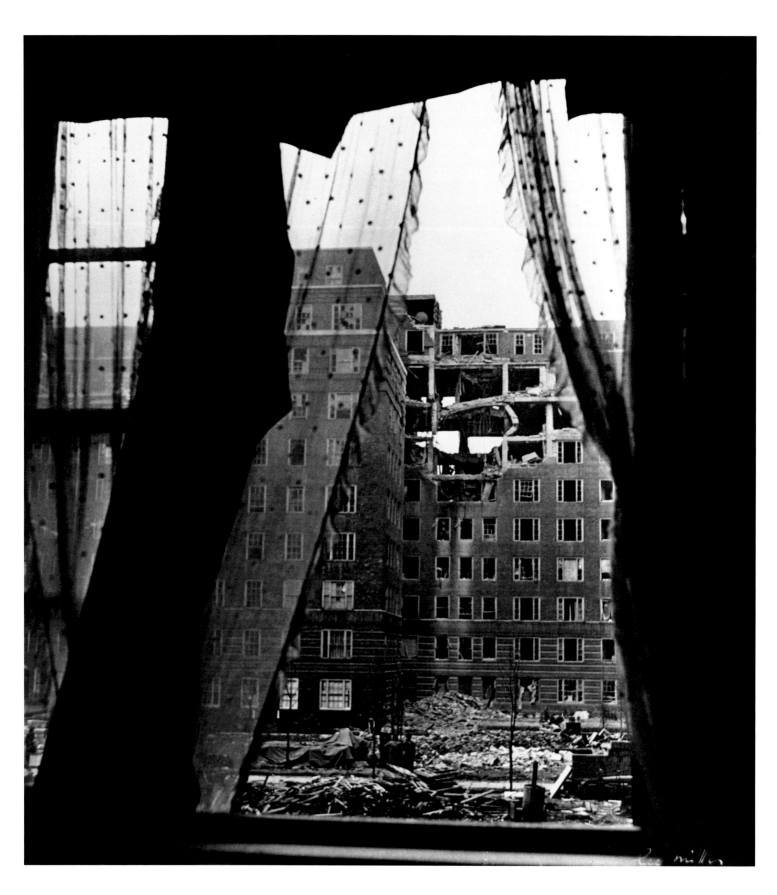

Lee Miller, Dolphin Court, London during
the Blitz, from *Grim Glory*, 1940.
Lee Miller Archives

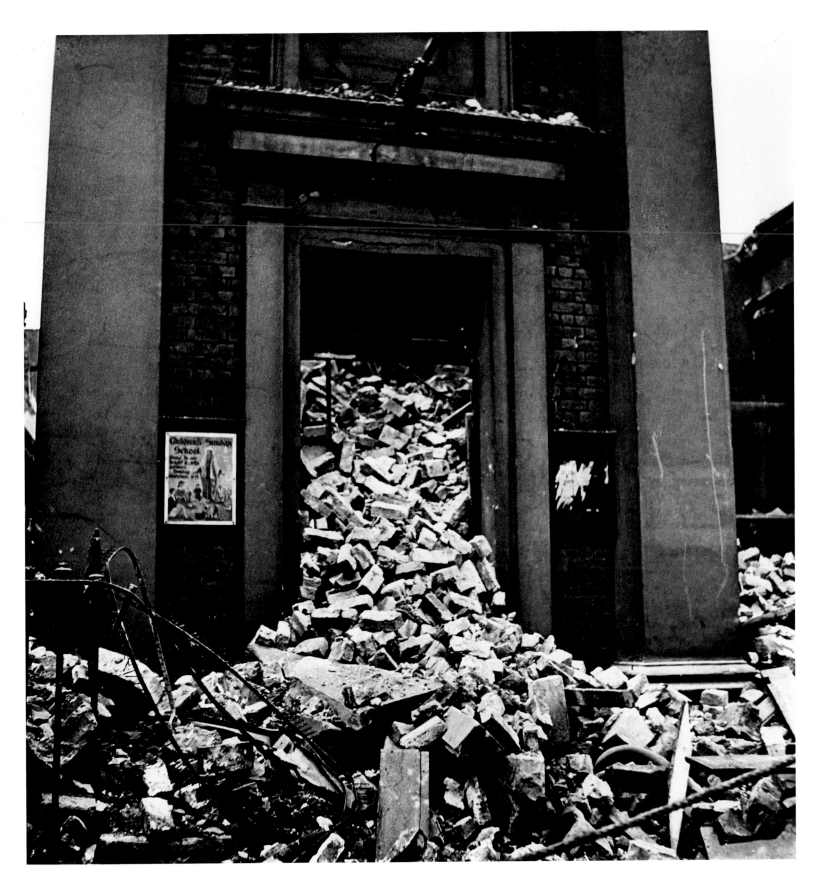

Lee Miller, Nonconformist Chapel,
Camden Town, London, from *Grim Glory*,
1940. Lee Miller Archives

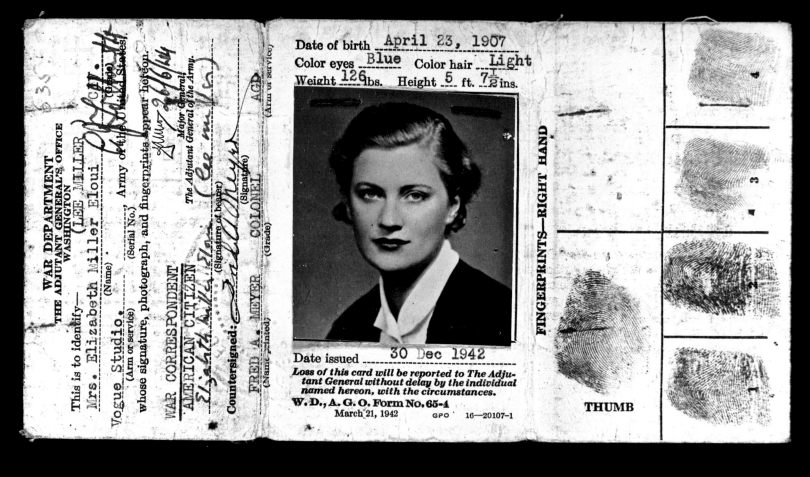

WAR DEPARTMENT
THE ADJUTANT GENERAL'S OFFICE
WASHINGTON

This is to identify— (LEE MILLER)
Mrs. Elizabeth Miller Eloui
(Name)
Vogue Studio.
(Arm or service) (Serial No.) Army of the United States,
(Grade)
whose signature, photograph, and fingerprints appear hereon.

Major General
The Adjutant General of the Army.

WAR CORRESPONDENT
AMERICAN CITIZEN
Elizabeth Miller Eloui (Lee Miller)
(Signature of bearer)

Countersigned: _____
(Signature)

FRED A. MEYER COLONEL AGD
(Name Printed) (Grade) (Arm or Service)

Date of birth April 23, 1907
Color eyes __Blue__ Color hair __Light__
Weight __126__ lbs. Height __5__ ft. __7½__ ins.

Date issued _____ 30 Dec 1942 _____

Loss of this card will be reported to The Adjutant General without delay by the individual named hereon, with the circumstances.

W. D., A. G. O. Form No. 65-4
March 21, 1942 GPO 16—20107–1

FINGERPRINTS—RIGHT HAND

THUMB

In the winter of 1941-42 Miller successfully applied for accreditation to the United States War Department as an American correspondent. Over the item "Arm or Service" on her identity card is typed *Vogue Studio* — but the creative freedom she gained professionally to find her own way altered suddenly and irreversibly the tenor of her former professional status with *Vogue*. Now she felt empowered to seek out her own subjects and to shape her own stories, both in photographs and in words. Rarely has the simple license to travel to the front, in order to picture war for those not in its midst, influenced more cogently the evolution of an important photographer's work. Everything in Lee Miller's unique combination of talent, temperament and training seems to have prepared her for this period in her work.

Of course, a number of factors aside from Miller's psychological readiness to take on new photographic challenges entered into the changes that occurred in her pictorial style in the early 1940s. A general revolution was occurring in photographic magazine journalism, primarily identified with *Life*, *Look*, and *Fortune* magazines, and greatly assisted by, among others, Miller's contemporaries in the United States, Margaret Bourke-White, Eugene Smith and Alfred Eisenstadt. *Life's* large format; its emphasis on photographs by themselves, increasingly freed from lengthy texts or captions to tell the story; and its preferences at this time, along with other American and European magazines, for black and white photography — all these factors signaled a shift in the relationship between magazine editors and photographers that allowed for the emergence of a number of journalistic photographers who thought of themselves as artists. Although Lee Miller was never a direct player in the new American photo-journalist star system, she clearly benefited from its values.

Ever more important to her release from the constraints of the studio — or lack of a studio — she had inevitably faced all during the 1930s, was the development of new films, and new, lightweight camera equipment. In the late 1930s the small, compact Leica cameras, using 35 mm film, became available; Lee Miller, however, seems to have used Rolleiflex equipment exclusively in her field work until the autumn of 1944, when she "looted a beautiful Zeiss Contact."[19] (David E. Scherman has corroborated for me Lee's use of the Rolleiflex in all her field work.)

Although Lee Miller was not placed squarely in the center of the new American photojournalism of the 1940s and 50s — primarily because she was not based in the U.S. — she was an accepted figure in its milieu. She was one of the earliest members of the Magnum photo agency, and as Antony Penrose points out,

> She became a great friend of Robert Capa. . . . And Lee was well accepted by the upper echelon of photographers then, and used to hang out with Jimmy Dugan, David Douglas Duncan, Eliot Elisofon, and others. They very often photographed the same story — as is evidenced in her photograph of the suicide of the Burgomeister of Leipzig [p. 150]. Margaret Bourke-White's photo of the same subject must have been taken at almost the same moment that Lee shot her pictures, yet neither photographer refers to the other, and the shots are markedly different.[20]

Although Lee Miller's longtime base magazine, *Vogue*, in the war years might have been assumed by definition to have been less responsive than many other magazines to combat journalism or candid photography in general, it was nevertheless *Vogue* that continued, throughout the war, not only to commission her work from afar, but to print it — much of it with narratives she herself supplied.

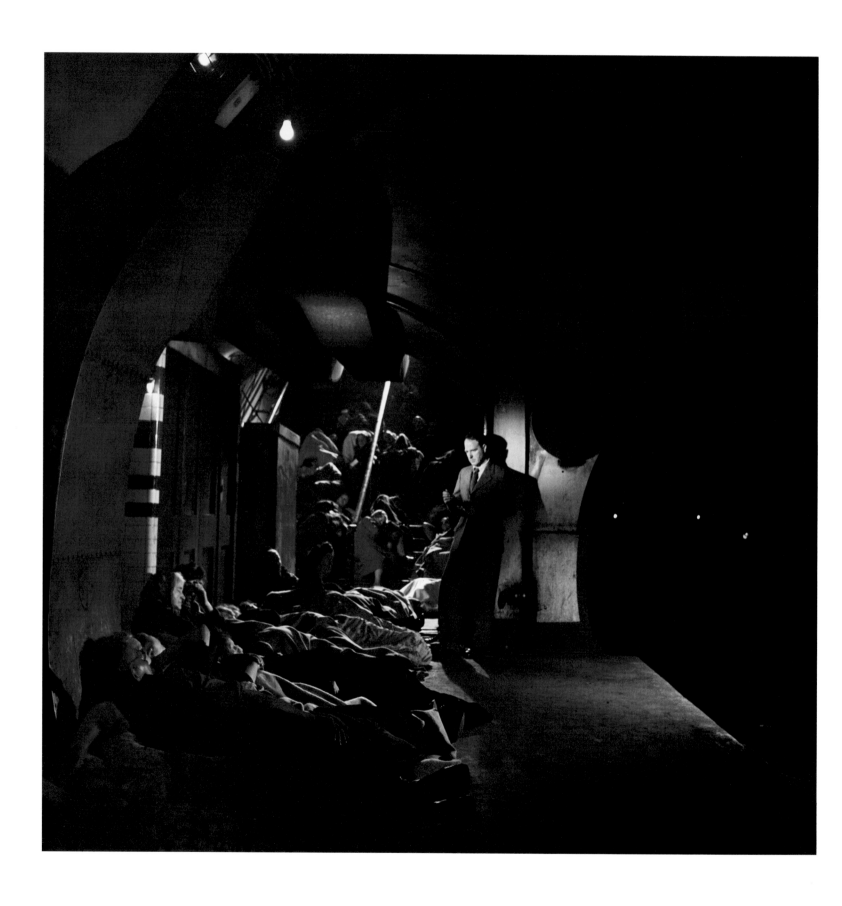

During 1941, 1942, and 1943, Miller alternately worked on fashion assignments and war-related stories for *Vogue* in England. On several assignments she collaborated with Dave Scherman, including one covering Henry Moore working as an official war artist in London's Underground air-raid shelters [p. 64]. (This story was occasioned by the location shooting of a film, *Out of Chaos*, directed by Jill Craigie, which also featured the work of artists Graham Sutherland and Paul Nash.)

The more war-related work Miller did, the more she liked it and the stronger were her images. In the words of Antony Penrose,

> The artificiality of contributing photographs of beautiful clothes to a magazine for the soigné elite gnawed at her. Fashion seemed utterly trivial at a time when she suspected that many of her friends in Paris were risking their lives every day in support of the resistance.[21]

Miller wrote her first published text, to accompany her own photographs, for a story for *Vogue* on the great American journalist Edward R. Murrow. Murrow, who lived in London and whom she had known for years, provided a subject upon which she could express some of her own aspirations for herself. She wrote, "Somehow he seems to put things together differently than other people — and I don't mean he draws startling or genial conclusions — but just that his facts are not axe-grindings and he's never tried to fool anyone and therefore they are emphasised and stabilised in their proper proportions."[22]

Lee Miller's involvement with *Vogue* may have been single-handedly responsible for that magazine's successful adaptation to the realities of war–time. There is some irony in the fact that the woman who was one of *Vogue's* paragons of elegance and high style — both as model and contributor — would be responsible for a basic shift in the magazine toward values that would seem to undermine its very *raison d'être*. It is a tribute to Lee Miller that her profound cosmopolitanism and acute social conscience, led her, not to abandon the institution with which she had for so long been involved, out of some sense that its concerns were necessarily trivialized by contemporary world events — but instead to work within *Vogue's* ranks to stretch the boundaries of its compass. *Vogue*, to its credit, through the eyes and ears of Lee Miller, let the war come into its pages, seemingly without flinching.

Several images included here were shot in a U.S. Army tent hospital near the Normandy battlefront a few weeks after D Day in the summer of 1944 [pp. 66, 67, 144, and 145]. What had begun as an assignment covering the nurses who treated soldiers in an evacuation hospital became a fourteen-image photo essay, action pictures accompanied by a hard-hitting narrative written by Miller, that appeared in the September 1944 *Vogue*. This was the first of many in-the-field articles photographed and written by Lee Miller over nearly a two year period.

The Normandy tent-hospital pictures contain all the elements that characterize the best of Lee Miller's war photographs. There is a new intensity of engagement with, and immersion in, her subject: looking at these images, we feel the dire psychological actuality of what is being pictured — and yet the natural chaos of the events depicted is tempered, made both concrete and manageable, by the artist's masterful compositional handling. The theatricality she achieves by using the framing device of the tents themselves to stage the action and the dramatic lighting integral to the scene never threaten to become artificial. That most difficult of balances in action photography is flawlessly struck, i.e., the balance between the visual legibility, or order, necessary to enduring images, and the charged confusion innate in traumatic events.

Lee Miller, Henry Moore Making Sketches for his Series of Drawings Titled "Sleepers," Holborn Underground Station, London, photographed during the filming of "Out of Chaos" by Two Cities Productions, Director Jill Craigie, 1940. Lee Miller Archives

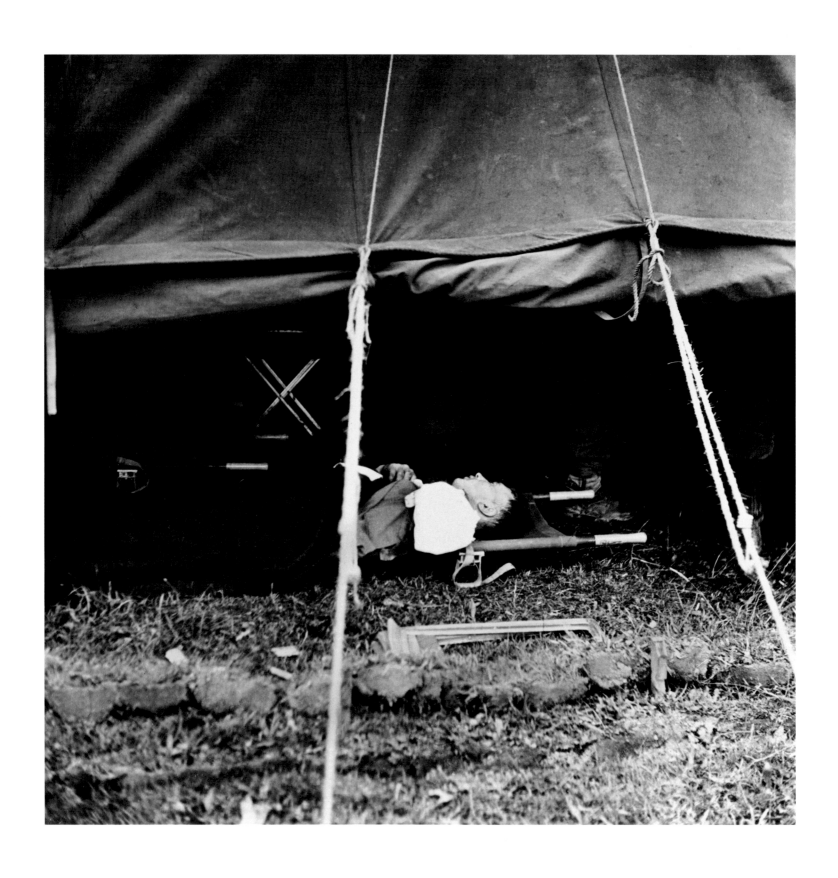

Lee Miller, Casualty Awaiting Evacuation
from a Normandy Field Hospital, France,
1944. Lee Miller Archives

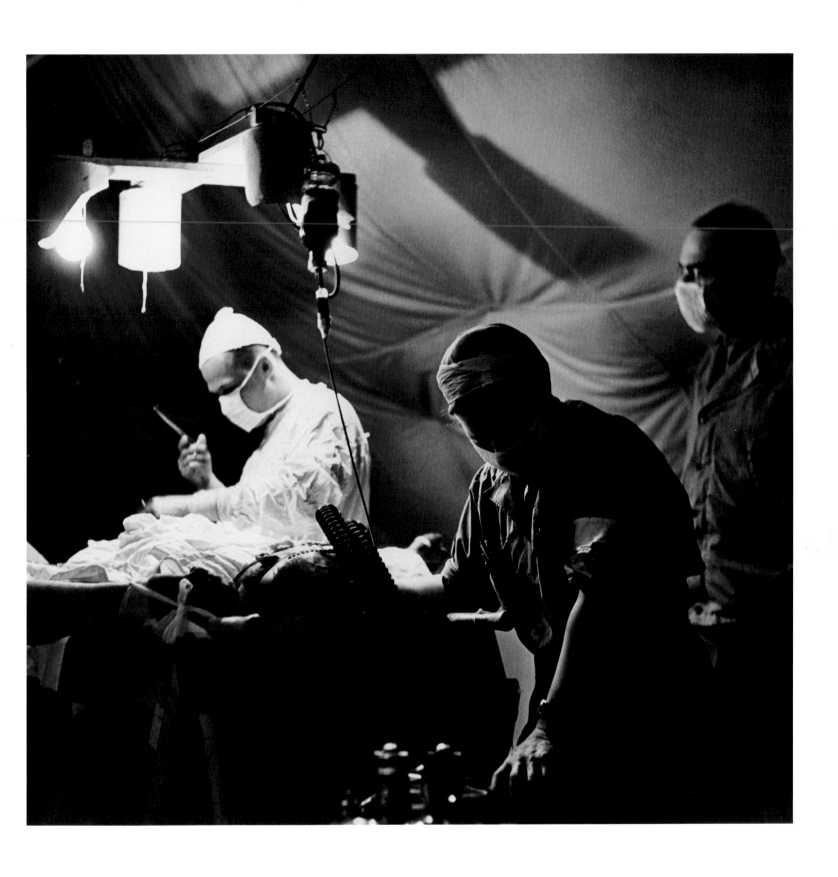

Lee Miller, Normandy Field Hospital,
France, 1944. Lee Miller Archives

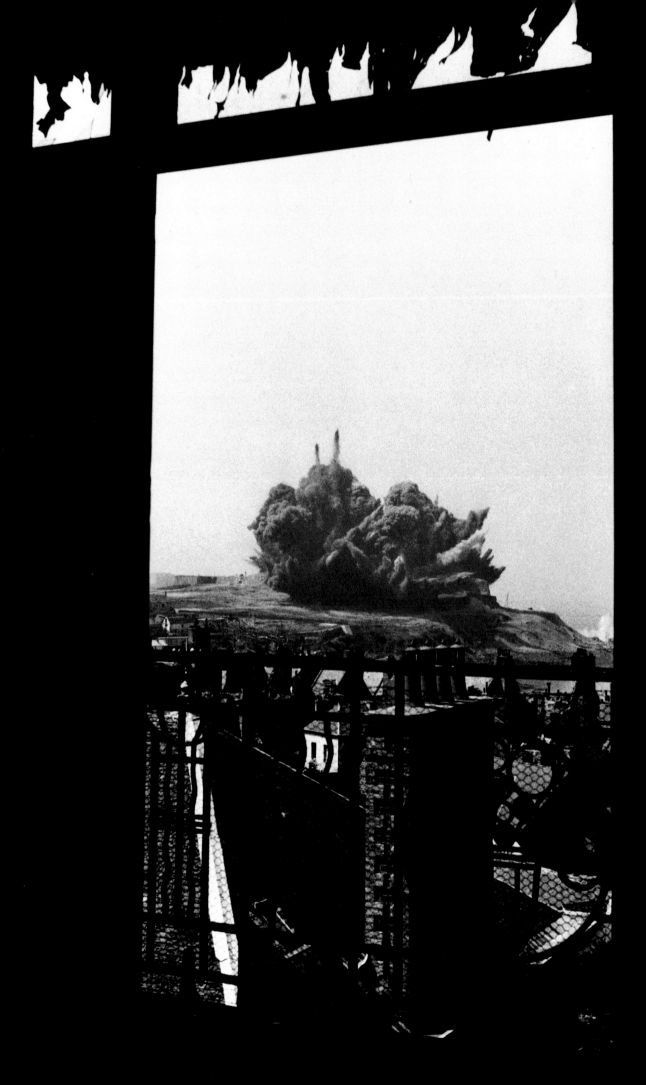

Miller's next assignment designated by the U.S. Army Public Relations Office sent her to the coastal town of Saint Mâlo, France, nominally to "cover the Civil Affairs team which had moved in after the fighting to speed the return to civilian life."[23] However, the Germans defending the great citadel, Forte de la Cité, situated on a promontory high above the Atlantic Ocean, were far from ready to surrender to the Americans, apparently convinced that reinforcements were imminent. Miller was the only reporter on the scene; she took full advantage of the situation, positioning herself in a top story room of a hotel and photographing the first explosions of the newest weapon, napalm, against the German-held fortresses. (The shots showing napalm were censored by the British and excluded from the *Vogue* story on St. Mâlo.) She watched and recorded the virtual destruction of the beautiful old town of St. Mâlo. As she wrote for *Vogue*, "...I was given a grandstand view of fortress warfare reminiscent of Crusader times."[24]

One of the most singular photographs perhaps ever taken in World War II was taken from that honeymoon suite window in the little French resort village as Colonel von Aulock fought his losing battle against a battalion of the American 83rd Division, commanded by Major Speedie [p. 68]. This picture expresses the idea of obsessed battle in civilized turf, without focusing at short view on the individual destruction and gore the photographer was actually seeing all around her. And it does so without betraying any overt sense of the immediate, sickening terror — in her words, "the stink of death and sour misery,"[25] — its maker was experiencing. Shot through a poignant interior foreground, this picture does, however, convey both its author's personal courage and her control of her medium.

Apparently, Lee Miller's accreditation as a war correspondent proscribed her operating in, or even entering, a combat zone, and shortly after the surrender at St. Mâlo she was placed under house arrest at the nearby town of Rennes. She seems to have used this circumstance to sleep long and imperturbably, then to write her *Vogue* piece — and then doggedly to make her way to Paris, where she arrived on the very day of Liberation.

"Paris had gone mad," she wrote for *Vogue*.

> The long, graceful, dignified avenues were invaded with flags and filled with screaming, cheering, pretty people. Girls, bicycles, kisses and wine and around the corner sniping, a bursting grenade and a burning tank. The bullet holes in the windows were like jewels, the barbed wire in the boulevards add a new decoration. The Parisians had made a fantastic game of their week of war. The stakes were life and death, as they had been for four grim years, but in their long-awaited battle they attacked with gaiety, irresponsibility and flowers in their hair. . . .

> I arrived exhausted by my share of millions of handshakes — handshakes for the 'femme soldat.' . . . The next day, Paris started cleaning up after the world's most gigantic party. The tinkle of glass reminded me of early blitz days in London. . . .[26]

Roland Penrose, by his own account, missed the action Lee Miller experienced in World War II. As a member of the Home Guard, he visited Italy in early 1944 to study warfare camouflage techniques, but, as he wrote,

> Apart from this brief taste of action at the front, I remained a homeground instructor thoughout the war, which gave me a sense of inferiority when I compared my own efforts to the immensely daring exploits of Lee. . . . Hearing that Lee had arrived in Paris, I was seized by an irresistible urge to get there too. With the help of a young bragging American officer in Shaef and some breathtaking bluff I found myself on a plane bound for Normandy with no papers other than my pass giving me

Lee Miller, U.S. Bombs Exploding on the Fortress of St. Mâlo, France, 1944. Lee Miller Archives

69

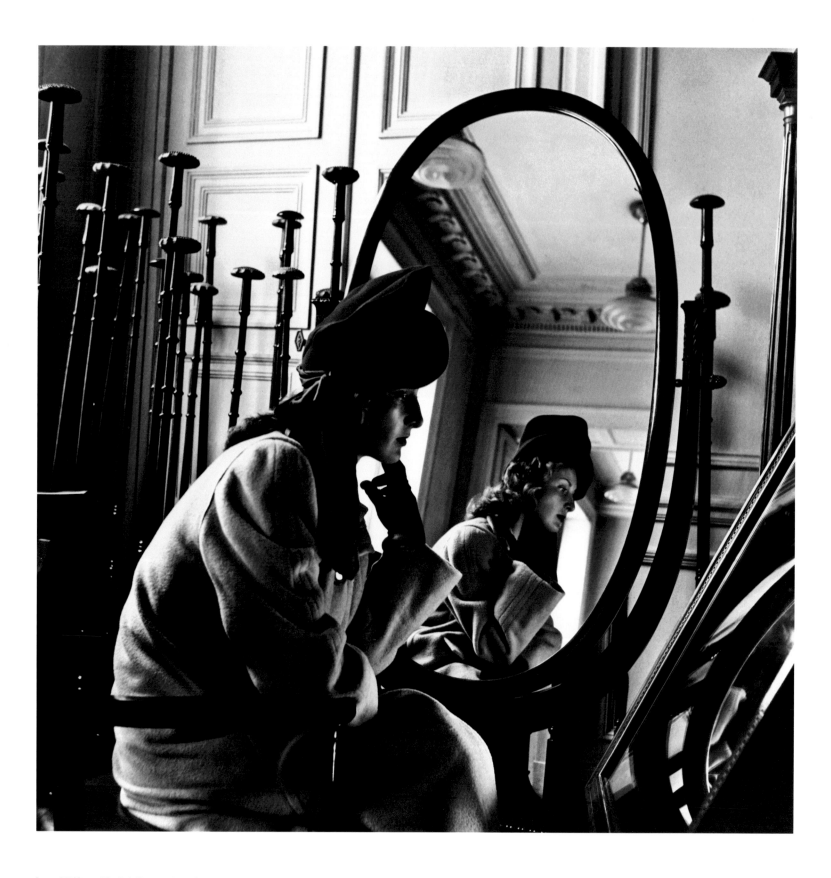

Lee Miller, Model Preparing for a
Millinery Salon after the Liberation of
Paris, 1944. Lee Miller Archives

David E. Schermann, Lee Miller in Room
412, Hotel Scribe, Paris, 1944.
Lee Miller Archives

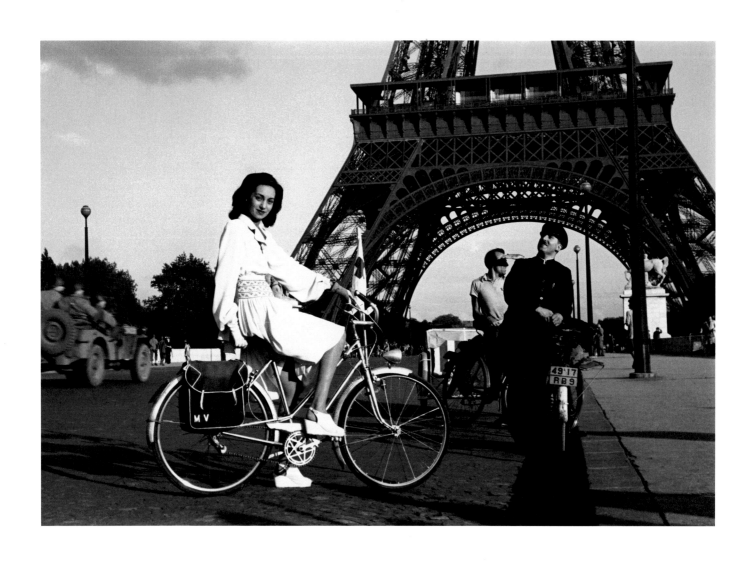

Lee Miller, Paris Fashion, 1944.
Lee Miller Archives

Lee Miller, Paris under Snow, 1945.
Lee Miller Archives

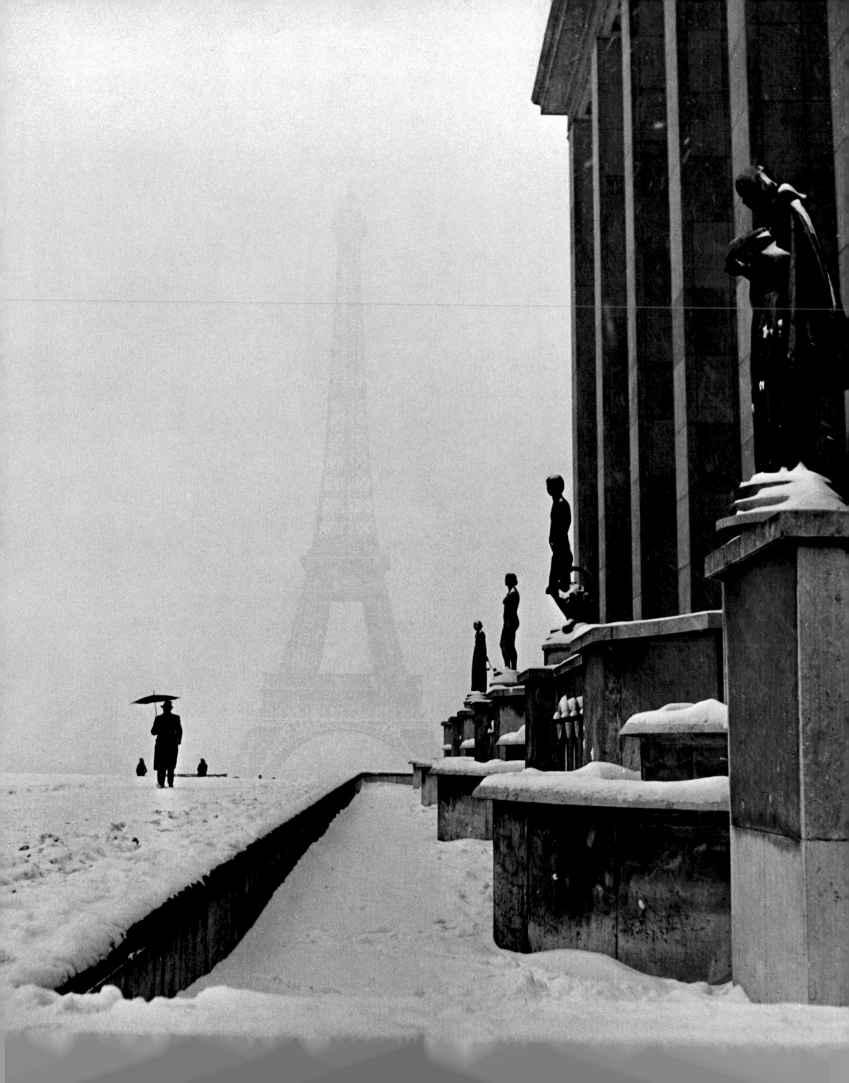

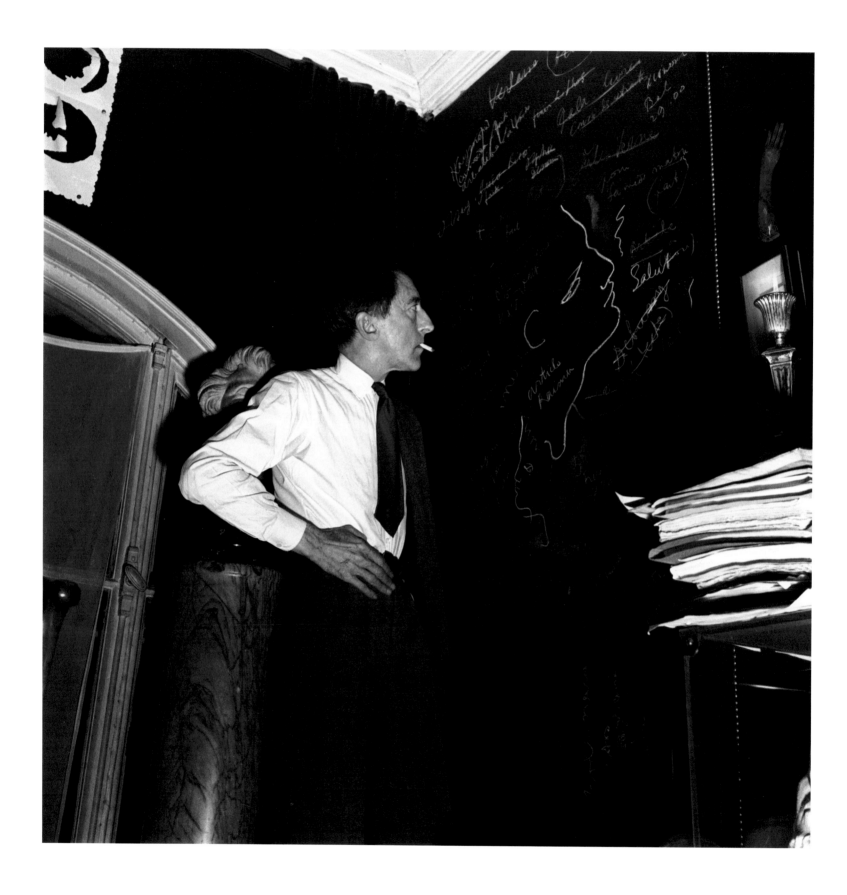

ten days home leave. Again, by luck I hitch-hiked a lift in a staff car going to the Hôtel Scribe in the centre of Paris which was at that time Press H.Q. for the Americans and finally, on asking tentatively for Lee Miller, to my surprise I was shown up to her room. Somehow it was intended that the miracle should continue. An hour later Lee and I joined Picasso, Eluard and Nusch for dinner — a reunion which seemed unbelievable. . . . The marvel of it all was to . . . renew contact with those who until then had seemed lost: Picasso, Eluard, Rene Char, George Hugnet, Tzara, Dominguez and others . . . like Max Jacob and Robert Desnos, whose names had become only echos.[27]

Among all the reunions in Paris during this intensely poignant and climactic interval was one with Jean Cocteau, described in her words: "He's looking . . . younger than I thought possible — less nervous and not mournful or whining which was so much his style when I left Paris five years ago [to the] day. . . ."[28]

And aside from all of the frenetic renewing of old friendships, she worked away at her craft in Room 412 of the Hôtel Scribe. According to Antony Penrose,

> For much of the time the [hotel] bathroom was a photo-lab where Lee made attempts at developing Ansco reversal film. There was plenty of colour negative available, but it was unusable at this stage of the war because the censors would not allow it to be sent back for developing in a commercial laboratory. The Ansco film came with a do-it-yourself development kit to allow the dispatch of finished film, but it was too slow and unreliable to be effective.[29]

One of the demands *Vogue* made on Miller at this stage was to cover the revival of French *haute couture* in the newly liberated capital, and to help *French Vogue's* editor, Michel du Brunhoff, revive the magazine. For these months in Paris just after the Liberation, she both coordinated efforts of photographers all over Paris, and contributed her own images [pp. 70, 72, and 73] and text to the magazine. Moreover, she managed to make some of her finest portraits in this brief period, such as the one of Colette at age 71, at her writing table [p. 142], Jean Cocteau [p. 74], or the group portrait showing Picasso, Nusch Eluard, Paul Eluard, Elsa Triolet, Roland Penrose, Louis Aragon and herself [p. 139].

Vogue's Audrey Withers assigned Lee Miller a story on the "Pattern of Liberation," focusing on refugees. This story, for which Miller traveled to Luxembourg, appeared in the January 1945 issue; in it, her growing revulsion at Nazism and the treatment of Jews in Europe is more evident than ever. She was obsessively drawn back to the scenes of action, and she was soon allowed to go to Alsace to cover the conflict there. In the deep winter of 1945 Lee Miller followed the slow and difficult incursion of the U.S. Army and other troops over the Colmar plains toward the Rhine. The battles against the Germans, whose backs were to the river, were constant and bloody, and were fought in a season of bitter, unremitting wind and cold. Miller, in her own jeep, went from Strasbourg south toward Colmar, seemingly moving at will among the infantry troops, many of whom knew her, or knew of her, and who allowed her an entree not given to many members of the press. In her story, "Through the Alsace Campaign," which appeared in *Vogue's* April 1945 issue, she wrote:

> The battle wasn't hard to find. At a crossroads there was a sign, 'Vers L'Ennemi.' The infantry was plodding from there single file down the road, burdened with gadgets for killing, and we went on with the tanks and came to inhabited ruins. Evil, sordid ruins, but the walls were a help against the wind, against a casual probe by small-arms fire or a shellburst from that side. Untidy figures trampled the blackened snow, sat on heaps of shell cases, pared bread and cheese with fighting

knives. They offered fragrant coffee in sawed-down black paper shell cases, laughed at the lip-rouge left on mine, and talked all at once in half-a-dozen languages.

They were foreign legionaires: Argentinians, Hungarians, Spaniards, Russians. The French Foreign Legion . . . not like the Beau Geste films, handsome, tall and matched to each other, but little runts of men, dirty and lean. Tall, gangling ones with unshaven faces, plump ones and a Russian with colossal white teeth and gargantuan hands, who offered me all his candy. Like all the other Russians, he was an ex-International Brigadier who had detached himself from French internment in '39, in order to continue the fight against Fascism.[30]

Lee Miller's evocative words describe slightly peripheral, anecdotal scenes and events around the raging battle. In this particular story, her words, strangely, more than matched the pictures that went with them. But soon her pictures would focus more and more directly and unsparingly on the brutal or bizarre evidence of destruction itself. Antony Penrose notes of her photographic technique at this time, that

Lee's Rolleiflex did not have a telephoto lens, auto-wind or built-in light meter. Under pressure, every exposure was an automatic guess. To compensate for having only twelve shots in a roll and to guard against malfunction, Lee alternated her shots on two cameras. This made caption writing a nightmare, but more than once it saved her from failure.[31]

Miller returned to the Hôtel Scribe in Paris to write the Alsace story. At that point she changed her press accreditation from the army to the U.S. Air Corps, apparently owing to the superior facilities and services offered to journalists as an armed services promotional incentive. Antony Penrose says that with this move, she gained priority for air-freighting film and accompanying text, and *carte blanche* to virtually every site even remotely available to the press. But instead of focusing on airforce action, she continued to follow army infantry, out of preference.[32]

The tireless quest to find access to the important field of action, and the opportunities taken whenever possible to optimize her chances to photograph where others might not, found its most dramatic results for Lee Miller in the next few months. All of Miller's daring, experience and mastery came together to make her ready to bear witness through her medium to the ensuing series of episodes, at a stage in the Second World War when its full genocidal horror was just beginning to be understood, and observed, by the world, and when the perpetrators of the holocaust were already beginning to be avenged.

War photography in this period was changing radically, in the context of a long tradition of pictures stretching from the 1850s with Roger Fenton or Felice Beato, through the great Civil War photographers, Matthew Brady, Alexander Gardner, Timothy O'Sullivan — when camera images of war began to be presented in the popular press — to the increasingly dynamic, immediate, often cinematic, imagery we associate with World War II photography. Among the most celebrated of the Second War photojournalists are Robert Capa, David Douglas Duncan, W. Eugene Smith, and Margaret Bourke-White; other important ones are Carl Mydans, Constance Stuart Larabee, and Dmitri Baltermants of the Soviet Union. Lee Miller takes her place easily in this company as one of those handful of photographers whose innate moral vision and formal approach to the medium of black and white photography created a uniquely pungent and ethically resounding body of images centering on war itself — often on nothing less than personal human cruelty and depredation in its most graphic form.

Nowhere is the importance of her contribution plainer than in the work she did in the spring of 1945. From Paris, in early spring, Miller and Scherman set out, in Scher-

man's 1937 Chevrolet — painted olive drab and stencilled with LIFE and a white star — for a scheduled link-up of American and Russian armies on the banks of the Elbe at Torgau. As it turned out, legions of journalists converged on Torgau to cover this huge meeting of troops, which had been mandated through the Yalta Conference. The place was chaotic; Miller, having temporarily gone off on her own to shoot, found "small towns whose inhabitants, thinking the dreaded Russians had arrived, scattered in all directions. Displaced people cheered and armed German soldiers ducked out of sight. The wrecked and abandoned streets of Torgau were choked by two columns of refugees heading in opposite directions. The Poles and Russians were trying to go east to get home while the others were fleeing to the west ahead of the Red Army."[33] Miller and Scherman, having arrived early on the scene, and "knowing they had got the best out of the story were making their getaway when Marguerite Higgins of the *New York Herald Tribune* turned up. She complained to Dave: 'How is it that every time I arrive somewhere to cover a story, you and Lee Miller are just leaving?'"[34]

From Torgau, Miller and Scherman followed the route of General Patton toward Munich, stopping at the 6th Armory Press Camp. There they were advised by Dick Pollard, an ex-*Life* journalist, that the Rainbow Company of the 45th Division was going in that evening to liberate the concentration camp at Dachau.

Early the next morning, April 30, 1945, Lee Miller and Dave Scherman entered the camp, which had been taken easily by Rainbow Company after a short exchange of fire with tower guards. Antony Penrose's description of what Lee Miller experienced at Dachau merits quoting at length:

> Lee's previous experiences had given her a degree of emotional defense against the horrors of war and her main reaction was one of total disbelief. Speechless and numb, she could not accept at first the enormity of the carnage and wanton slaughter. Here, and later at Buchenwald, this reaction was shared by some of the G.I.s. Unprepared for the hideousness of political and racist crimes against civilians, they thought at first that the camp was a grotesque propaganda stunt faked by their own side. Many of the S.S. guards who had survived the firefight had been ripped apart by the prisoners. A few remaining had tried to disguise themselves in cast-off clothing but had been caught because their well-fed appearance always gave them away. If they were lucky enough to be rounded up by the M.P.s, they mostly grovelled abjectly in cells, sobbing for mercy. Many of them were crippled or had been wounded, which had earned them the option of running the camp.
>
> The smell, the awful nightmarish cloying stench, is what remains uppermost in the memories of those who took part in the liberation. They recall that it was almost tangible and that they felt they would never be free of it for the rest of their lives. Then they recall the cordwood piles of bodies. . . . The evidence of mass execution and mass starvation could not be concealed because the crematoriums had run out of fuel five days earlier. . . .
>
> A railway siding terminated in the camp, where the prisoners had arrived on a trip that was intended to be strictly one way. Some trains of box cars and cattle trucks were too long to fit into the siding and halted outside the camp. Beside the track were the bodies of those who had died on their last march, yet the civilian population of the town claimed they had not the remotest idea of the camp's purpose.
>
> Lee's sense of outrage fired her to take pictures. 'I IMPLORE YOU TO BELIEVE THIS IS TRUE,' she cabled to Audrey Withers, wanting to confront the world with this atrocity. The prisoners were fascinated by her as she moved among them. Her baggy combat uniform was chosen to divert attention from her sex, but the lipstick and stray wisps of blond hair gave her away. They gazed at her with amazement and

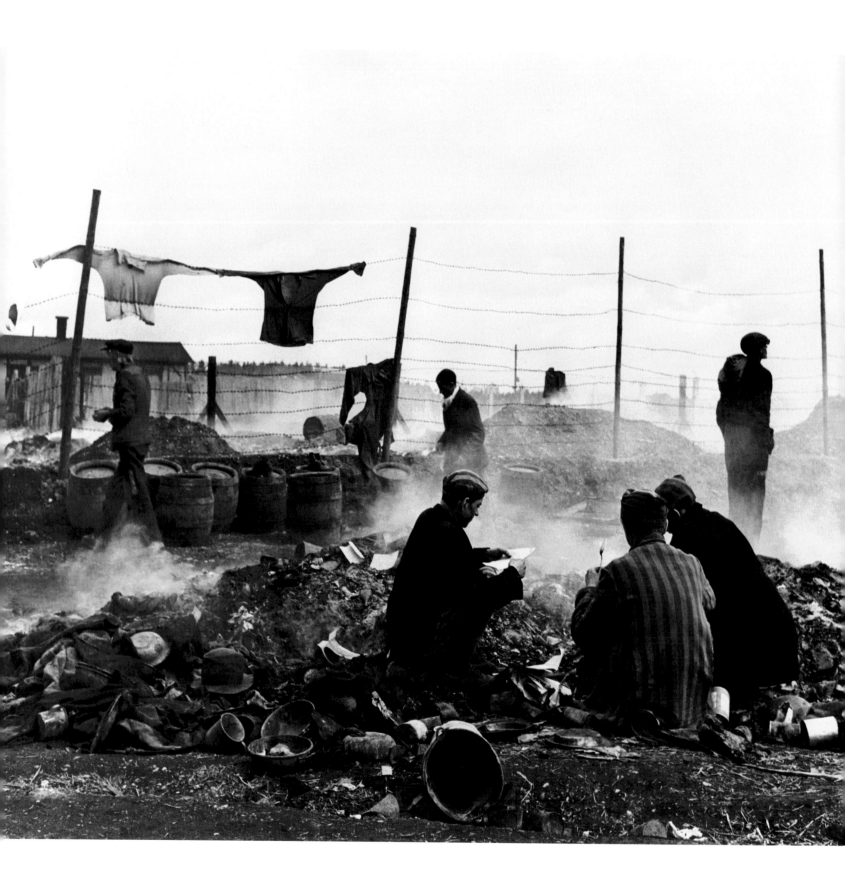

Lee Miller, Freed Dachau Prisoners
Scavenging in the Rubbish Dump, 1945.
Lee Miller Archives

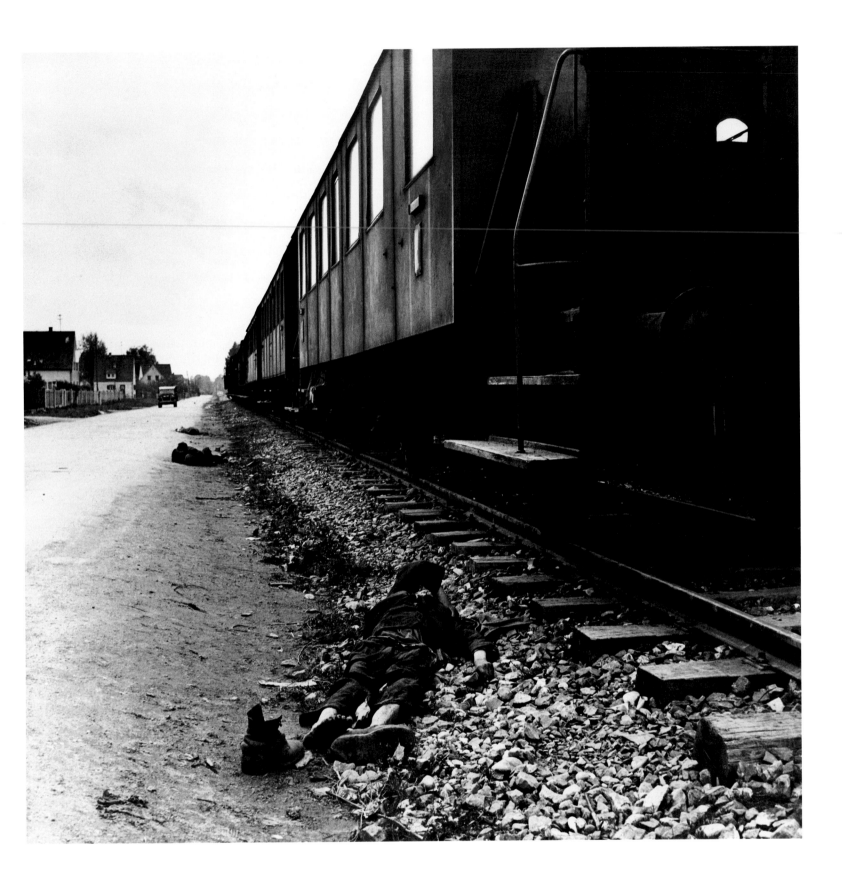

Lee Miller, Trains at Dachau; Prisoners
have died on the short march to camp,
1945. Lee Miller Archives

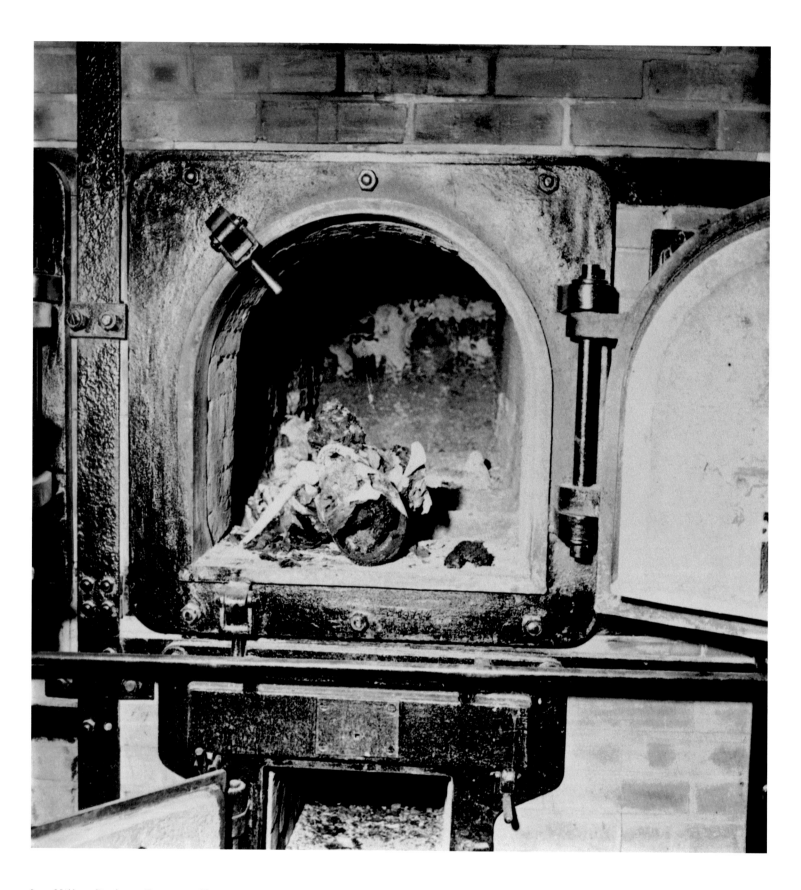

Lee Miller, Dachau, Germany: Human
Remains in a Cremation Furnace, 1945.
Lee Miller Archives

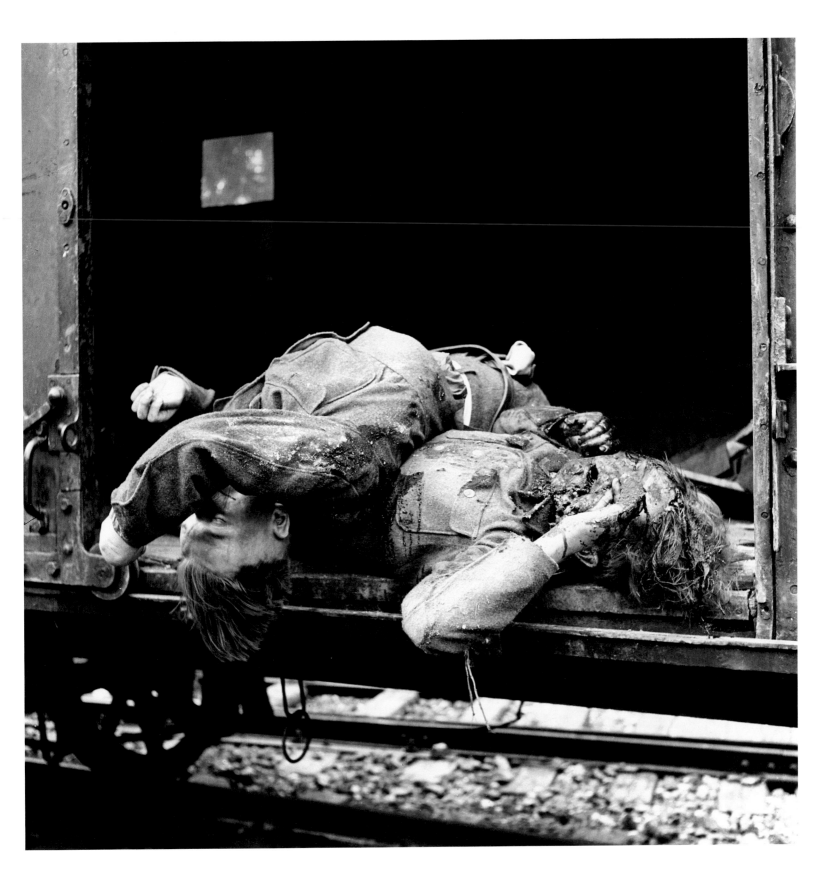

Lee Miller, Dachau, Germany: Beaten
Prison Guards, April 30, 1945.
Lee Miller Archives

adoration. Remembering she had some K ration chocolate in her pocket, she unwisely gave it away. Dave hauled her out from the ensuing mêlée, and after that they stuck close together. . . . [35]

The photographs Lee Miller shot that day at Dachau — and the ones a few days after the U.S. Army raid of the camp at Buchenwald on April 11 — are among her most extraordinary, and are unexcelled by others' pictures of these same scenes. Some of the Dachau pictures — of the railway track, with decaying corpses lying alongside a stopped train [p. 79], or the image showing prisoners in a rubbish dump, with clothes hanging on a barbed wire fence [p. 78] — let us glimpse the suffocating climate of desolation that pervaded these camps, forecasting the extinction of an entire civilization. Others, including those showing open ovens in the wake of fuel shortages, with half-burned remains, or stacked bodies — those now familiar images of wasted limbs and tortured, skull-like faces — are grueling and yet riveting pictures of atrocities even now a little more able to be believed, because they are incontrovertibly presented in Lee Miller's camera eye.

In the June 1945, issue of *Vogue*, many of these photographs were published, with the story headed, "Believe It." The magazine comments that Miller cabled them when she dispatched these pictures, "No question that German civilians knew what went on. Railway siding into Dachau camp runs past villas, with trains of dead and semi-dead deportees. I usually don't take pictures of horrors. But don't think that every town and every area isn't rich with them. I hope *Vogue* will feel that it can publish these pictures." [36]

The series of pictures Lee Miller took just after the liberation of Buchenwald of beaten prison guards is one of the most extraordinary wartime photographic documents ever made [pp. 84, 85, and 87]. She wrote about these images,

> The ex-prisoners have found and recognized a certain number of their former torturers, S.S. soldiers disguised as civilians and wandering around the fringes of the encampment. If they catch them, they give them a thorough working over and bring them back to the camp jail house. Their condition is terrible but they are still alive; and they are not so badly off as their new captors had been when beaten, as at least they have been well fed and never been beaten before. A couple throw themselves on the floor for mercy everytime the door opens. [37]

It is not easy to deal with these Holocaust images, taken in circumstances unlooked-for, unprepared for, unimaginable, in stylistically analytical terms. But a few observations may clarify the distinction between these photographs and others depicting the same subjects. In these pictures, whether of murdered human remains, the scenes of their making, or the terrified objects of uninhibited revenge, we are presented with a nightmarish reality made somehow *fully present*. The perceptual chaos that the artist must have been experiencing in confronting this pageant of atrocities, somehow resolves itself in her camera's eye into a group of images that are legible, unforgettable in the sense of classic art. There is a character of monumentality, and, ultimately, a kind of unflinchingness, that separates these photographs from others of their kind. These photographs are about raw communicative power. And they are a summation of all their maker's formal and intuitive artistry accumulated during the preceding twenty years.

A very different kind of image, one that serves as a kind of footnote to this group of photos, is the eerie photograph of the S.S. Officer submerged in a shallow river, where his body has been dumped by camp prisoners [p. 88].

Lee Miller, Dachau, Germany: Dead Prisoners, April 30, 1945.
Lee Miller Archives

82

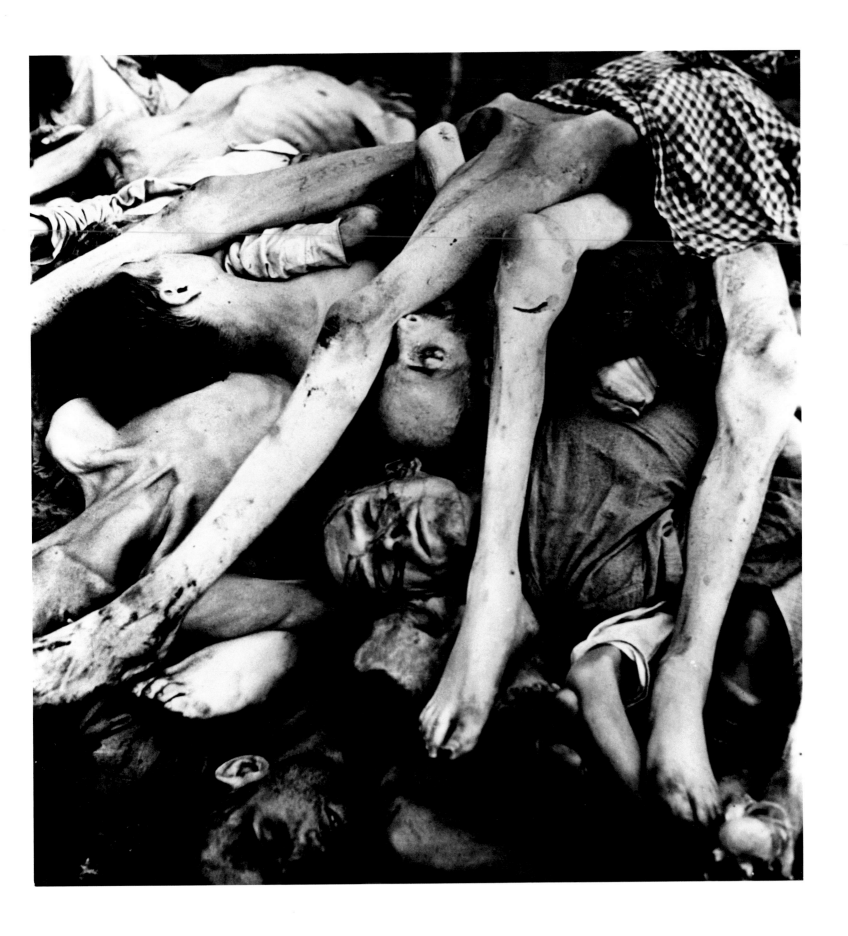

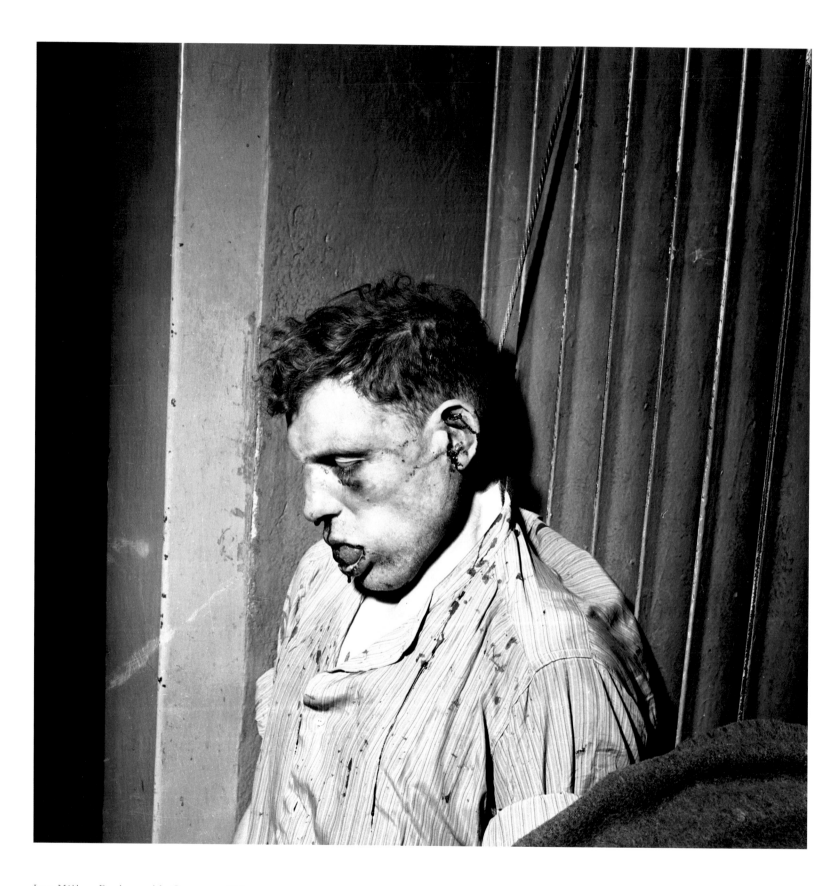

Lee Miller, Buchenwald, Germany: Prison
Guard after Suicide, April 1945.
Lee Miller Archives

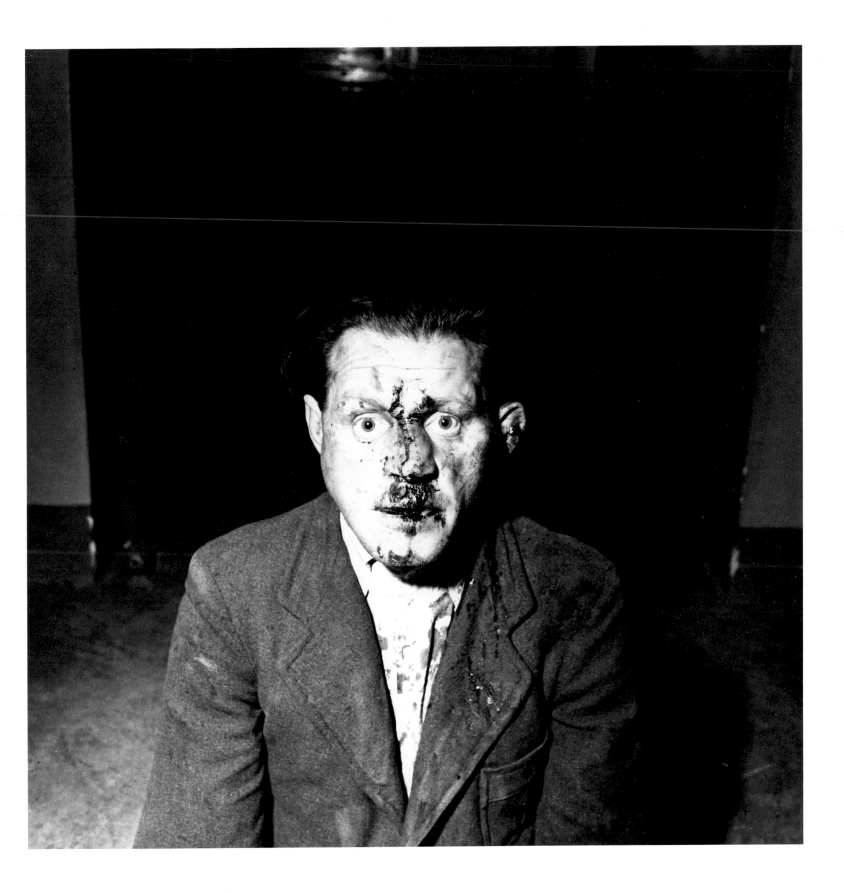

Lee Miller, Buchenwald, Germany: Beaten
Prison Guard, April 1945.
Lee Miller Archives

Lee Miller, Buchenwald, Germany:
Guards Beaten by Liberated Prisoners
["They threw themselves on the floor for
mercy every time the door opened."
(L.M.)], April 1945.
Lee Miller Archives

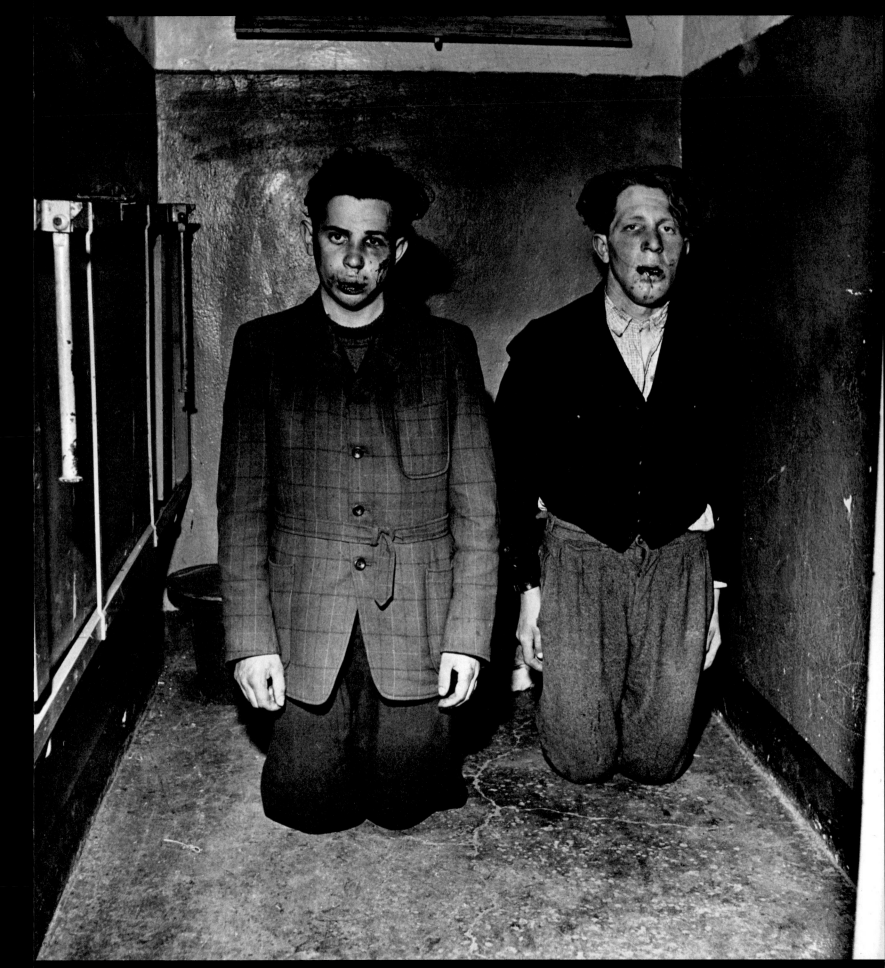

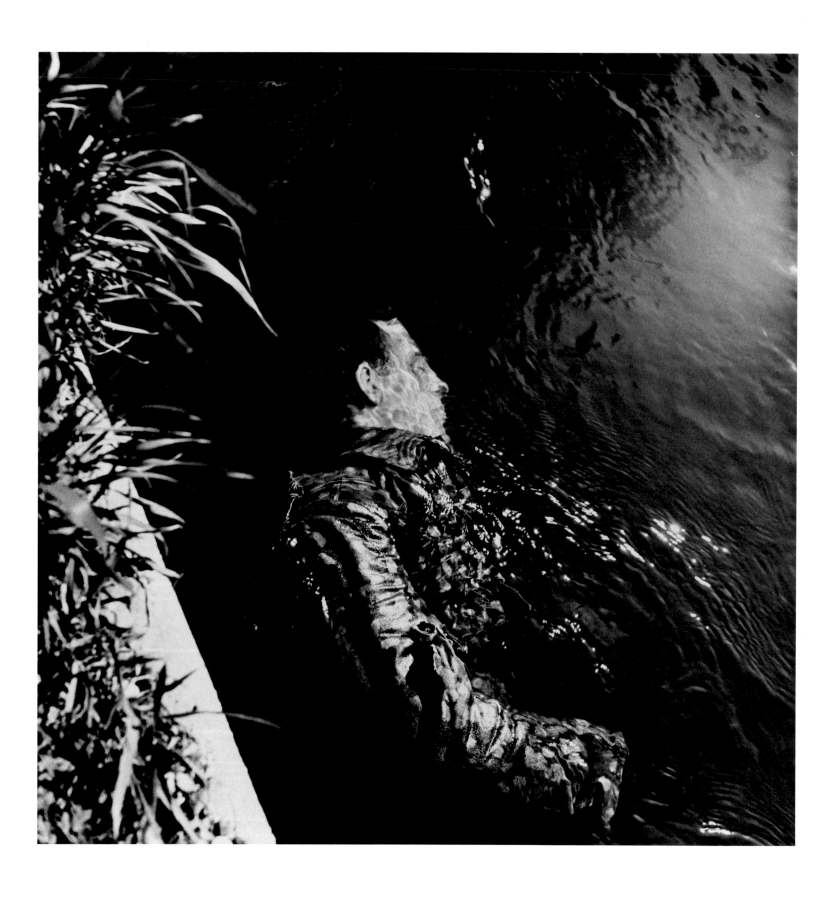

The night of April 30, after her first incredulous view of the Nazi concentration camps, Miller and Dave Scherman billeted in Munich at the command post of the 45th Division. The address of the building, an outdated, unremarkable, middle class dwelling, was Prinzenregenplatz 27. It turned out, of course, to be the Munich residence of Adolf Hitler, the place where he had spent much of his time during the reign of the Third Reich and where he had conferred at least once with most of the leaders of Europe. It was in this house, on that night, that Dave Scherman photographed Miller taking her first bath in weeks in Hitler's bathtub [p. 91].

Lee Miller touched another intimate part of the Fuhrer's existence, as Antony Penrose tells it:

> About three blocks away, at Wasserburgerstrasse 12, was the square stucco villa of Hitler's mistress, Eva Braun. The small rooms were furnished in a precise, impersonal way as though everything had been chosen from the same department store. Only the bathroom demonstrated the personality of the occupier; its shelves were crammed with enough medicines for — as Lee put it — 'a ward of hypochondriacs.' She wrote, 'I took a nap on her bed. It was comfortable but macabre to doze on the pillow of a girl and a man who were dead, and be glad they were dead if it were true.'[38]

The second momentous advisory by 6th Army Press Officer Dick Pollard to Dave Scherman and Lee Miller sent them from Munich to Hitler's fortress-like mountain retreat at Berchtesgaden, Austria. Pollard informed them that the 15th regiment of the 3rd Division was preparing to attack; Miller and Scherman drove to Salzburg in one difficult day-long push, and arrived at the site of Hitler's "Eagle's Nest" at dusk, in time to photograph the chalet in flames from a position on the mountainside behind the building. Lee Miller's photograph of Berchtesgaden in flames may take on its peculiar resonance mainly from our knowledge of its subject — but resonate it does [p. 90].

It should be hardly surprising that Lee Miller developed a bitter and obsessive "wall of hate and disgust," in her words, in reaction to the Nazi genocide. In fact, a vivid, ever-present, worried hatred of German Nazis would never leave her. It was with this acrid feeling, and the inevitable sense of anticlimax following the armistice, that she moved, probably a little robotically, through the next weeks and months, continuing to travel and work on assignment for *Vogue*. She went immediately to Denmark to do a travel and fashion piece for *Vogue*, and was still capable, despite her let-down, of capturing one of her better images [p. 152]. She then returned to London.

Lee Miller was greeted warmly and admiringly in London by Roland Penrose, her friends, and the *Vogue* management, but she did not stay there long. After a violent argument with Penrose, she returned to Paris in a state of exhaustion and emotional confusion. In a letter written to Roland Penrose, but never sent, she said,

> When the invasion occurred — the impact of the decision itself was a tremendous release — all my energy and all my pre-fabricated opinions were unleashed together; I worked well and consistently and I hope convincingly as well as honestly. Now I'm suffering from a sort of verbal impotence. . . . This is a new and disillusioning world. Peace with a world of crooks who have no honour, no integrity and no shame is not what anyone fought for.[39]

Lee Miller, Dachau, Germany: Murdered Prison Guard, 1945. Lee Miller Archives

From Paris, Miller traveled to Salzburg, where the opera festival was taking place. She reported for *Vogue* on the city and this reinstated event, and after ten days went on to Vienna. Vienna was still occupied, in zones, by Soviet, French, American, English and "international" forces — and suffering shortages of virtually every kind. Lee

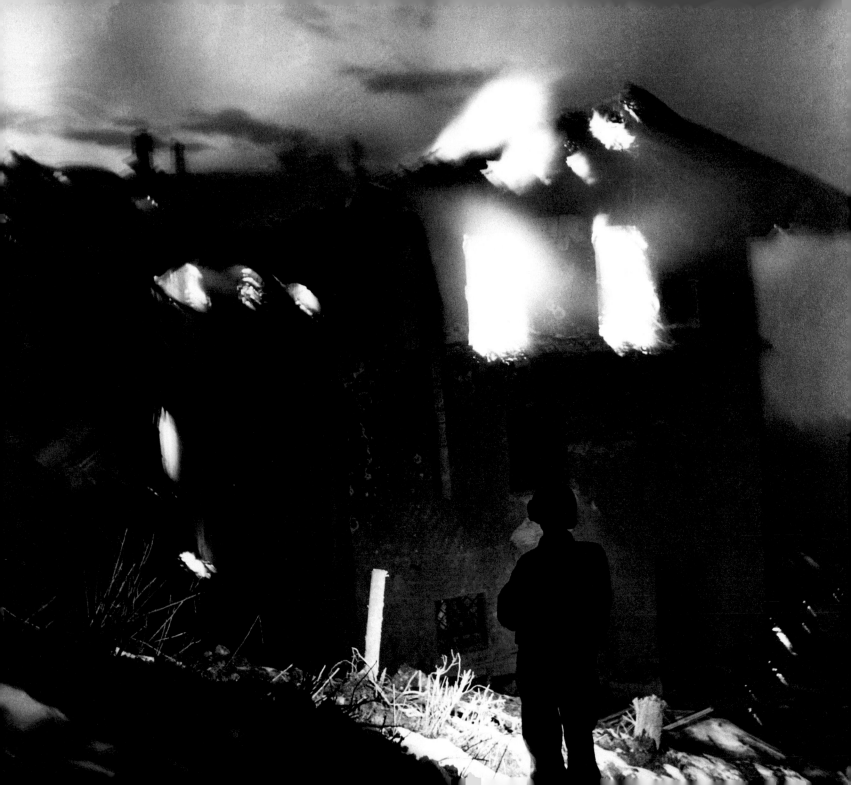

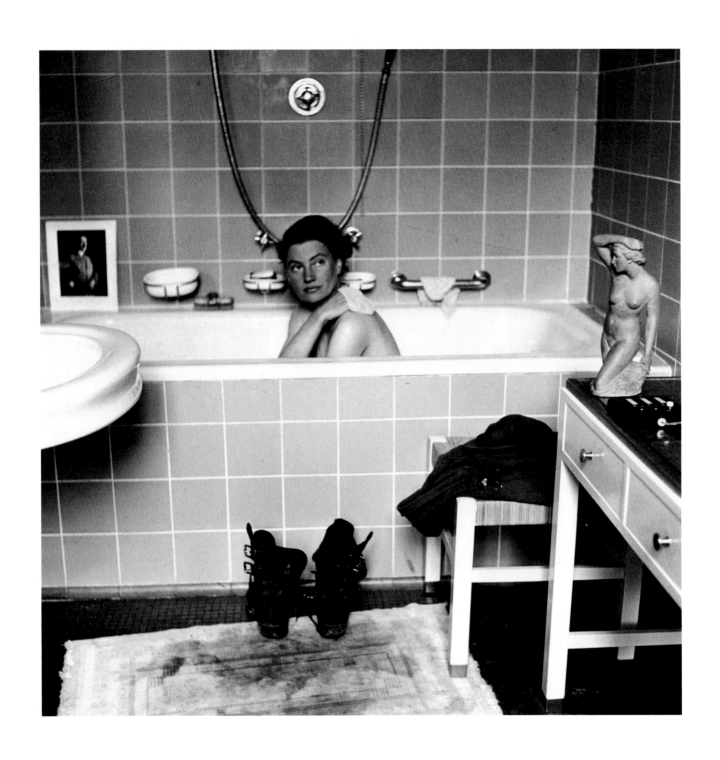

Lee Miller, Funeral Pyre of the Third
Reich: Hitler's House at Berchtesgaden in
Flames, 1945. Lee Miller Archives

David E. Scherman, Lee Miller in Hitler's
Bathtub at Prinzregentenplatz 27, Munich,
Germany, 1945. Lee Miller Archives

Miller's wrenching photograph of a dying baby [p. 93] was taken in a Viennese children's hospital, and accompanied by this text, cabled to *Vogue:*

> For an hour I watched a baby die. . . . he was a skinny gladiator. He gasped and
> fought and struggled for life, and a doctor and a nun and I just stood there and
> watched. There was nothing to do. In this beautiful children's hospital with its
> nursery-rhymed walls and screenless windows, with its clean white beds, its
> brilliant surgical instruments and empty drug cupboards there was nothing to do
> but watch him die. . . . This tiny baby fought for his only possession, life, as if it
> might be worth something. . . .[40]

From Vienna Miller traveled to Eastern Europe. It was late October 1945 and extremely cold; she spent weeks obtaining visas, but she seemed determined to move on, and to destinations as inhospitable as possible. She drove a Chevrolet from Vienna to Budapest, experiencing a number of typical close calls at borders and checkpoints along the way. In Budapest, she quartered at the Sisters of Mercy Catholic Convent along with *Life* magazine's John Phillips and Simon Bougin of *Stars and Stripes;* she persuaded Robert Halmi, brother of the Hungarian photographer Bela Halmi, to interpret for her. Halmi, years later, said,

> Lee's story [in Budapest] was 'Women's Fashions After the Siege.' The Russian
> battle with the Germans had left half the city in ruins. The story was bullshit: I
> found the [pretty] girls I knew, and any rag on them became fashion. . . . [Lee] wore
> those baggy army slacks and she drank too much. She was an excellent photogra-
> pher and she knew what she was doing. She was also absolutely fearless. She
> probably would have been raped a hundred times if the Russians hadn't thought she
> was a boy. And she had a marvellous sense of humor. . . .[41]

Lee Miller stayed in Budapest for many weeks, falling into a social life of sorts with her fellow journalists and a group of dispossessed Hungarian aristocracy whose center was the exclusive Park Club. Early in 1946, she witnessed and photographed an incident that is perhaps little remembered in the enormity of all the retributive aftermath of the Second World War, but which occasioned one of Miller's most amazing photographs [p. 94]. She and John Phillips were among the journalists on the scene to cover the hanging of Laszlo Bardossy, the fascist, collaborator and ex-Prime Minister of Hungary; they waited in a bleak holding room of the prison where he was captive; the power had given out and there was no heat or electric light. Miller wrote,

> When the gendarme beckoned us out we could hear the pressure and the murmur of
> the several hundred people with permission to witness a hanging waiting to get into
> the yard. . . . They thought the delay meant that they were being barred from the
> performance. In the yard it was almost light — as light as it would probably ever get
> in that weather and between those walls. The whole set-up was being changed.
> Instead of the big beam-like vertical stake, attendants were stacking sandbags
> against the brick wall. They had changed their minds and were going to give him the
> dignity of a firing squad. The crowd surged in. . . . There was a long wait.
> . . . [Finally], accompanied by a priest and some gendarmes and a noise of the
> silent crowd shifting, a cocky little man jaunted in from a dark archway. He wore
> the same plus-fours, tweed suit, ankle high shoes with white socks turned over the
> edges as when he'd been arrested. He held his beaky grey face high and his
> gestures were taut. He listened to the words of the judge and as he walked in front of
> the sandbags he waved his hand refusing the blindfold. The four gendarmes who had
> volunteered for the execution stood in line awaiting the order to fire. They were less
> than two yards from him. Bardossy's voice orated in a high pitched rasp, 'God save

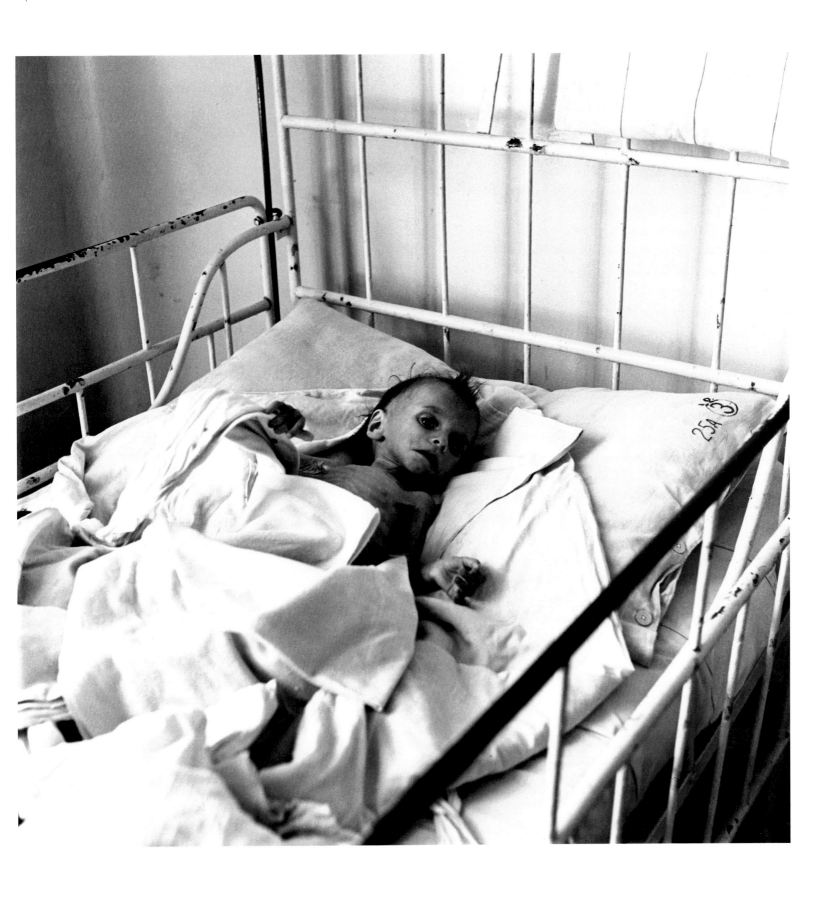

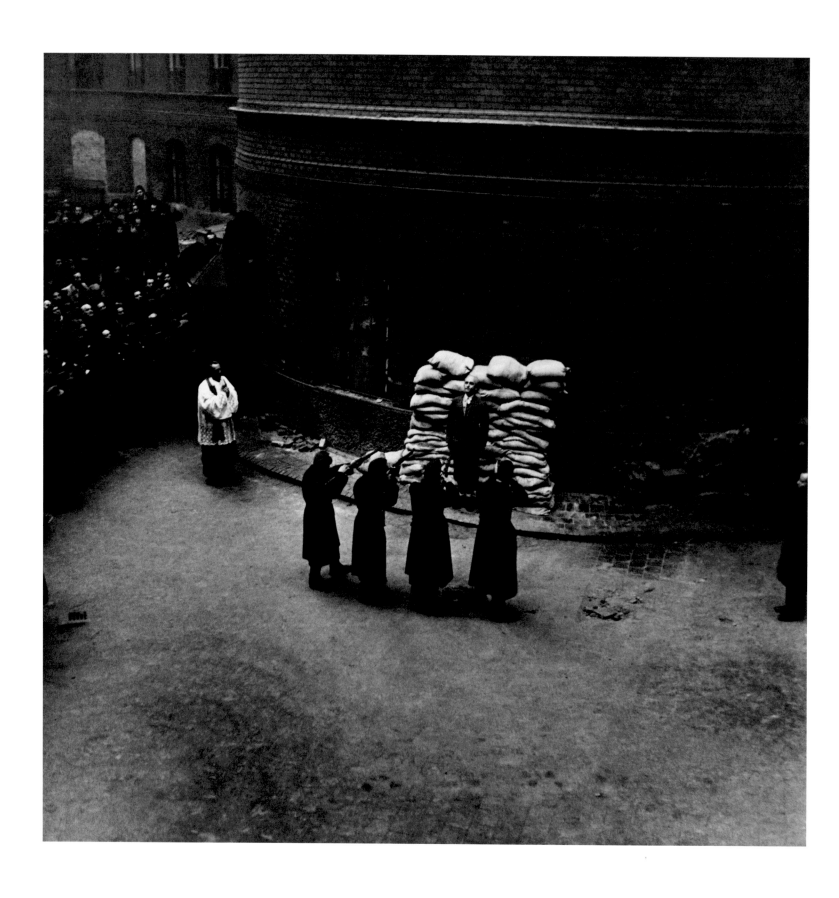

Hungary from all these bandits.' I think he started to say something else but a ragged tattoo of shots drowned it. The impact threw him back against the sandbags and he pitched to his left in a pirouette, falling on the ground with his ankles neatly crossed.[42]

Miller stayed on in Hungary through Christmas and the New Year, attending parties and trying in various way to help people who needed medicine or refugee assistance or freedom from political imprisonment. Eventually she and John Phillips departed from Romania in her Chevrolet (borrowed from Dave Scherman), still ostensibly on assignment for *Vogue*, or at least continuing to submit expenses, but sending little useable material to the magazine.[43]

In Bucharest, Lee Miller found her old friend and brilliant folklorist, Henry Brauner; in nearby Sinaia, she photographed the King and Queen, Michael and Helen of Romania, at one of their palaces. She also visited the U.S. cemetery, with 800 symmetrically positioned crosses marking recently dug graves. "In a sense it was here," wrote Antony Penrose, "that Lee dug a grave for part of herself. . . . Try as she might to write the Romanian piece, the words would not flow. Assailed by rising panic and despair, she found she could neither stop nor go on. Through her self-alienation from Man Ray, Aziz and Roland she had forced herself into a position where she could not go back without a crushing loss of pride. . . ."[44]

The photographs Lee Miller shot in Denmark, Vienna, Hungary and Romania in these strange months of winding down after the height of the war, and her own efforts in its cause, are analogous to her work in the "Egyptian period." There is in both these periods a character of strong technical and compositional proficiency, but in comparison to the Paris/New York output preceding Egypt, or the action war photography preceding this episode, the latter bodies of work seem somehow to communicate their author's lack of purpose, or of concentration. It is difficult to define the precise quality, having to do with the existential nature of purposefulness, which is meant here. Yet it amounts to a distinct contrast in intensity between two kinds of work that anyone can see who intuitively senses the difference between the strangely egoless experience of climactic imaging, and the more self-conscious experience of most art-making, in which the imagery is essentially as if remembered or foretold.

Through these disoriented months, Roland Penrose had been faithfully writing to her; she had not responded. Finally, it was a telegram from Dave Scherman in New York who knew that Penrose was on the verge of settling down with another woman — simply saying "GO HOME" — that pushed her to move. She returned to Paris, collected her belongings from the Hôtel Scribe, and went on to London. There Miller finally finished the piece on Romania for *Vogue*; it appeared in the May 1946 issue with ten photographs — and would be the last article recounting the long adventure of her war.

Roland Penrose and Lee Miller reconciled and, in the summer of 1946, flew across the Atlantic to visit Lee's family in Poughkeepsie and attend a Condé Nast reception in her honor in New York. Miller and Penrose stayed at Julien Levy's apartment; they attended a series of parties among old friends, and met some new ones. Penrose introduced Miller to his acquaintance Alfred Barr of the Museum of Modern Art; they became close friends, and Barr provided Roland Penrose both with his own example and his help in the latter's subsequent founding of London's Institute of Contemporary Art.

Lee Miller, Laszlo Bardossy facing the Firing Squad, Budapest, 1946.

From New York, Miller and Penrose flew to Arizona to visit Max Ernst and Dorothea Tanning, who were building a house and studio in the sublime high desert setting of Sedona. Together the four of them attended a long Hopi rain dance ceremony with masked Kachinas holding live rattlesnakes; Miller and Penrose drove to the Grand Canyon, which was filled to the top with fog.

As usual, on this visit Lee Miller shot a few informal pictures of her friends — but one photograph from this interlude is rare in her production. It is a photograph of Ernst and Dorothea Tanning standing in the exotic American mesa desert, one of several she shot of the two of them in this same setting. But this image [p. 98] is "manipulated" — it is Lee Miller's only even marginally successful use of "combined" technique in her work. In it, Max Ernst, sandaled feet planted in a striding position, one hand closed into a fist, stands like a giant in a rocky landscape. Positioned beneath his extended, clenched fist, looking up with her right hand raised as if to ward off a blow, or to shake her own fist at the giant, is the tiny figure of his wife, Dorothea. Max Ernst and Dorothea Tanning were, of course, themselves prominent Surrealist artists, and on one level we must read this picture as a kind of playful take-off on its subjects. But on another level, we sense that its author is projecting herself into this scene. She was at a point in her life when she was about to ally herself more permanently and exclusively with a man than she had ever done — and moreover, as it would turn out, she was at a point of radical break with her past as a photographer. From now on, she would be less prolific than before, and finally would cease altogether to shoot serious pictures. Miller's best work from this moment on was virtually exclusively in the realm of informal portraiture. We cannot help, then, but read into this photograph a sense of protest — against her own feelings of impotence, perhaps, or against acknowledging the end of the long and painful and precious episode of independence she had managed to carve out in her life. At the very least, we glean from this image a feeling of feminine ambivalence in relation to a virile and creatively empowered man.

From Arizona, Miller and Penrose went on to Los Angeles to stay with Erik Miller, who since 1941 had worked as a photographer for Lockheed Aircraft Corporation, and his wife Mafy. As in New York, they saw many old friends and made new acquaintances. Man Ray was living in the center of Hollywood and had just married Juliette Browner; the four of them established and continued a vital relationship. Among the well-known people they spent time with on this visit were the Gregory Pecks and the surrealist collector Walter Arensberg. Miller made her striking portrait of Igor Stravinsky at this time [p. 161].

In the fall of 1946, Miller and Penrose returned to London. Lee Miller's next *Vogue* assignment took her to St. Moritz, Switzerland, in January 1947, to photograph the fashionable people who were beginning to return to their familiar turf after the war. She was accompanied on this trip by *Vogue* writer Peggy Riley (now known as Rosamond Bernier Russell.) In St. Moritz she found out she was pregnant — and, as she wrote to Roland Penrose, felt "mild astonishment [to be] so happy about it."[45]

Lee Miller and Roland Penrose settled in at the Downshire Hill house, where, in June 1947, Aziz Eloui Bey made a friendly visit to them and officially divorced Lee by solemnly repeating to her, according to Moslem law, "I divorce thee, I divorce thee, I divorce thee."[46] Shortly afterward, Lee Miller and Roland Penrose were married in a brief civil ceremony.

Antony William Roland Penrose was born on September 9, 1947, at the London clinic. By 1949, Lee and Roland Penrose had settled into a life that was, surely, from

the beginning, more domesticated than any Lee Miller had known since childhood. In February of that year, the Penroses found, in the hamlet of Muddles Green, near Chiddingly in the Sussex Downs, the place where they settled, when not in London, for the rest of their lives, and that still remains in the family. It sits on 120 acres of gently rolling meadowland, with a view of the ancient "Long Man of Wilmington," and is known as Farley Farm.

Lee Miller's life with Roland Penrose at Farley Farm increasingly centered on their shared world of contemporary art and artists; on gardening; on entertaining; and, by the 1960s, on cooking. In their early years of living both in Sussex and London, the Penroses were intensely engaged in the founding and successful running of the Institute for Contemporary Art. According to Roland Penrose's conception,

> It was to be something which was not a copy of the café life in which surrealists had flourished in Paris, not an imitation of the Museum of Modern Art in New York. . . . [but], rather than trying to establish a collection, a place where poets, artists, actors, musicians, scientists and the public could be brought together. . . . The first exhibition in 1948, relying on a few imaginative collections in this country, was limited to 'Forty Years of Modern Art,' whereas the second, a year later, announced itself as 'Forty Thousand Years of Modern Art.' Its intention was to show how the contemporary movement had broken through the limitations of academic rules and good taste and now took inspiration from the same notions that are to be found in primitive tribal art, going back as far as the cave paintings of Lascaux and showing indisputable affinities. . . . It contained as well a splendid display of ethnographic objects lent by museums and collections, great paintings such as Picasso's *Demoiselles d'Avignon*.[47]

Lee Miller wrote a carefully informative piece on the show for *Vogue* (January 1949). Roland Penrose had for years been both painting and collecting Surrealist art — some of his collection was stored with Lee Miller's family in Poughkeepsie during the war — and Lee Miller had obviously continued to be familiar with and perceptive about modernist painting and sculpture since her own direct, early participation in the development of Surrealism in Paris. Hosting visiting artists became a constant and necessary part of her life with Roland Penrose, evolving into a constant routine of weekends at Farley Farm with such artists as Picasso, Max Ernst, Dorothea Tanning, Leonora Carrington, Man Ray, Paul Eluard, Georges Limbour, Jean Dubuffet [p. 162], Saul Steinberg [p. 99], Henry Moore and André Masson — most of whose work filled the home and grounds. And though Lee Miller Penrose continued for a time to work for *Vogue*, her best photographs henceforward were directed toward the work and personae of these artists. The fashion stories for *Vogue* in the late 1940s and early 50s were proficient but perfunctory; there were also occasional assignments to cover literary or artistic celebrities in London. One of these occurred in 1951, when she was assigned to write a piece on Picasso in connection with the artist's seventieth birthday, and an attendant show at the I.C.A. Lee Miller had seen Picasso at work in various studios over the years — in Paris, at Mougins, in his house near St. Tropez, at Vallauris. In the *Vogue* article, she wrote,

> Picasso doesn't collect — he just never throws anything away. Each thing has some aspect of beauty and meaning to him that he does not want to lose. Even my own used flash-bulbs, which had caught his fancy, are still in the corner by the stairs where I left them in Liberation week, six years ago. When a studio or apartment gets too crowded, even for him, he locks it up and starts anew elsewhere. His house in Vallauris must already be filling up — I wonder if in five years' time I'll find some of the things he collected on his recent English trip.[48]

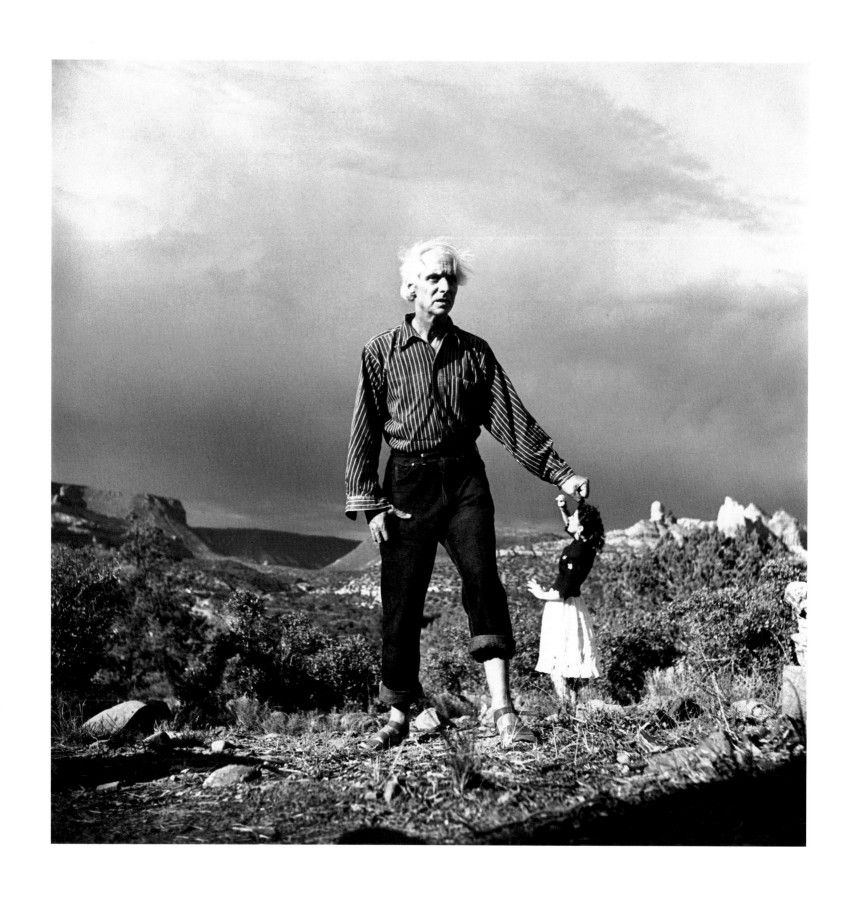

Lee Miller, Max Ernst and Dorothea Tanning,
Arizona, 1946. Lee Miller Archives

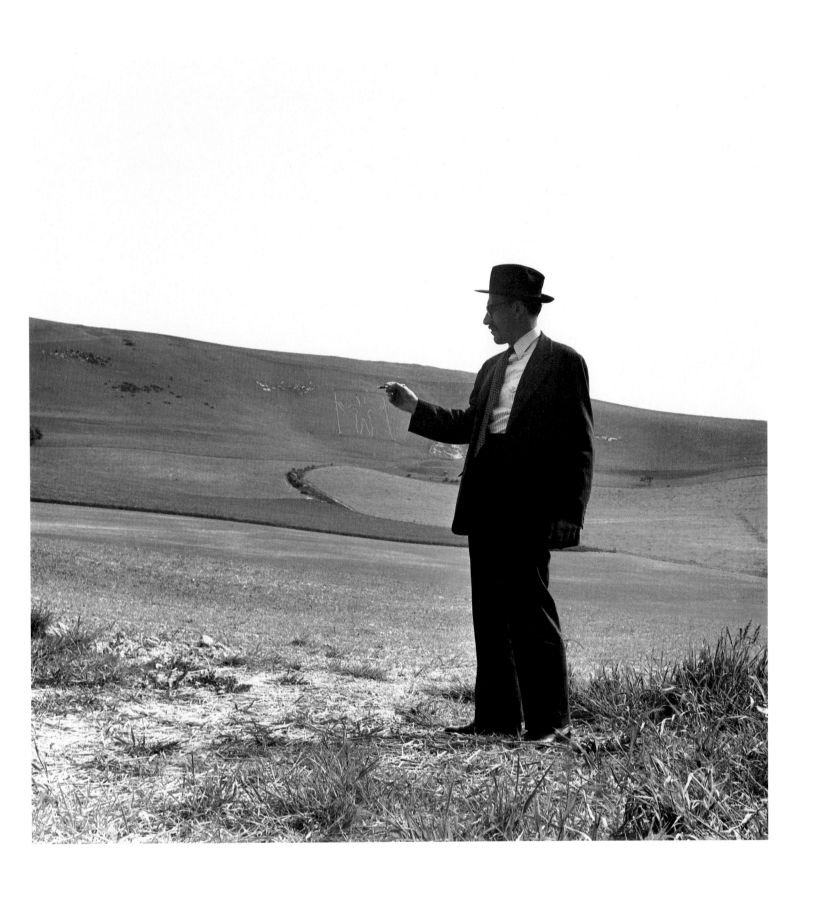

Lee Miller, Saul Steinberg at Farley Farm,
c. 1954. Lee Miller Archives

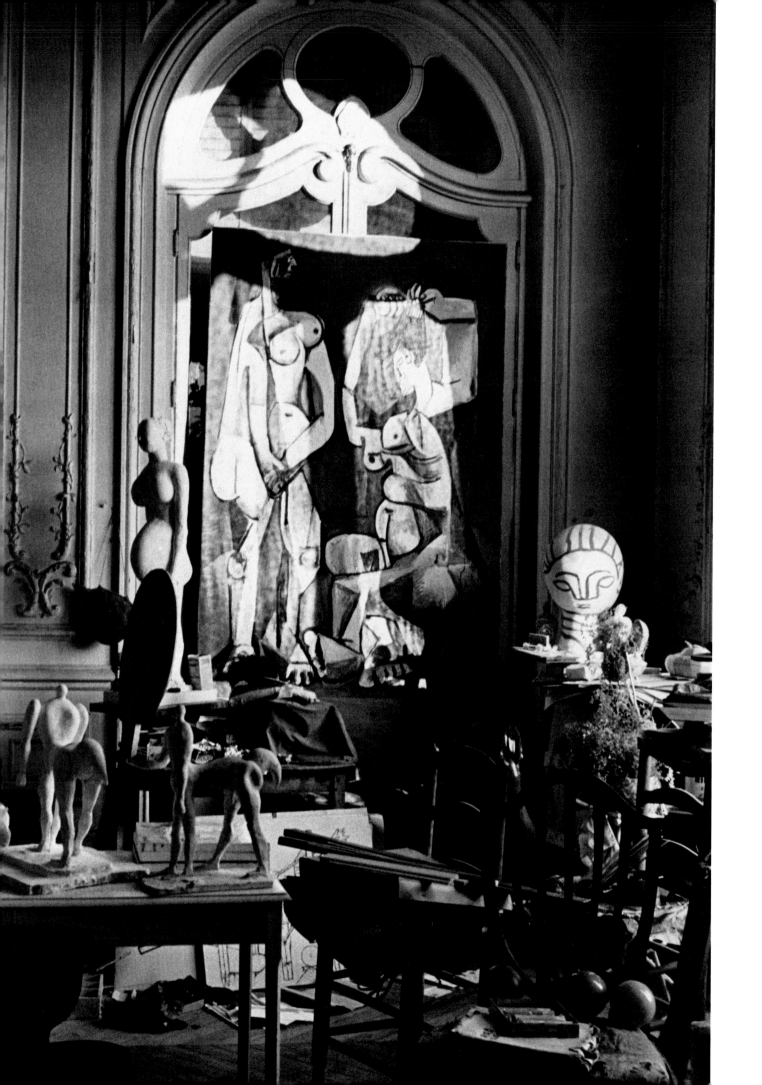

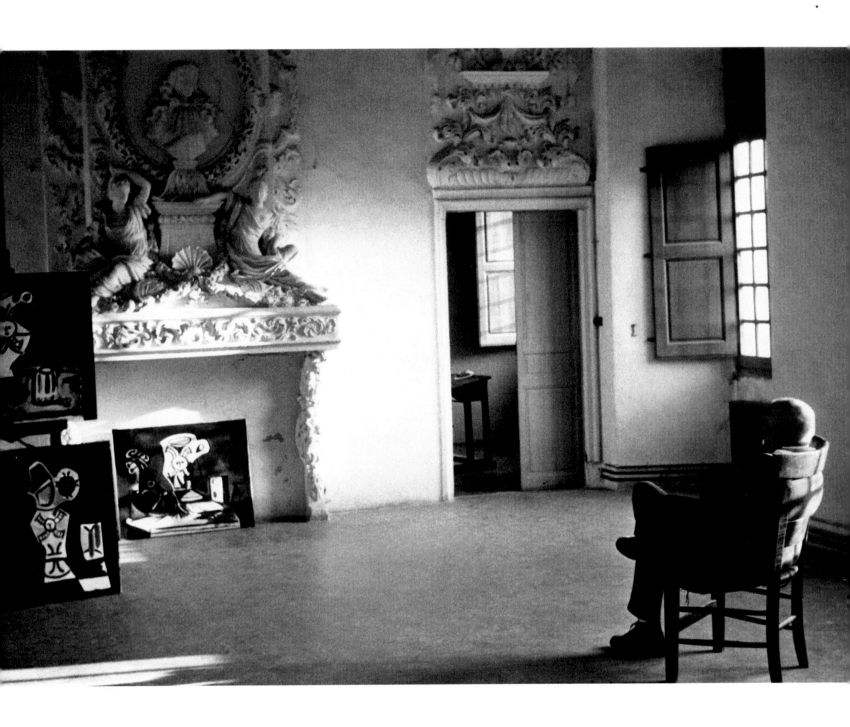

Lee Miller, Picasso at Chateau de
Vauvenargue, c. 1960. Lee Miller Archives

Lee Miller, Picasso's Studio, Villa La
Californie, 1956. Lee Miller Archives

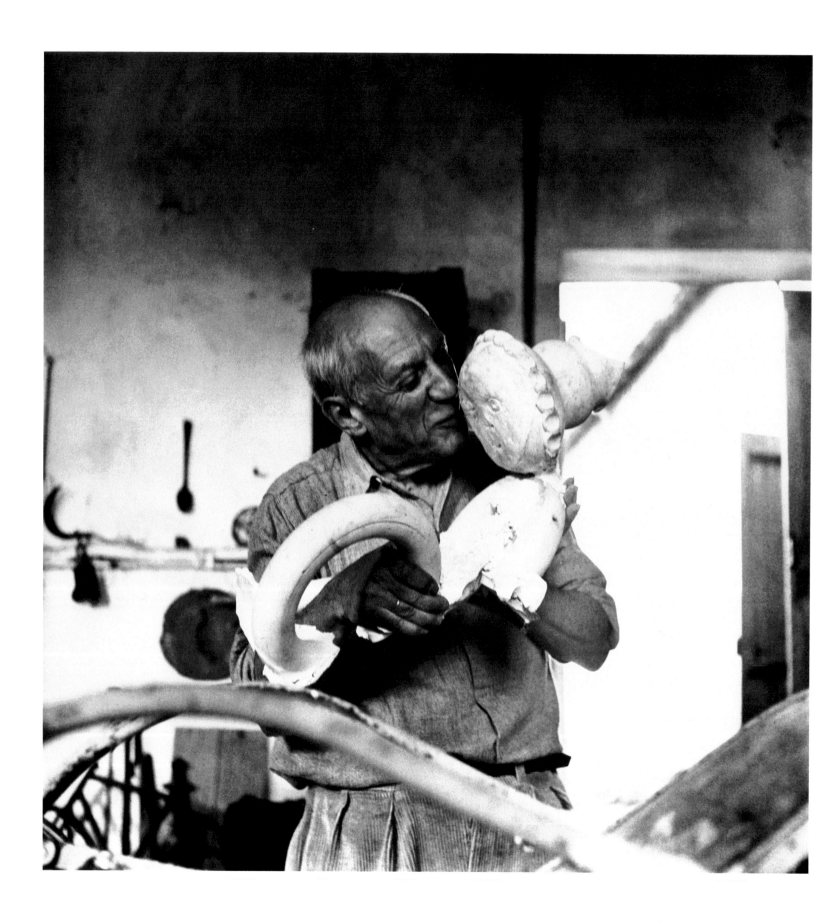

In 1956, Lee Miller began to work with Roland Penrose to research his major book, *Picasso, His Life and Work*, published in 1960. Many of her photographs from this period were included in the I.C.A.'s exhibition, "Picasso Himself."

Lee Miller clearly had a particular affinity for Picasso's successive environments, as much as for the man himself. She photographed him often and in widely various circumstances, but the best pictures are usually those in which the artist's studio, and the objects in it, speak for the man [pp. 100, 101, and 102]. Some of the studio shots taken at *La Californie* in Cannes, 1955-56, or the ones at the Chateau de Vauvenargues, 1960, count among the outstanding photographs in either of two genres — that of Lee Miller's own photographic oeuvre, and the massive body of photographs of Pablo Picasso. Something about Picasso's unconscious prodigality — the seeming perpetual disorder out of which his own restless vision made the most inarguable sense — resonated deeply in Lee Miller's own sensibility. Her many pictures of Picasso when seen together and in comparison to the rest of her work, take on a definition that sets them apart. They are often chameleon-like in their adaptation to the subject; it is Picasso, not Lee Miller, whose presence commands these images. Sometimes it is as though the imperious subject inhabits the consciousness behind the view-finder. And yet, the more we look, the more we see the sensibility of their shrewd and gifted maker, even as she merges with her subject.

The impetus for her work in the environment of the I.C.A. and its participants, and the people with whom she and Roland Penrose worked to make it succeed, may have been as important to Lee Miller's well-being in the early 1950s as to her husband. Certainly it is her pictures of the people engaged with the two of them in the world of modern art that stand as her significant production in her final period.

Beginning in the mid 1950s, Lee Miller seriously cultivated her long-time interest in food and cooking, compiling a massive collection of cook books and creating a series of repasts that became renowned for their often outre creativity. And suddenly, a little later in the 1960s, she added another obsession to her repertory by becoming an intense devotee of classical music. She attended concerts and the opera, read about, listened to, and collected records. During this decade, Theodore Miller visited Farley Farm every other year (Lee's mother had died of cancer in 1954); Miller and Penrose took her father to Venice and Rome and continued to travel abroad, together or separately. In 1966 Roland Penrose was knighted for his efforts in support of contemporary art in Britain; Lady Penrose, cook and hostess, was the frequent subject of articles in newspapers and magazines in England and the United States.

Lee Miller Penrose continued to the end her cycle of engagement with and retreat from photography. In the 1960s and 70s she did not take photographs. Nor did she demonstrate much interest in her past work — requests for loans or reproductions of her photographs were generally declined or ignored. The material that is now so thoroughly preserved and indexed in the Lee Miller Archive, and in a few museum collections, at that time existed in a state of neglect and disarray in the Sussex house, or in the offices of London *Vogue*.[49]

One of Lee Miller's last trips abroad was to visit the annual Arles photo festival in the summer of 1976, at the invitation of Lucien Clergue. The festival that year centered on Man Ray; Lee Miller accepted the honors for her old friend in his absence. The next winter, she was diagnosed as having cancer. From the time of the diagnosis, she declined rapidly, and by early June 1977, she was unable to leave her bed at Farley Farm. She died there on July 27, 1977.

Lee Miller, Picasso, Vallauris, 1954.
Lee Miller Archives

The photographs left behind have been slow to receive the attention they merit. Yet it may be part of the logic of Lee Miller's productive life that only a long process in which periods of inactivity alternate with spurts of intense interest, can determine the nature of her posthumous career. We may hope that with this publication and exhibition of Lee Miller's work — the first to give full exposure to the photographs of the 1940s, and to put into perspective the entire range of photographic activity — the world may finally see this oeuvre apart from the myth of Lee Miller's life, for the extraordinary accomplishment it is.

When Miller ceased taking photographs in the 1960s, and refused to discuss or even acknowledge her own career as a dedicated and ambitious photographer, she effectively cut off the possibility of others' taking seriously her artistic contribution. After about 1960, while she was alive, it was simply impossible either sufficiently to honor her as a photographer or to delve into the work she had amassed. After her death, the legends surrounding her biography seemed to overwhelm any objective appreciation of her work. The impression of Lee Miller's achievement, among those who knew of it in the American photographic community, has sometimes been of a somewhat dilettantish and uneven output, though others of us have suspected its greatness.

Ironically, the former impression was fostered by the artist's own behavior. If one were to speculate about the reasons for Miller's self-abnegating, even self-destructive, final stance in relation to her work, it might be to put forward a sad and radical view: that the artist never wholly believed in the reality of her own driving gift and powerful achievement.

It is tempting to believe that with a background less fascinating than the sometimes melodramatic circumstances of this woman's life and its intersecting with others' lives, the body of photographs we are viewing here would always have radiated more securely on their own terms. But aesthetic images must finally stand on their own and draw us to them in direct confrontation without the extenuating or mitigating baggage of their histories. The more one looks at and works with Lee Miller's many best images, the more their distinctive character asserts itself. Hers is a vision informed throughout by a quirky, literary, surrealist-inspired sensibility — in everlasting counterpoint to a courageous engagement with the world on its own complicated terms.

Lee Miller, Tanja Ramm, Paris, 1931.
Lee Miller Archives

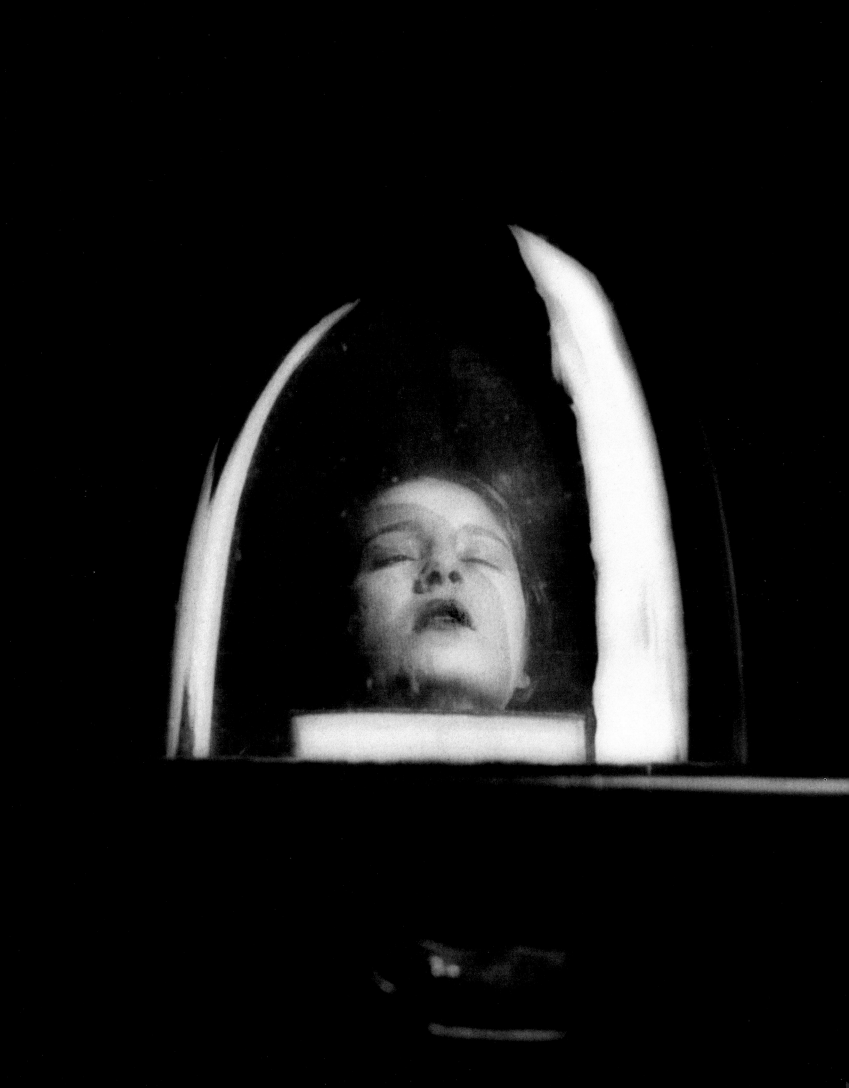

Lee Miller, Walkway, Paris, c. 1929.
The Art Institute of Chicago;
The Julien Levy Collection

Lee Miller, Nude with Wire Mesh Sabre
Guard, c. 1930. Lee Miller Archives

106

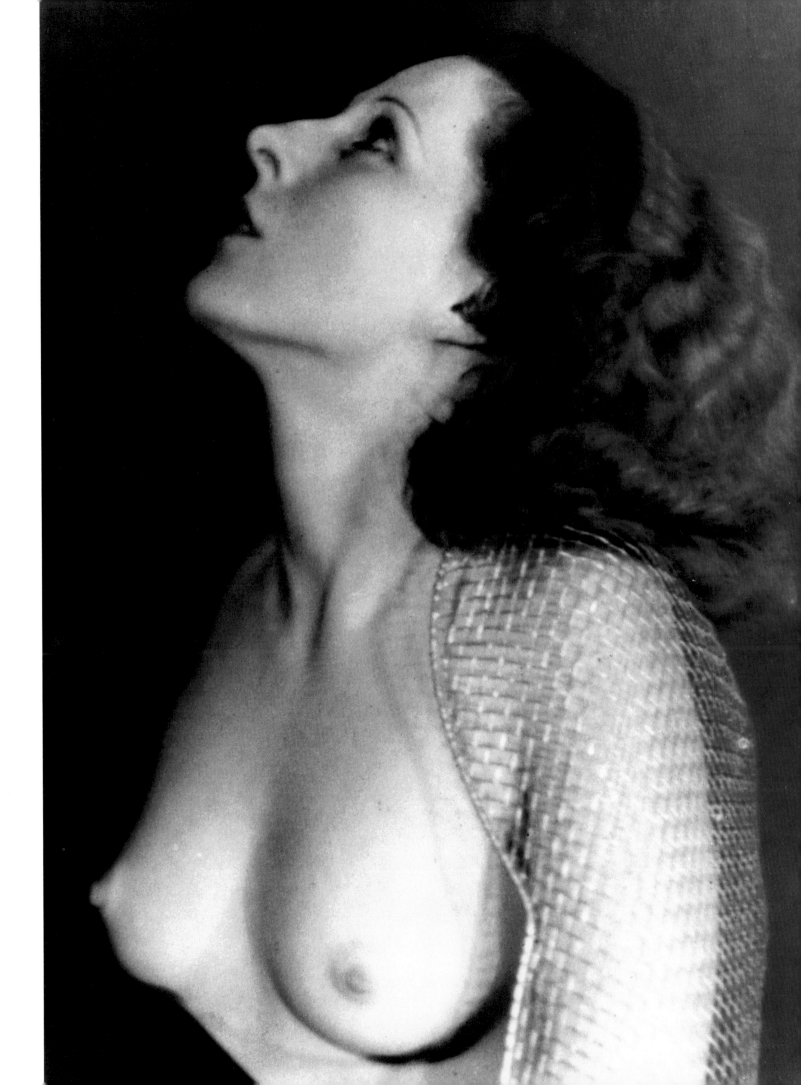

Lee Miller, Inez Duthie, c. 1931.
The Art Institute of Chicago;
The Julien Levy Collection

Lee Miller, Dorothy Hill, Solarized
Portrait, New York, 1933. Lee Miller Archives

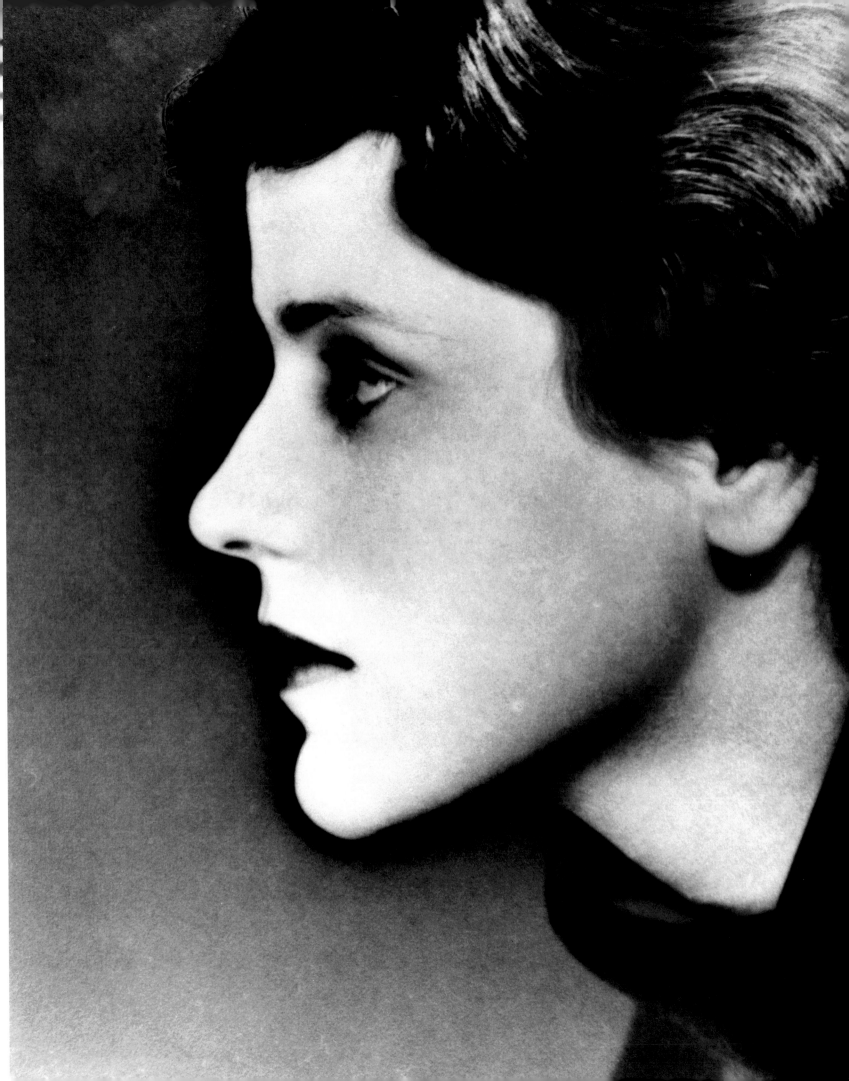

Lee Miller, Guerlain, Paris, c. 1930.
Lee Miller Archives

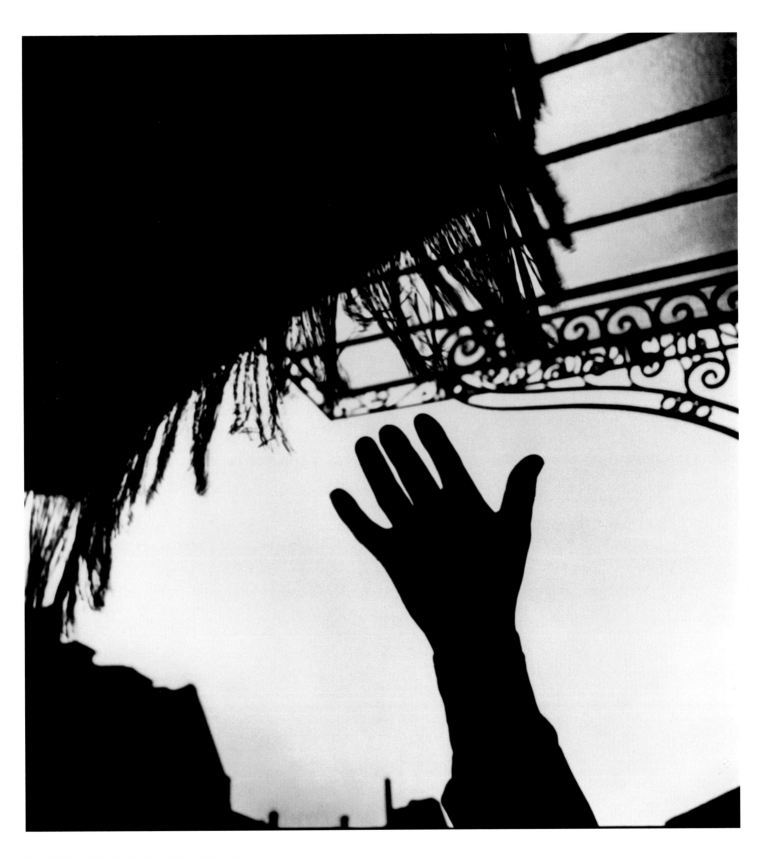

Lee Miller, Untitled (Hand Reaching for
Umbrella Fringe), c. 1929.
The Art Institute of Chicago;
The Julien Levy Collection

Lee Miller, Caged Birds, Paris, c. 1930.
Lee Miller Archives

Lee Miller, Untitled (Trees and Shadows),
c. 1929. The Art Institute of Chicago;
The Julien Levy Collection

Lee Miller, Sabots on Parched Earth,
c. 1930. Lee Miller Archives

Lee Miller, Woman with Hand on Head,
Paris, 1931. The Art Institute of Chicago;
The Julien Levy Collection

Lee Miller, Joseph Cornell, 1933.
Lee Miller Archives

Lee Miller, Work by Joseph Cornell,
1933. Lee Miller Archives

117

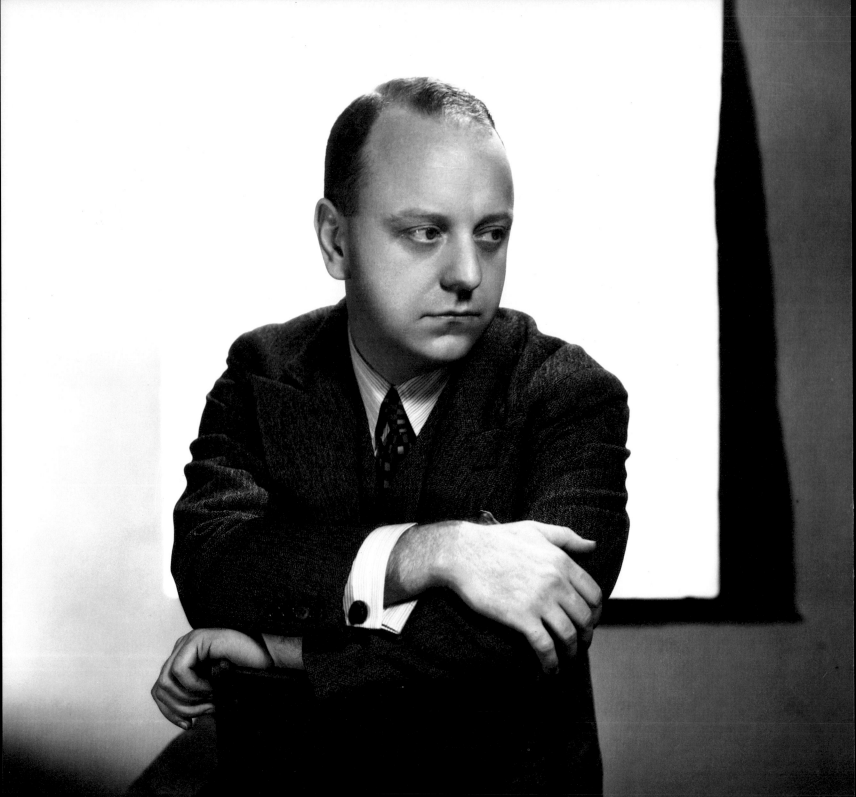

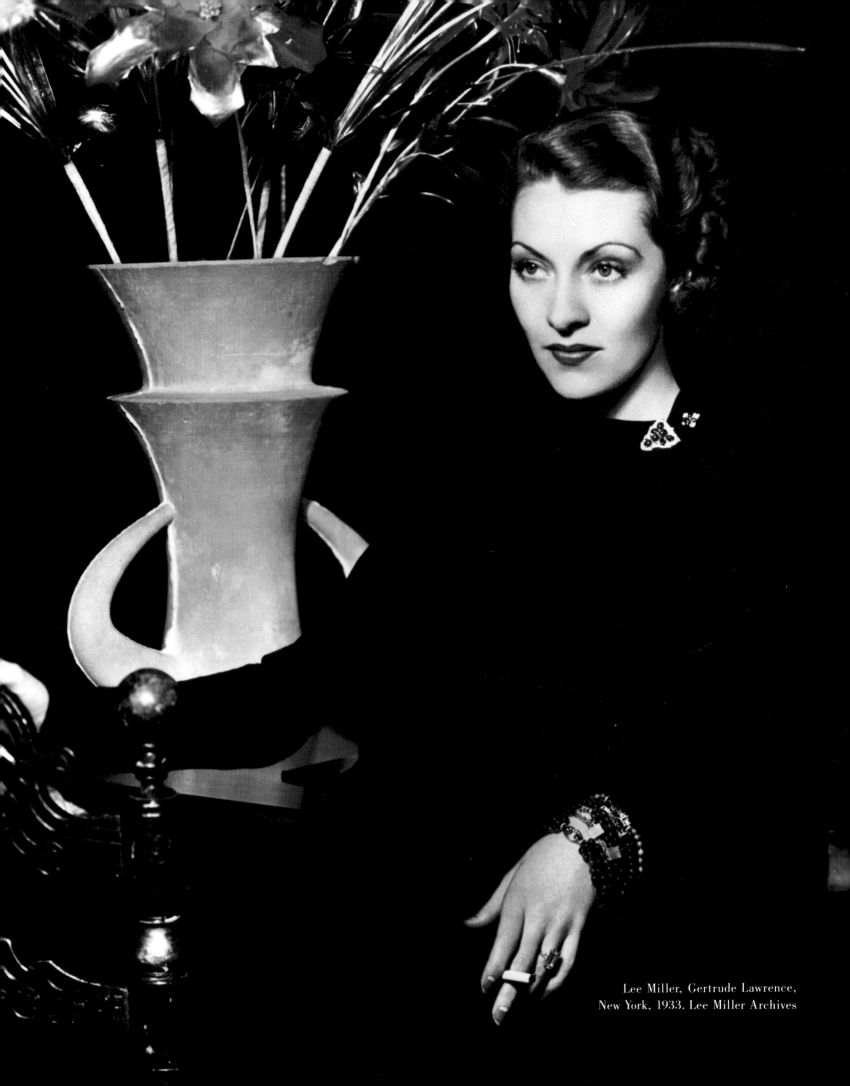

Lee Miller, Gertrude Lawrence,
New York, 1933. Lee Miller Archives

Lee Miller, Bleached Shells of Snails
Marooned by the Receding Waters of the
Nile, Egypt, c. 1936. Lee Miller Archives

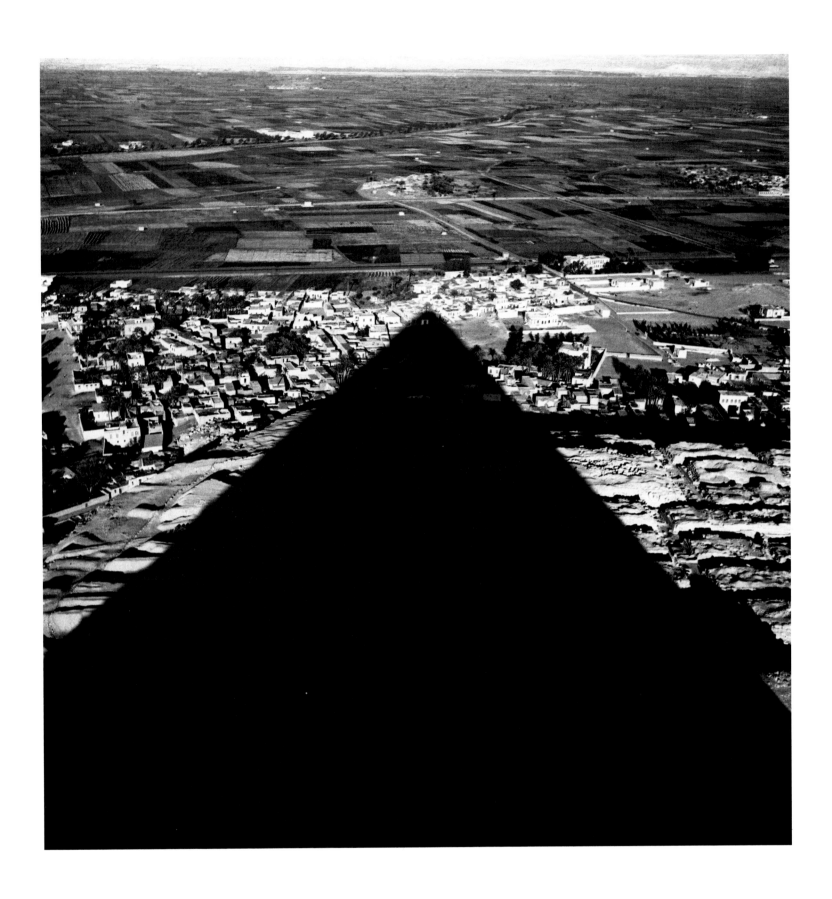

Lee Miller, From the Top of the Great
Pyramid, Egypt, c. 1938. Lee Miller Archives

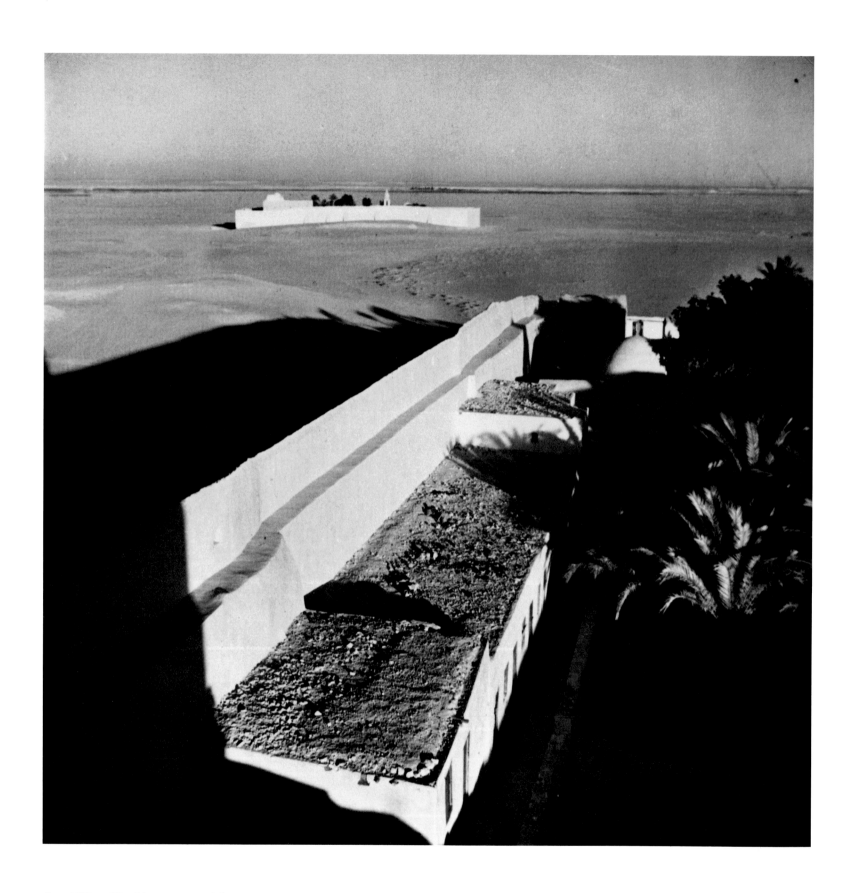

Lee Miller, The Monasteries of Dier
Simon and Dier Barnabas, Egypt,
c. 1936. Lee Miller Archives

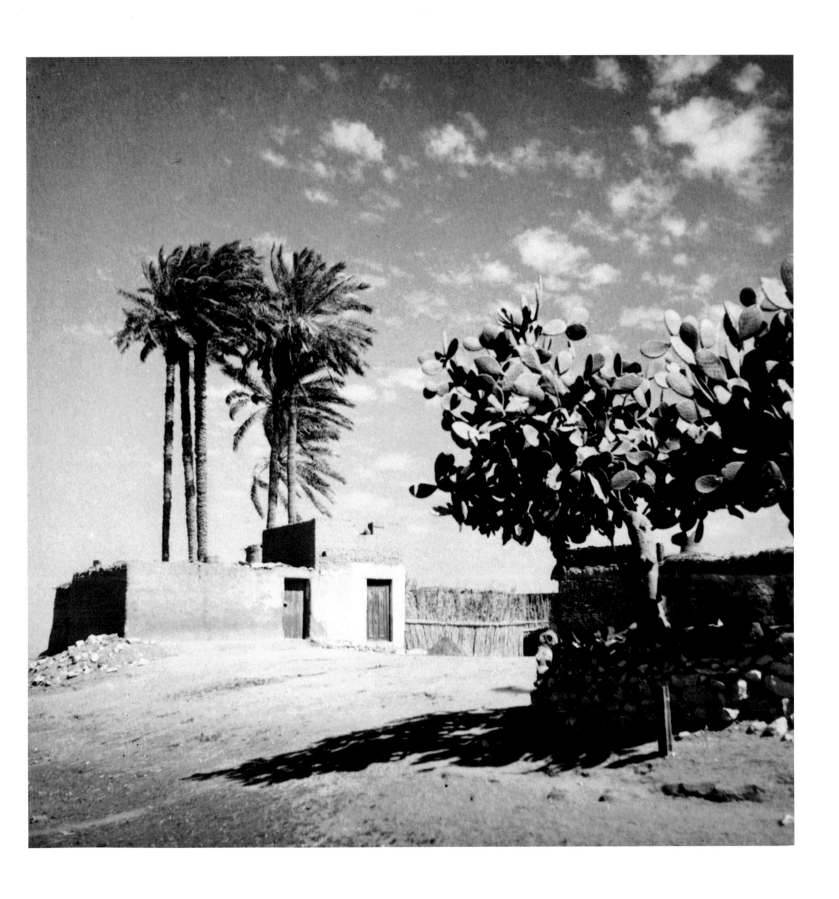

Lee Miller, Oasis Village, Egypt,
c. 1936. Lee Miller Archives

Lee Miller, Stairway, Cairo, 1936.
Lee Miller Archives

Lee Miller, Egypt, c. 1936.
Lee Miller Archives

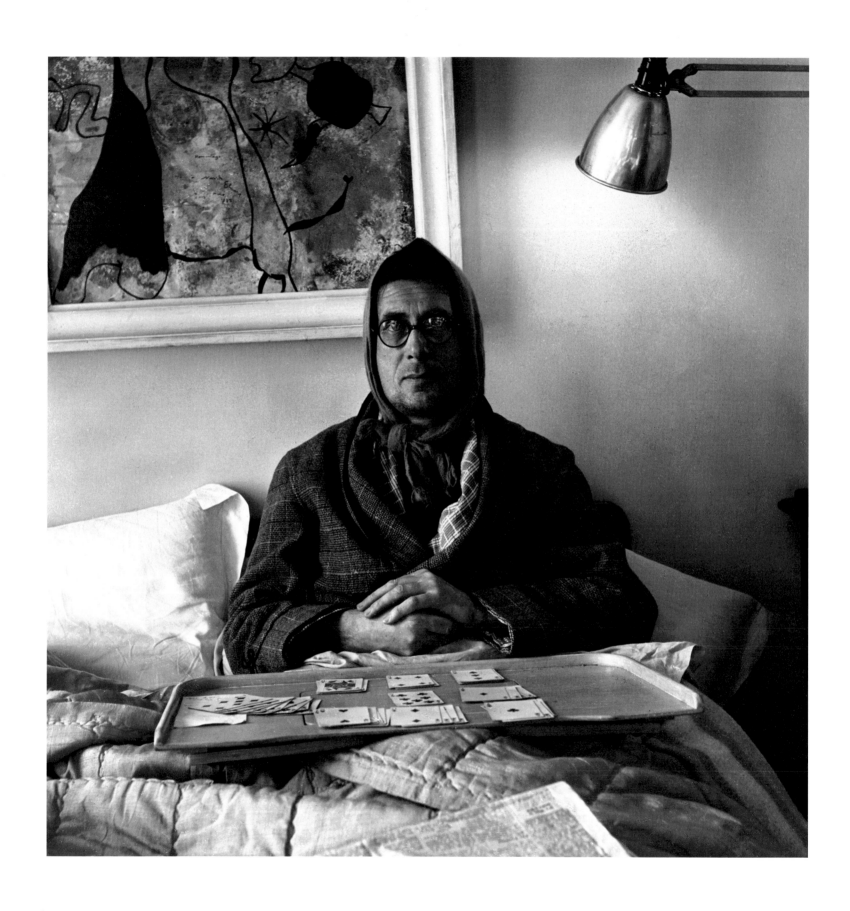

Lee Miller, Roland Penrose with Mumps,
London, 1941. Lee Miller Archives

126

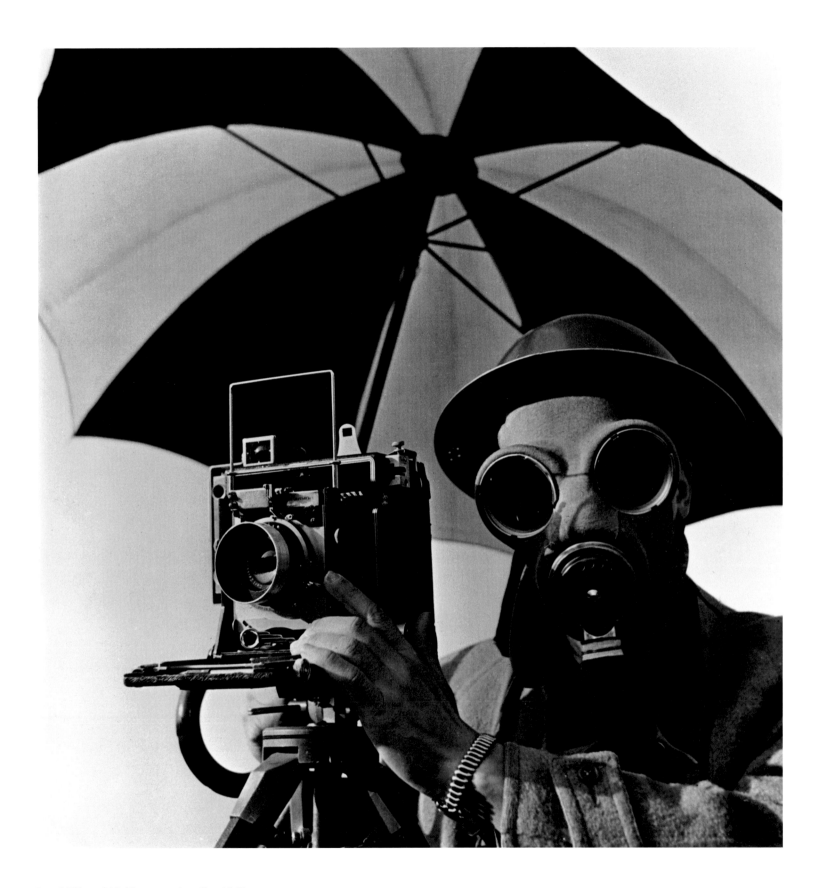

Lee Miller, *Life* Photographer David E.
Scherman Equipped for the War in
Europe, London, 1942. Lee Miller Archives

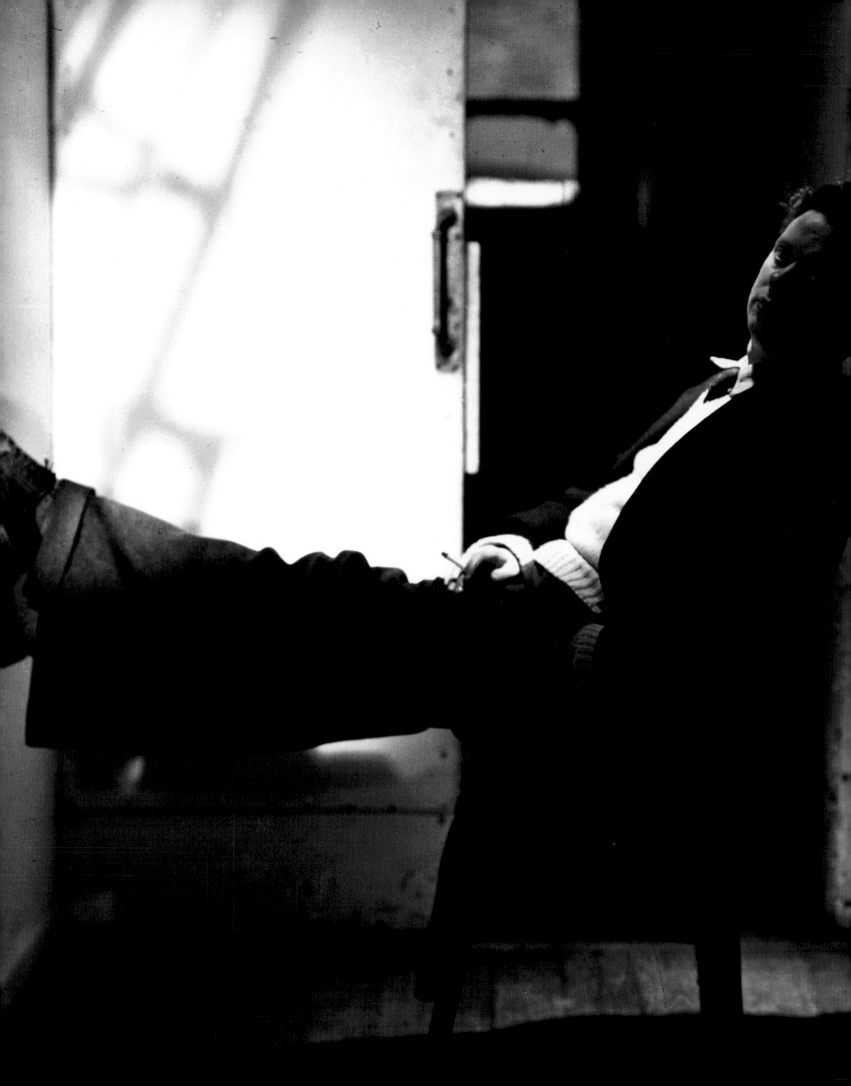

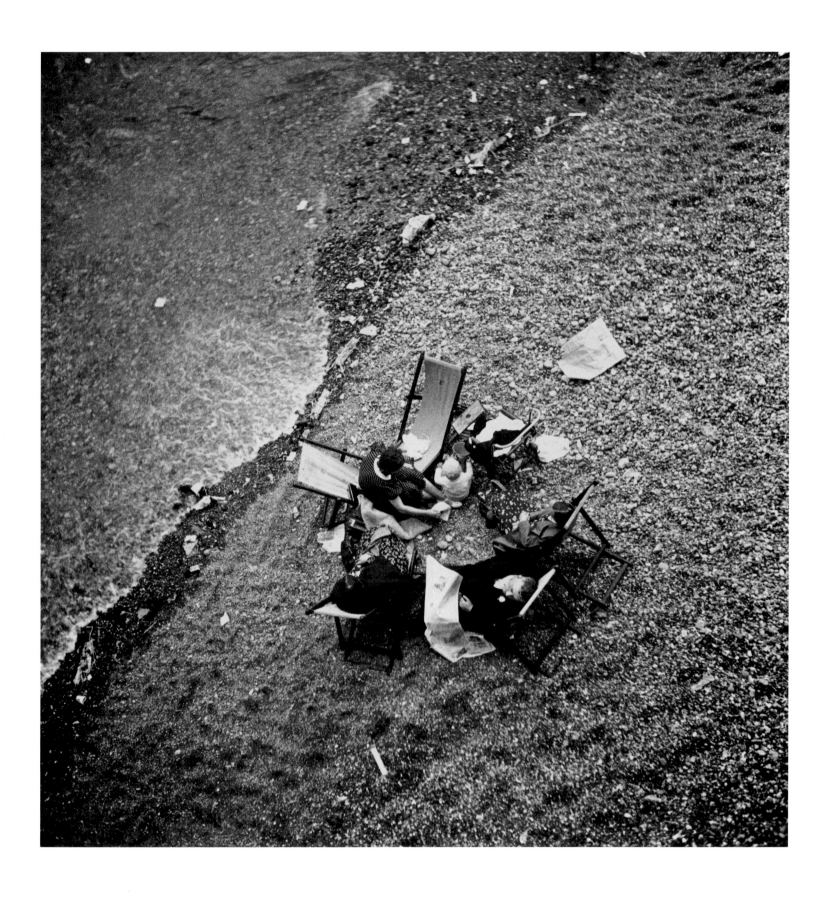

Lee Miller, Dylan Thomas, 1943.
Lee Miller Archives

Lee Miller, Brighton Beach, England,
1937. Lee Miller Archives

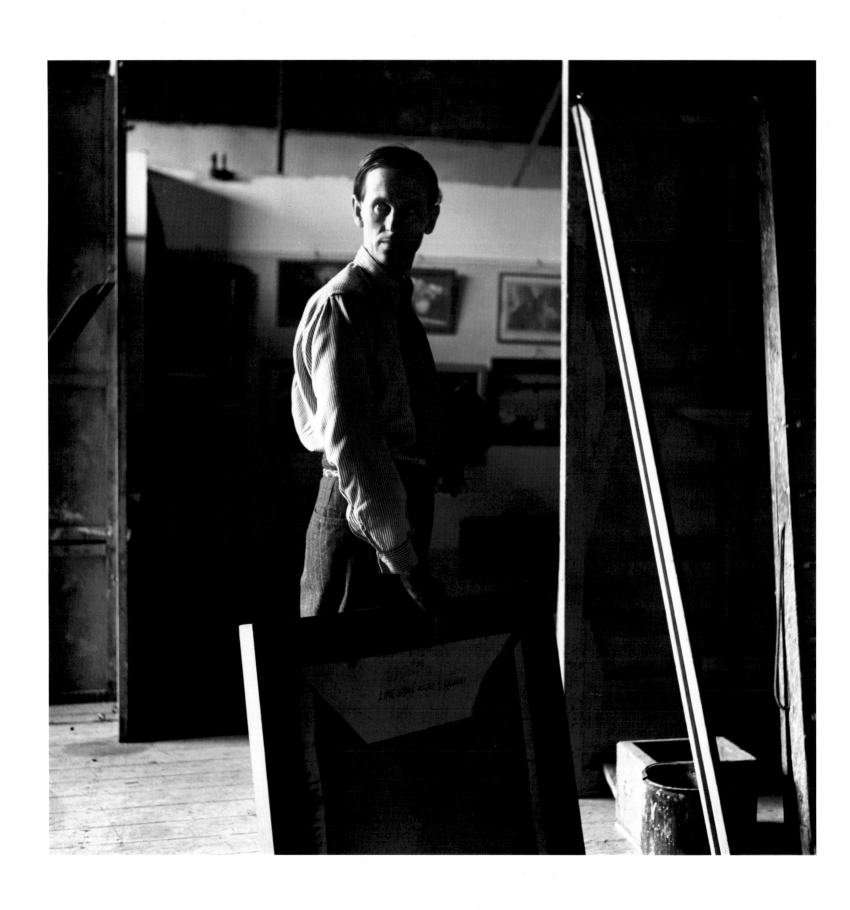

Lee Miller, Graham Sutherland,
England, 1940. Lee Miller Archives

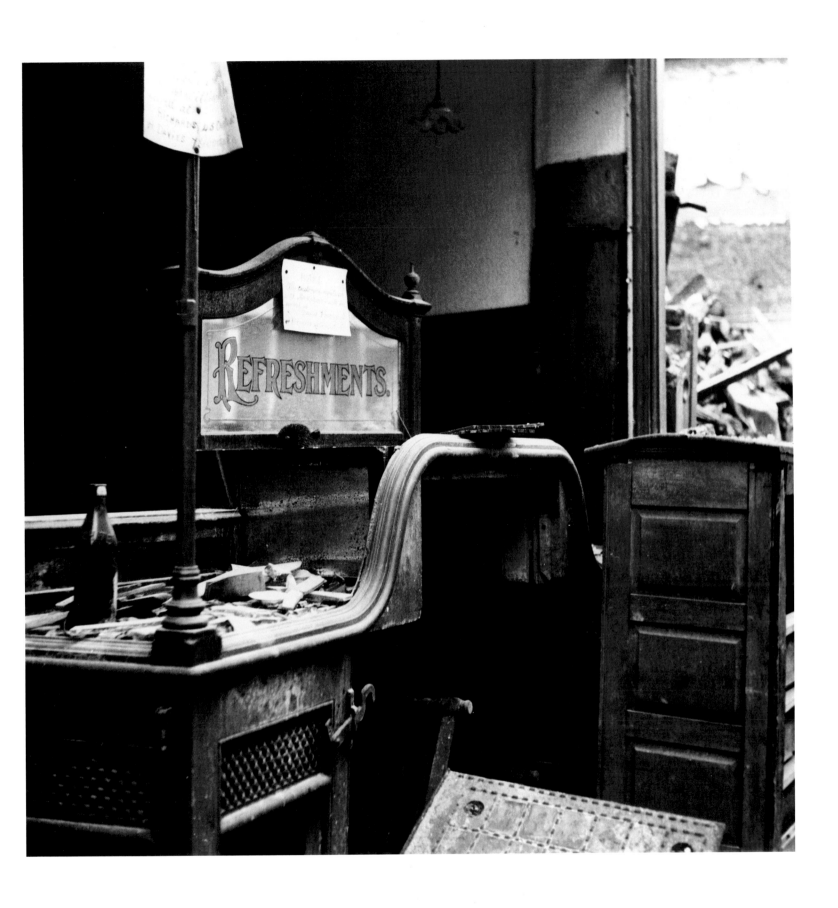

Lee Miller, A London Cafe Wrecked in
the Blitz, from *Grim Glory*, 1940.
Lee Miller Archives

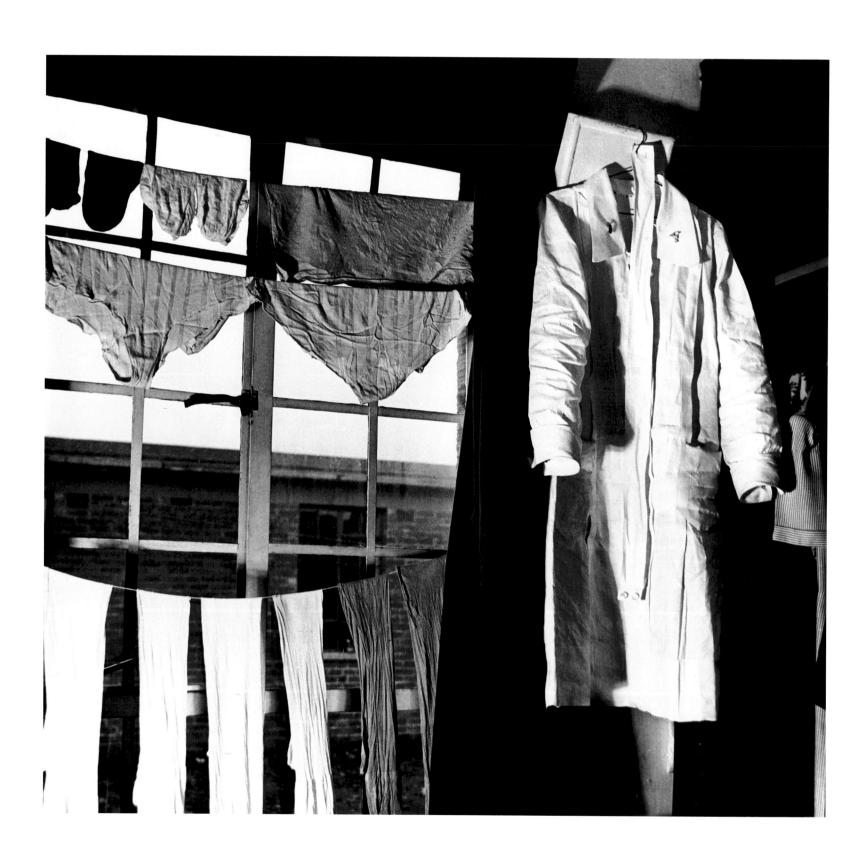

Lee Miller. WRVS Billet, England, from
Grim Glory, c. 1941. Lee Miller Archives

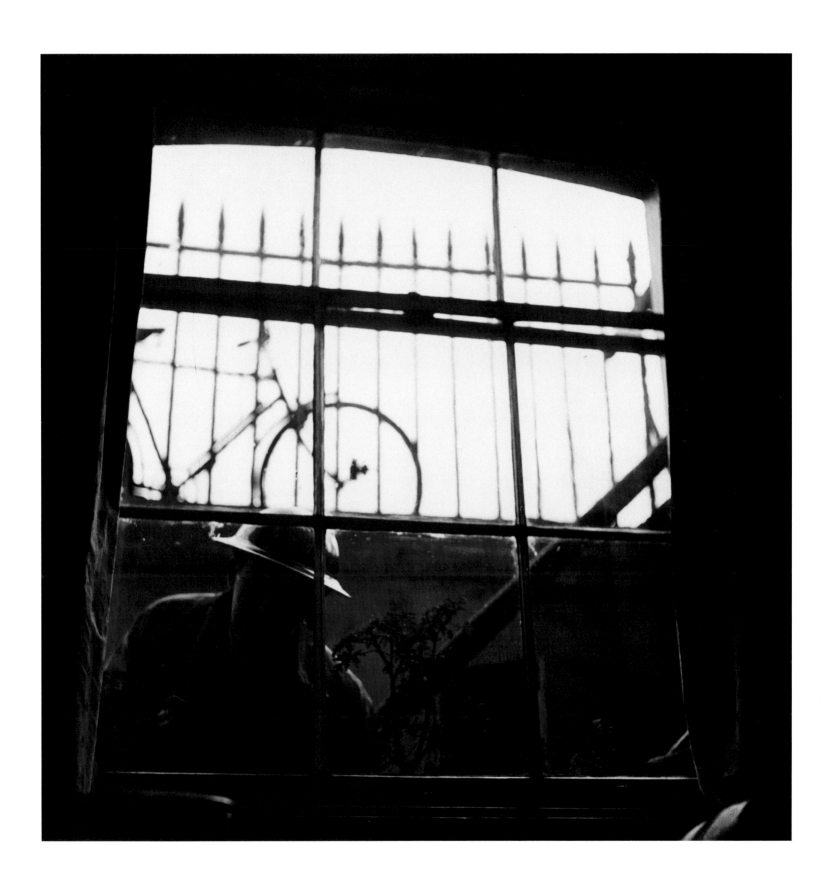

Lee Miller, The Well Known Art Dealer
Freddie Mayor doing his rounds as an Air
Raid Warden, London, 1940. Lee Miller Archives

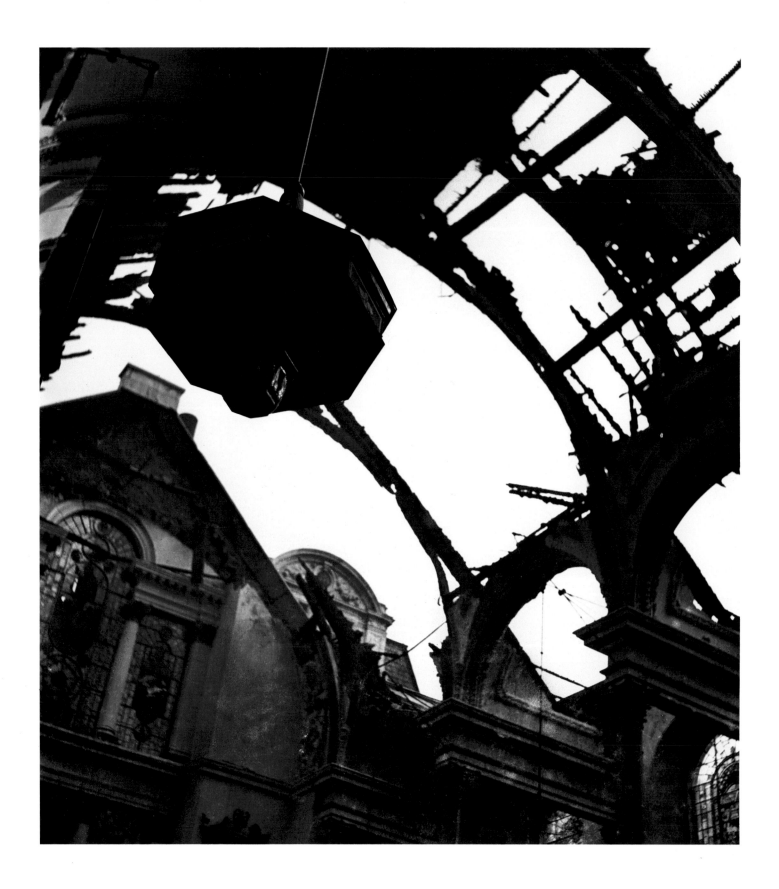

Lee Miller, The Roof of St. James's
Piccadilly, Destroyed in the Blitz, from
Grim Glory, 1940. Lee Miller Archives

Lee Miller, Paddington, London, from
Grim Glory, 1940. Lee Miller Archives

Lee Miller, Roof of University College,
London, from *Grim Glory*, 1940.
Lee Miller Archives

Lee Miller, English Plumbing at its Most
Fascinating, from *Grim Glory*, c. 1940.
Lee Miller Archives

Lee Miller, Picasso's Studio (L to R
sitting: Picasso, Nusch and Paul Eluard,
Elsa Triolet; L to R standing: Lee Miller,
Roland Penrose, Louis Aragon),
September 1944. Lee Miller Archives

138

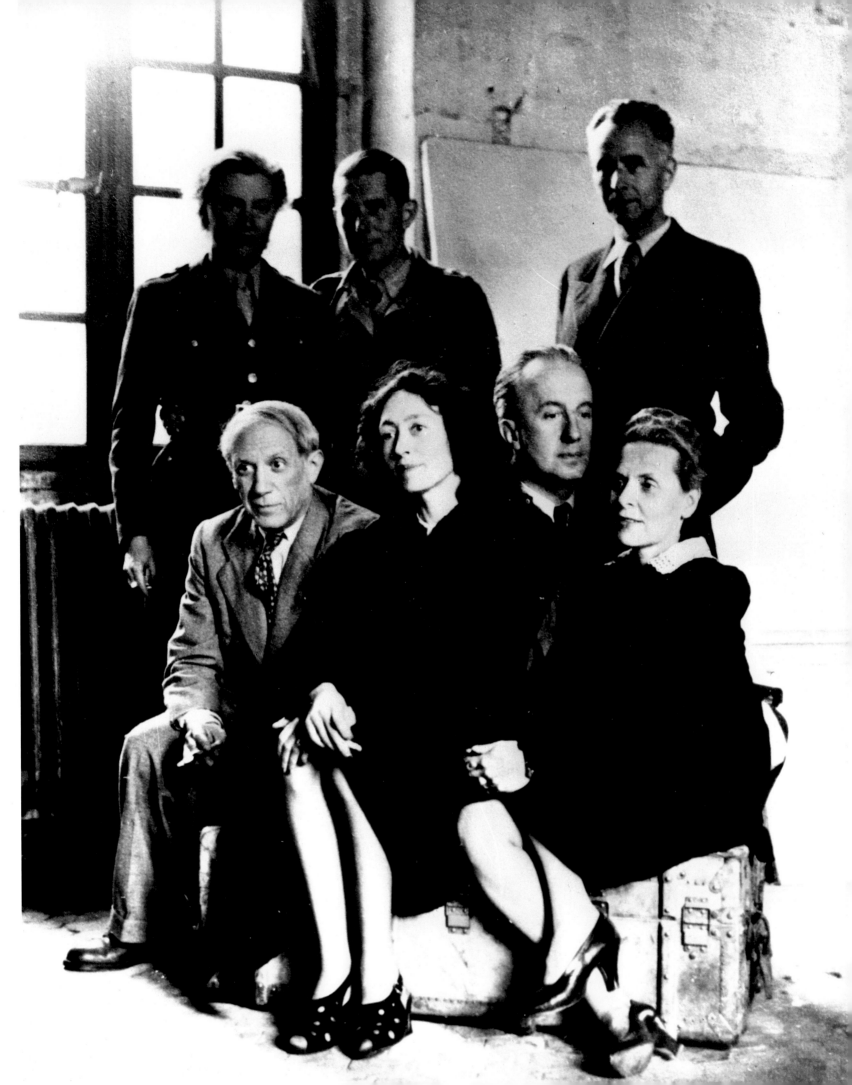

Lee Miller, Paul Delvaux and René
Magritte, Brussels, 1944.
Lee Miller Archives

Lee Miller, René Magritte, 1944.
Lee Miller Archives

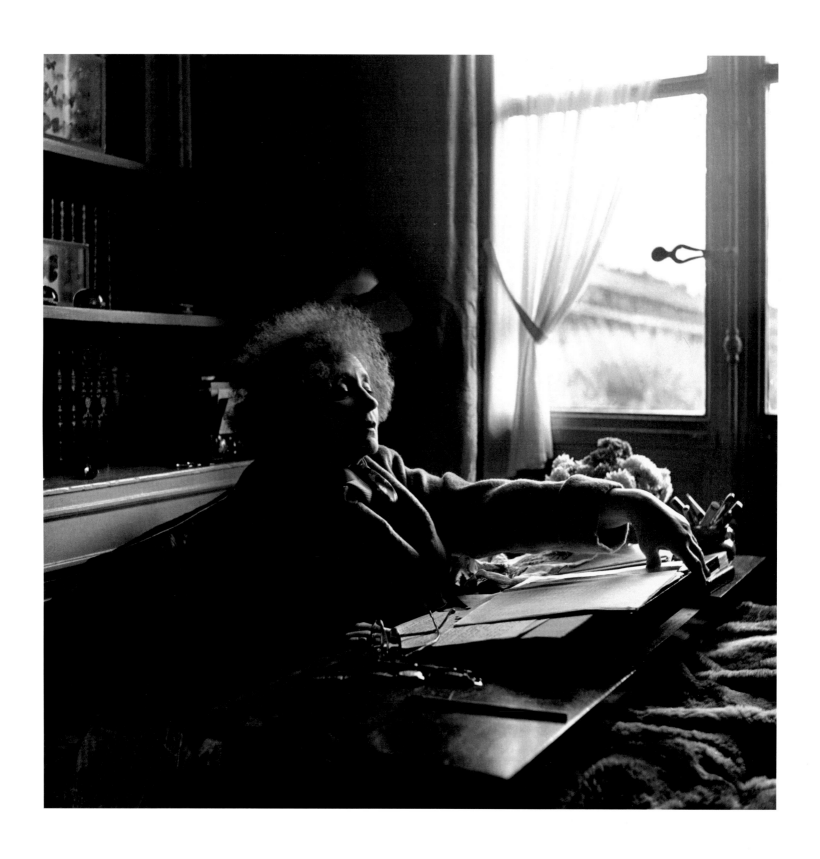

Lee Miller, Colette, Age 71, in her
Apartment at 9 Rue de Beaujolais,
Paris, 1944. Lee Miller Archives

Lee Miller, Marlene Dietrich in Paris
with the U.S.O. to Entertain the Troops,
1944. Lee Miller Archives

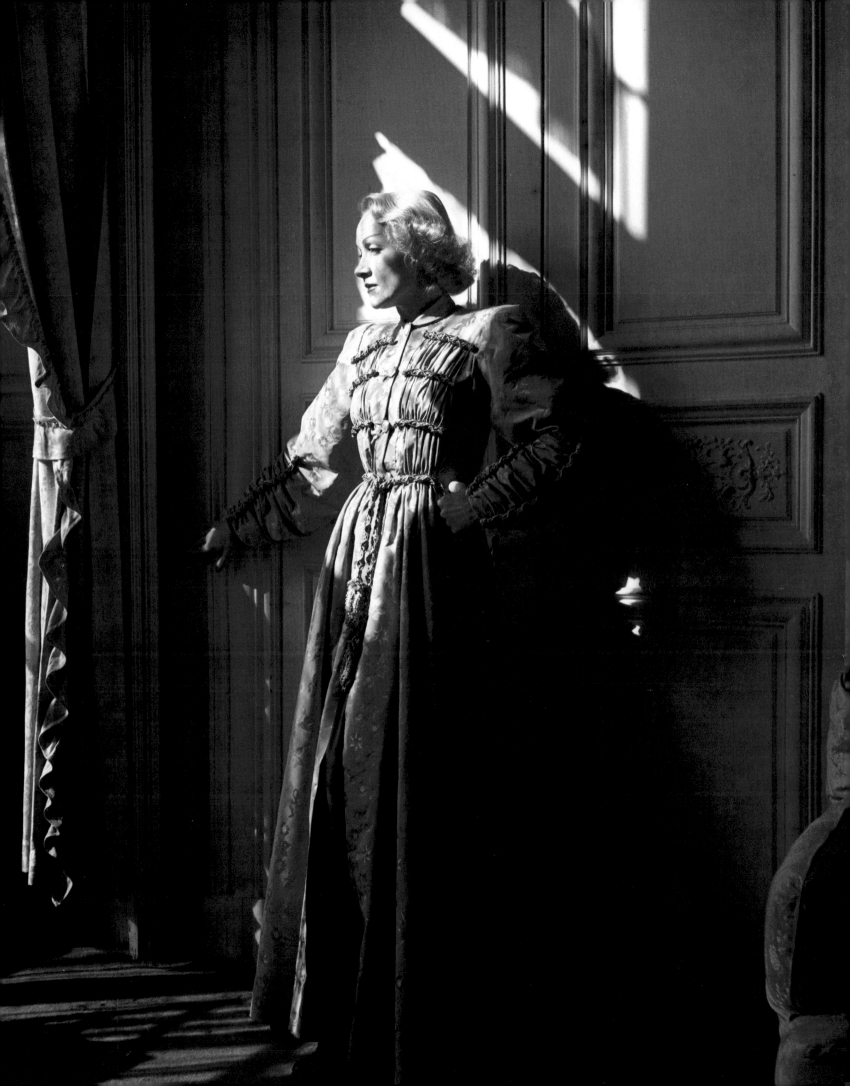

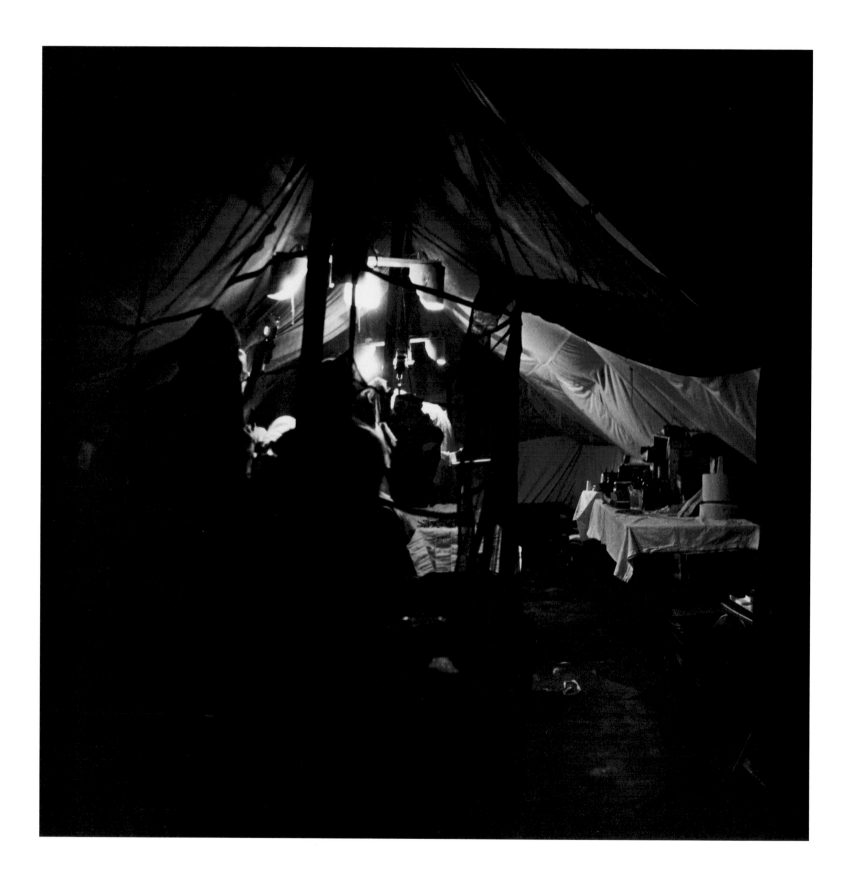

Lee Miller, Surgical Team Working in a
Normandy Field Hospital, France, 1944.
Lee Miller Archives

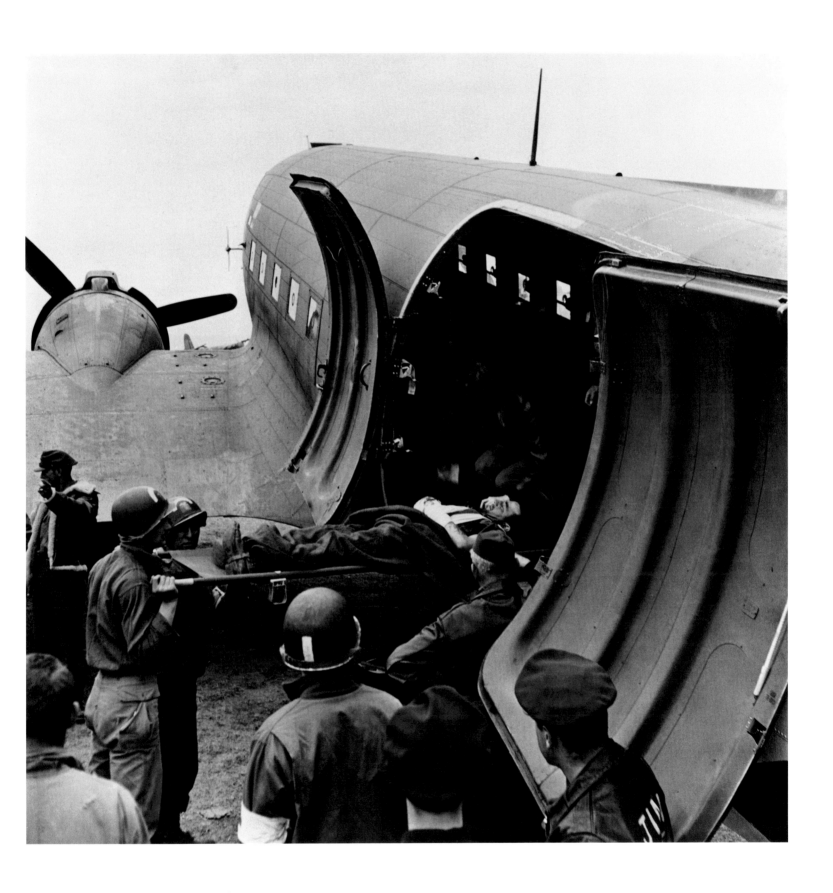

Lee Miller, Loading Casualties into the
Dakota in Normandy Beachhead, 1944.
Lee Miller Archives

Lee Miller, Ludwigshaven Chemical
Works after Allied Bombing, 1945.
Lee Miller Archives

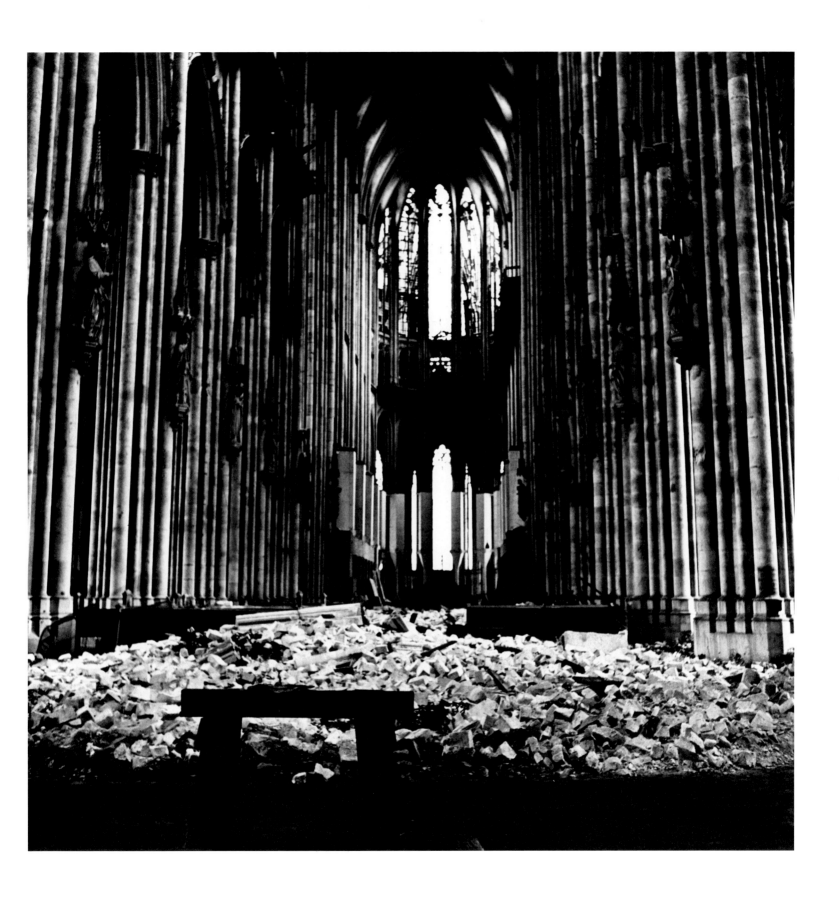

Lee Miller, Cologne Cathedral,
Germany, 1944. Lee Miller Archives

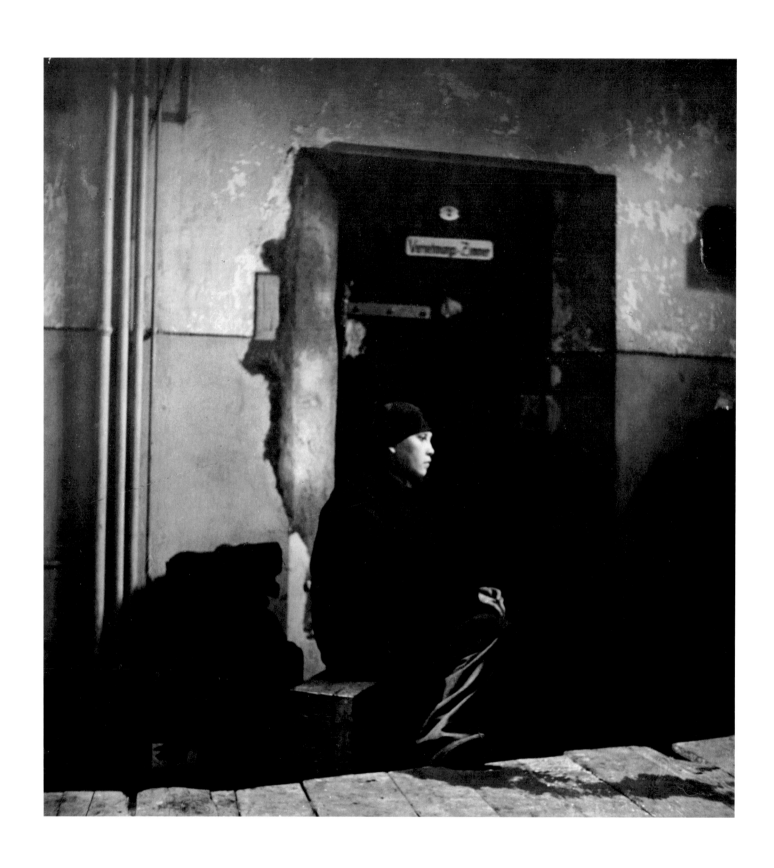

Lee Miller, Liberated Prisoner waits in
Cologne Gestapo for his Official Release,
Germany, 1945. Lee Miller Archives

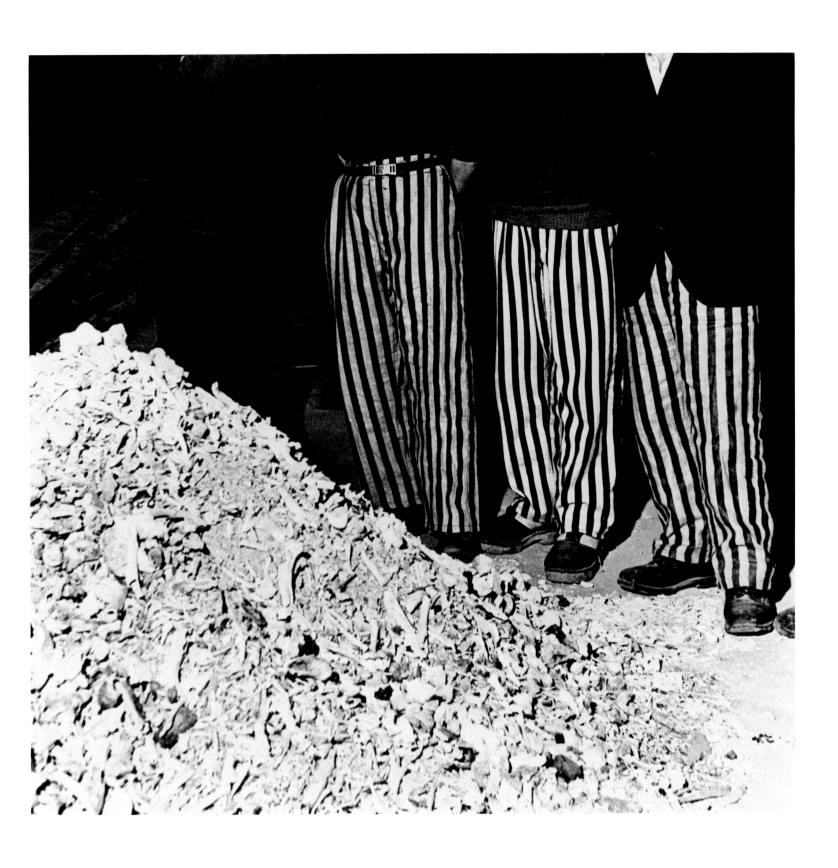

Lee Miller, Dachau, 1944.
Lee Miller Archives

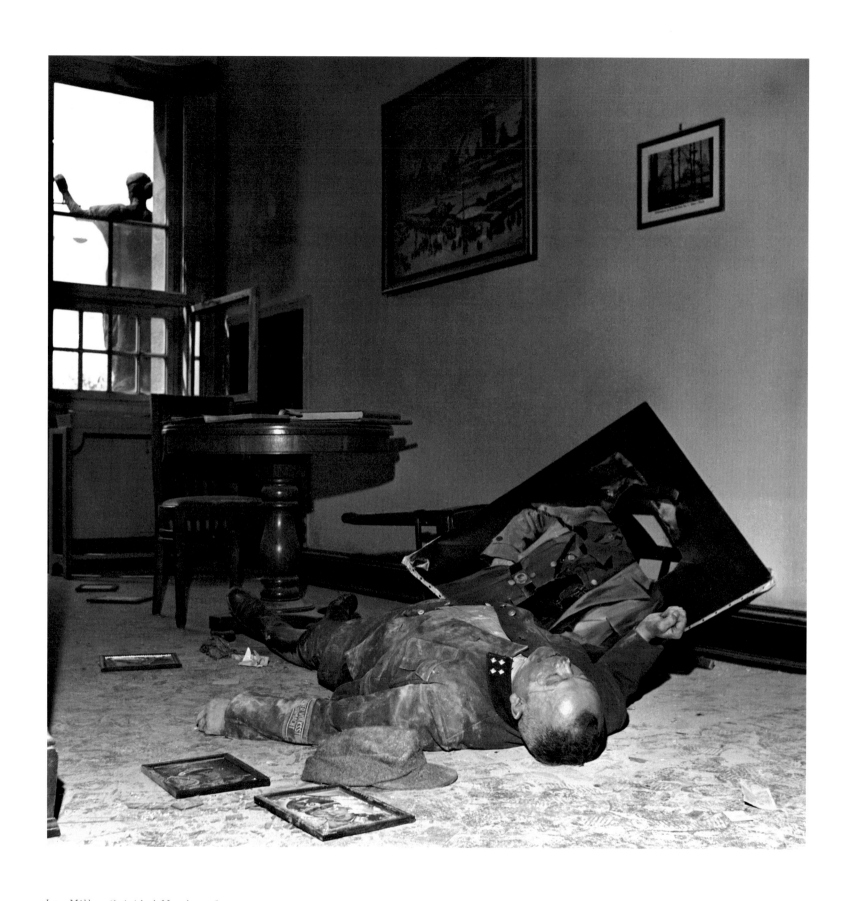

Lee Miller, Suicided Member of
the Burgomeister's Staff, Leipzig,
Germany, 1945. Lee Miller Archives

Lee Miller, Hitler's Desk in his House
at Prinzregentenplatz 27, Munich,
Germany, 1945. Lee Miller Archives

Lee Miller, Victory Celebration in the
Tivoli Gardens, Copenhagen, 1945.
Lee Miller Archives

Lee Miller, Giorgio Morandi, 1948.
Lee Miller Archives

Lee Miller, Joan Miro Visiting London
Zoo, c. 1964. Lee Miller Archives

Lee Miller, Roof Top Study, c. 1956.
Lee Miller Archives

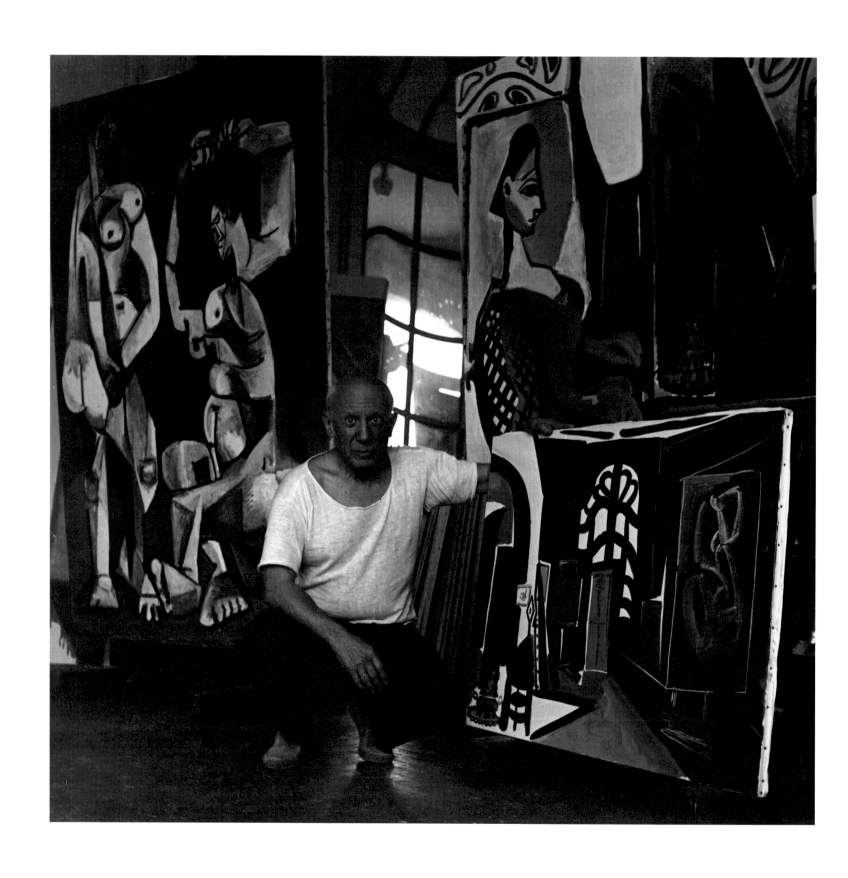

Lee Miller, Picasso at Villa La
Californie, 1956. Lee Miller Archives

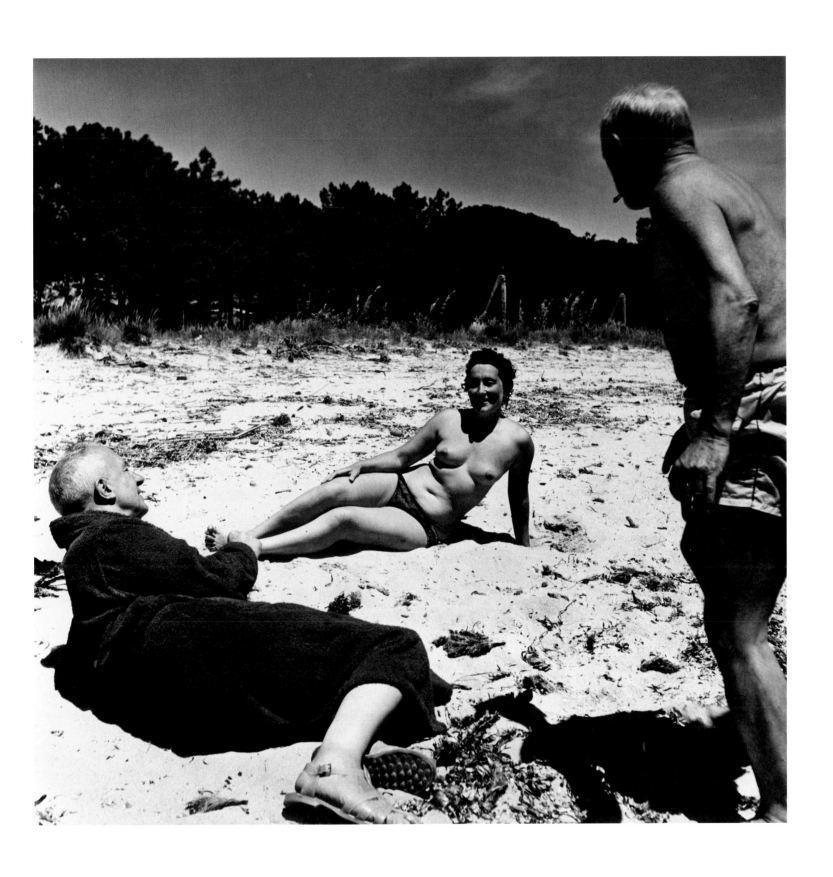

Lee Miller, Paul and Dominique Eluard
with Picasso near St. Tropez, 1951.
Lee Miller Archives

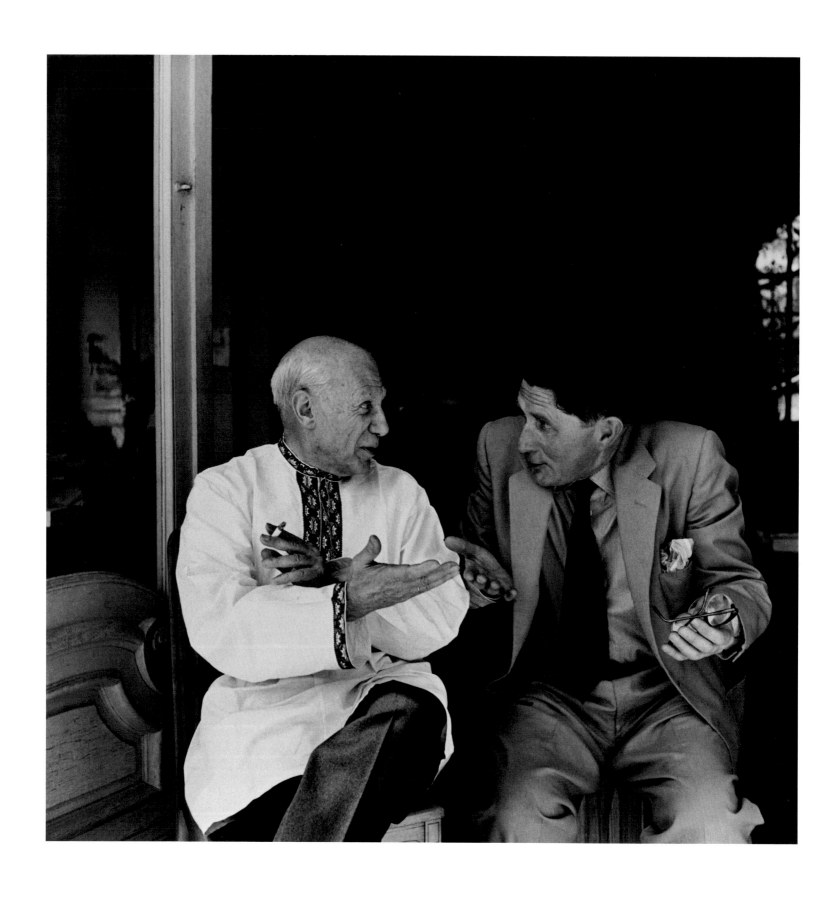

Lee Miller, Picasso and Roland Penrose,
Villa La Californie, 1955. Lee Miller Archives

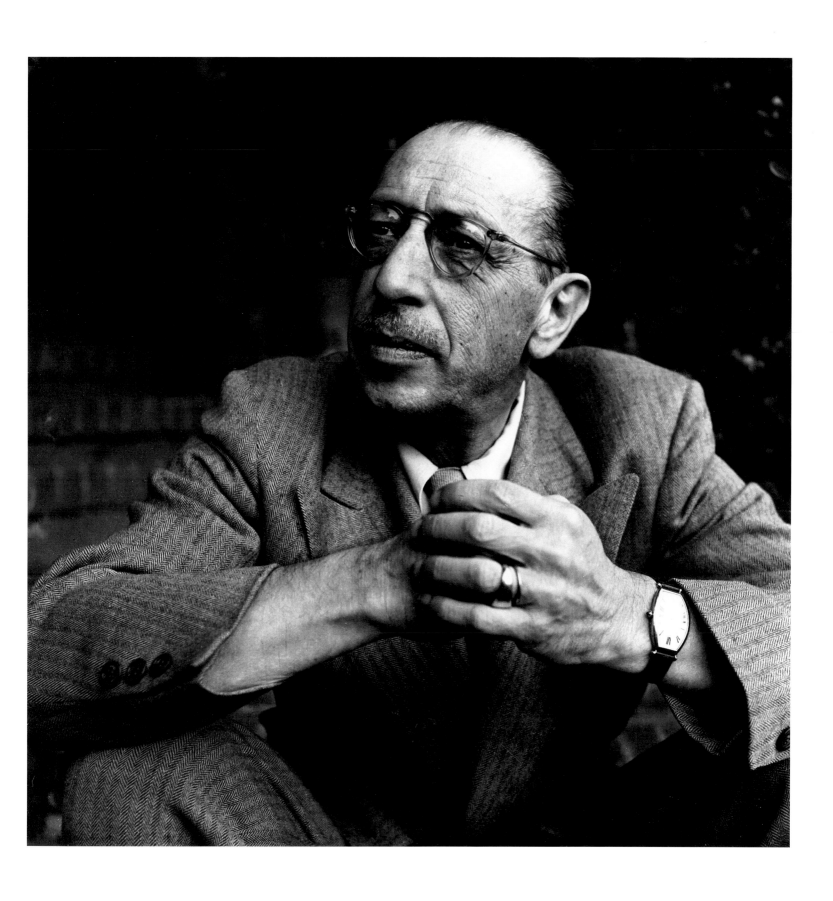

Lee Miller, Igor Stravinsky, Hollywood,
1946. Lee Miller Archives

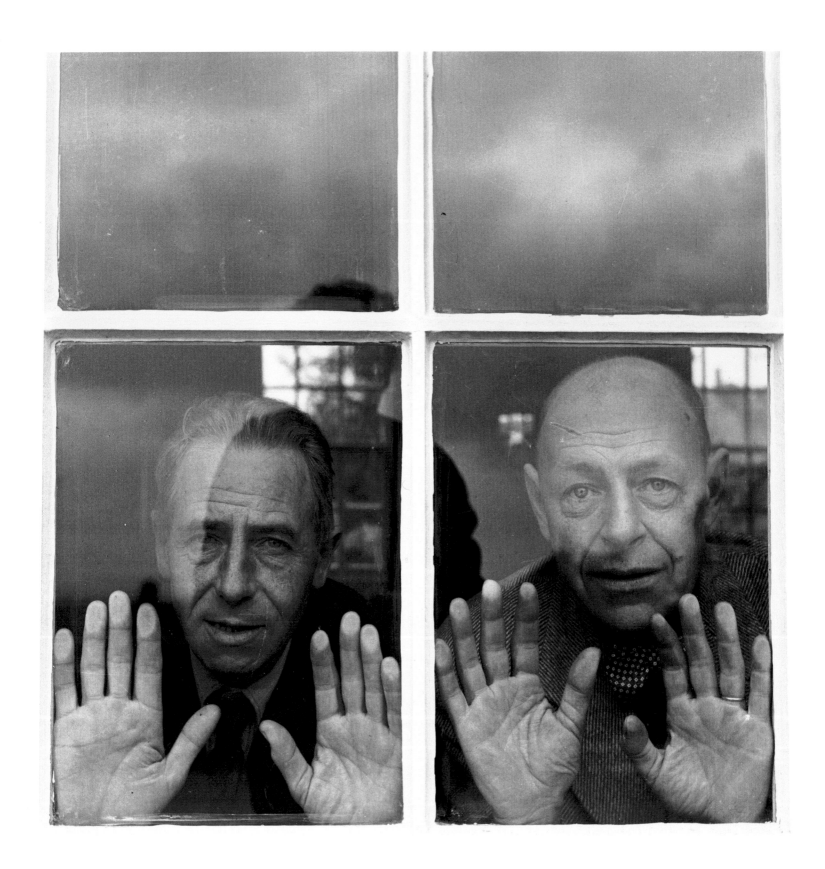

Lee Miller, Georges Limbour and Jean
Dubuffet at Farley Farm, 1959.
Lee Miller Archives

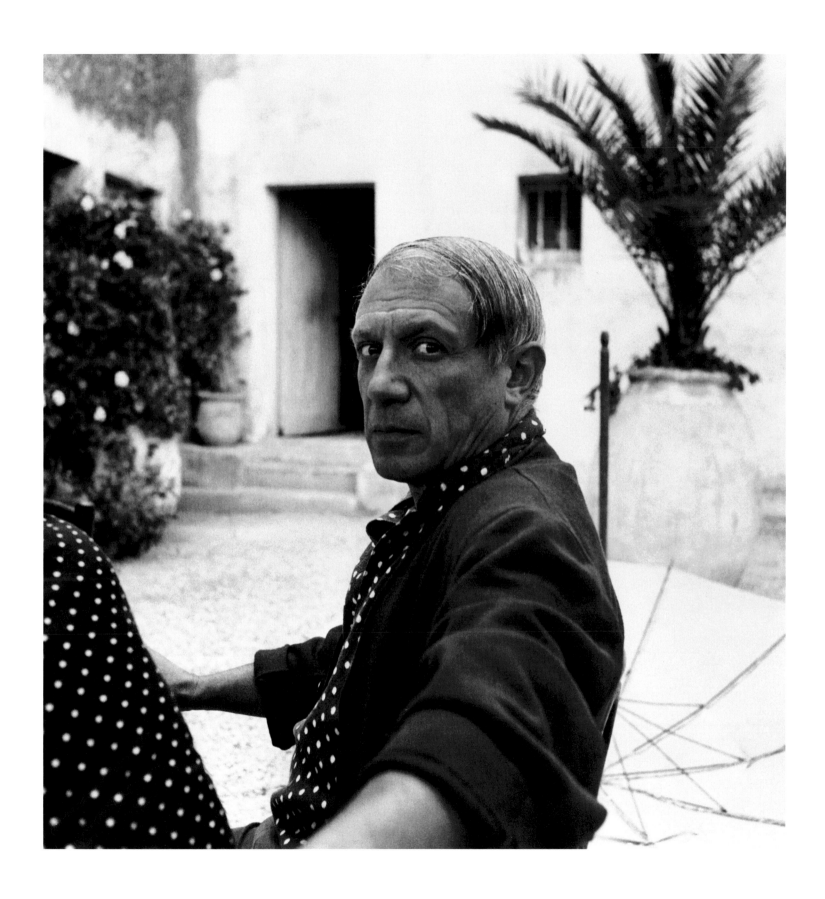

Lee Miller, Picasso, Hôtel Vaste Horizon,
Mougins, France, 1937. Lee Miller Archives

ENDNOTES

1. Antony Penrose, *The Lives of Lee Miller*, London, Thames and Hudson; New York, Holt, Rinehart, Winston, 1985, p. 22.

2. *Ibid.*, p. 22, quoting Brigid Keenan, *The Woman We Wanted to Look Like*, London, 1977, p. 136.

3. *Ibid.*, p. 30.

4. *Ibid.*, p. 30, quoting Mario Amaya, "My Man Ray" (interview with Lee Miller), *Art in America*, May–June 1975, p. 57.

5. For discussion and documentation of Surrealist photography in France, see Rosalind Krauss and Jane Livingston, *L'Amour Fou: Photography and Surrealism*, New York, Abbeville Press, 1985.

6. André Breton, "La beauté sera convulsive," *Minotaure*, no. 5, 1934; trans.; David Gascogne, in André Breton, *What is Surrealism?*, New York, Nunad Press, 1978.

7. Antony Penrose, *Ibid.*, p. 37.

8. *Ibid.*, p. 29.

9. *Ibid.*, p. 44, from unidentified newspaper article, November 1932.

10. *Ibid.*, p. 45, from interview with Erik Miller, July, 1974.

11. *Ibid.*, p. 55, from interview with Erik Miller, February, 1979.

12. *Ibid.*, p. 65.

13. *Ibid.*, p. 69.

14. *Ibid.*, p. 78.

15. *Ibid.*, p. 74.

16. Roland Penrose, *Scrap Book, 1900-1981*, London, Thames and Hudson, 1981, p. 128.

17. *Ibid.*, p. 127.

18. *Ibid.*, p. 128.

19. Antony Penrose in a letter to Jane Livingston, September, 1988.

20. *Ibid.* (Antony Penrose to Jane Livingston, 1988)

21. Antony Penrose, *op. cit.*, p. 113.

22. *Ibid.*, p. 114.

23. *Ibid.*, p. 119.

24. Lee Miller, "St. Mâlo," *Vogue*, November, 1944, p. 27.

25. *Ibid.*

26. Lee Miller, "Paris Fashion," *Vogue*, November, 1944, p. 27.

27. Roland Penrose, *op. cit.*, p. 132.

28. Antony Penrose, *op. cit.*, p. 124.

29. *Ibid.*, p. 124. Previously to this period, and the shortages and logistical problems implicit, Lee Miller had evinced an inclination to experiment with color photography. Antony Penrose writes, "The catalyst was Planskoi, the Russian colour expert and physicist with whom she became friendly when he visited London in the winter of 1943-44. The colour reversal process was in its early stages and Planskoi was one of the leaders in the field. His connections with Kodak gave him access to...quantities which Lee shamelessly made use of to improve her technique, while plundering his knowledge.... Most months, [*Vogue*] carried a prestigious full-page colour shot which became Lee's regular assignment and the June 1944 issue used one of Lee's colour pictures on its cover." (*Ibid.*, p. 116).

30. Lee Miller, "Through the Alsace Campaign," *Vogue*, April, 1945, p. 51.

31. Antony Penrose, *op. cit.*, p. 131.

32. *Ibid.*, p. 133.

33. *Ibid.*, p. 138.
34. *Ibid.*
35. *Ibid.*, p. 139.
36. Lee Miller, *Vogue*, June, 1945.
37. Lee Miller, caption written for prison guard photo, Lee Miller Archive.
38. Antony Penrose, *op. cit.*, p. 142 (citing Lee Miller, "Hitleriana," *Vogue*, July, 1945, p. 74).
39. *Ibid.*, p. 147.
40. *Ibid.*, pp. 152–153.
41. *Ibid.*, pp. 160–161.
42. *Ibid.*, pp. 166–167 (citing unpublished part of manuscript for "Hungary," *Vogue*, April, 1946).
43. *Ibid.*, p. 168.
44. *Ibid.*, p. 174.
45. *Ibid.*, p. 182.
46. *Ibid.*, p. 183.
47. Roland Penrose, *op. cit.*, pp. 142–143.
48. Antony Penrose, *op. cit.*, p. 189 (from Lee Miller article, *Vogue*, November 1951).
49. *Ibid.*, p. 209.

REFERENCES

Penrose, Antony. *The Lives of Lee Miller*, London: Thames and Hudson; New York: Holt, Rinehart, Winston, 1985.

Penrose, Roland. *Scrap Book, 1900–1981*, London: Thames and Hudson, 1981.

Krauss, Rosalind and Jane Livingston. *L'Amour Fou: Photography and Surrealism*, New York: Abbeville Press, 1985.

Fralin, Frances, with Jane Livingston. *The Indelible Image: Photographs of War, 1846 to the Present*, New York: Harry N. Abrams, 1985.

INDIVIDUAL EXHIBITIONS

1933 Julien Levy Gallery, New York

1978 *Lee Miller*, Mayor Gallery, London, February

1984 *Picasso's Gaze*, Photographers Gallery, London, May

1986 *The Lives of Lee Miller*, Staley-Wise, New York, 21 November 1985–28 February, 1986

RETROSPECTIVE EXHIBITIONS

1986 Photographers Gallery, London, 17 January–22 February

1986 Gardner Arts Centre, Brighton, England, 28 May–18 June

SELECTED GROUP EXHIBITIONS

1931 *Group Annuel des Photographes*, Galerie de la Pleiade, Paris

1932 *Modern European Photography*, Julien Levy Gallery, New York

1955 *The Family of Man*, Museum of Modern Art, New York (and world tour)

1976 *Photographs from the Julien Levy Collection*, Art Institute of Chicago

1977–78 *The History of Fashion Photography*, International Museum of Photography at George Eastman House, Rochester, New York (traveled to Brooklyn Museum of Art, New York; San Francisco Museum of Modern Art; Cincinnati Art Institute, Ohio; Museum of Fine Art, St. Petersburg, Florida)

1978 *Dada and Surrealism Reviewed*, Hayward Gallery, London

1982 *Atelier Man Ray 1920–1935*, Centre George Pompidou, Paris

1985–86 *L'Amour Fou: Photography and Surrealism*, Corcoran Gallery of Art, Washington, D.C. (traveled to San Francisco Museum of Modern Art; Centre George Pompidou, Paris; Hayward Gallery, London)

1985–86 *The Indelible Image*, Corcoran Gallery of Art, Washington, D.C. (traveled to the Grey Gallery, New York; the Rice Museum, University of Texas, Houston)

1986 Musée Cantini, Marseille, France

LEE MILLER CHRONOLOGY

by Antony Penrose

1907 Born Poughkeepsie, New York, on 23 April to Frances and Theodore Miller. Brother John born 1905

1910 Brother Erik born, Poughkeepsie, New York

1914 Sexually molested and infected with VD

1925 30 May, departs for Paris with chaperon to attend L'Ecole Medgyes pour la Technique du Théâtre

1926 Winter, dragged home by Theodore

1927 Discovered by Condé Nast. Portrait of her by Georges Lepape appears on front cover of *Vogue*, March 1927. Photographed by Steichen, Genthe, Muray, with numerous appearances in magazines

Has own flat in New York City

Attends Art Students League in New York City

1928 July, image used as Kotex Ad in *Vogue* and other magazines

1929 Departs for Paris, then to Florence and Rome to study art. Returns to Paris, meets Man Ray and becomes his student, model and lover

Discovers solarization

1930 Establishes herself as a photographer in her own right with studio at 12 Rue Victor Considérante

Erik Miller visits Lee Miller in Paris

Stars in Jean Cocteau's film "Blood of a Poet"

December, Theodore Miller visits Lee in Paris and they travel to Stockholm

1931 Visits London to do stills work at Elstree Studios for 1 July issue of *The Bioscope* and photographs sports clothes for June issue of *Vogue*

Exhibits at Group Annuel des Photographes, Galerie de la Pleiade, Paris

Meets Aziz Eloui Bey

1932 Aziz's wife Nimet commits suicide

20 February–11 March, first exhibition at Julien Levy Gallery, New York

Lee Miller parts from Man Ray and closes her studio, returning to New York in November

30 December–25 January, 2nd exhibition at Julien Levy Gallery, *Modern European Photography*

On arrival in New York sets up own studio at 8 East 48th Street, New York

1933 Meets and photographs John Houseman, Virgil Thompson, Joseph Cornell, Gertrude Lawrence and other celebrities; 22 August, Erik Miller marries Mary Frances Rowley, known as Mafy

1934 19 July, marries Aziz Eloui Bey and after a honeymoon at Niagara Falls, leaves to live in Egypt. Erik packs up the studio

1936 Resumes photographing for pleasure on trips into the desert

1937 4 March, Erik and Mafy Miller arrive in Cairo to work for Aziz Eloui Bey's company, the agency for Carrier air conditioning

Early summer, goes to Paris and meets Roland Penrose. Travels with him to England and then to Mougins, France to holiday with Man Ray, Picasso, Eileen Agar and the Eluards

1938 Meets Roland Penrose in Athens, and travels with him through the Balkans photographing village life in remote areas. Returns via Beirut

1939 Roland Penrose visits Lee Miller in Asyut, Egypt, and they travel to Siwa and other oasis villages

2 June, parts amicably from Aziz Eloui Bey and sails to England and Roland Penrose. They travel to the south of France to visit Max Ernst and Leonora Carrington, then return to England on the outbreak of war

1940 January, lives with Roland Penrose at 21 Downshire Hill, Hampstead. Joins staff of *Vogue*. Photographs fashion and scenes of the Blitz, later to be used in *Grim Glory: Pictures of Britain under Fire*, published in Britain and United States

David E. Scherman arrives in England as *Life* photographer, and moves into Downshire Hill

1942 30 December, becomes accredited as U.S. Forces War Correspondent. Photographs for her book *Wrens in Camera*

1944 First photo-journalism article published on Edward R. Murrow in *Vogue*, followed by
Unarmed Warriors September 1944
St. Malo October 1944

Teams up with David E. Scherman, publishes further *Vogue* stories,
The Way Things Are In Paris November 1944
Loire Bridges November 1944
Players in Paris December 1944
Patterns of Liberation January 1945
Brussels — More British than London February 1945
Colette March 1945
Through the Alsace Campaign April 1945
Scales of Justice June 1945
Germany — the war that is won June 1945
Hitleriana July 1945
In Denmark Now July 1945

1945 Vienna, covers children dying in hospital

1946 Budapest, covers plight of deposed aristocrats, execution of Bardossy, rural areas such as Mezokovesd, and celebrities such as Strobol, Szentgyorgi etc.

On to Bucharest, Romania; photographs King and Queen Mother, gets massaged by a bear, wrecks car near Sibiu

In the spring returns home via Paris to a heroine's welcome from *Vogue* staff

Photographs Isamu Noguchi

Travels with Roland Penrose to Arizona and visits Max Ernst and Dorothea Tanning, then to Los Angeles to visit Erik and Mafy Miller (Erik Miller now chief photographer for Lockheed Aircraft Corporation) and Man Ray and Juliette Browner, soon to become wife. Returns to England, too Europeanized to comfortably settle in U.S.A.

1947 Does fashion assignment in St. Moritz with Peggy Riley (later Rosamond Russell) and discovers she is pregnant. Moves across the street to 36 Downshire Hill.

Aziz Eloui Bey travels to England and divorces Lee Miller

Lee Miller and Roland Penrose marry on 3rd May at Hampstead Registry office

9 September, son Antony born, writes on the experience for April 1948 issue of *Vogue*

1948 Covers Venice Biennale for August *Vogue*

1949 Writes about the Institute of Contemporary Art's exhibition, *Forty Thousand Years of Modern Art* for January *Vogue*

Farley Farm purchased

1951 Writes on exhibition covering Picasso's birthday for November issue of *Vogue*

1953 Writes and photographs life at Farley Farm for "Working Guests," July issue of *Vogue*

1954 Photographs for Roland Penrose's book "Picasso, His Life and Work."

1955 Exhibits in *The Family of Man*, Museum of Modern Art, New York (and world tour)

1960 Becomes passionately interested in cooking

1963 Goes to Egypt to meet Aziz Eloui Bey

1966 Becomes Lady Lee Penrose

Articles about Lee appear in *Vogue*, *Studio International*, and *House and Garden*.

Travels extensively with Roland Penrose to Japan, Spain, etc.

1973 Photographs Antoni Tapies for Roland Penrose's biography of him

1976 July, guest of Lucien Clergue at the Arles Photo Festival, deputizing for Man Ray

Exhibits in *Photographs from the Julien Levy Collection*, Art Institute of Chicago

Diagnosed as having cancer

1977 Granddaughter Amy born 25 April

Exhibits in *The History of Fashion Photography*, organized by the International Museum of Photography at George Eastman House, Rochester, New York

Dies at Farley Farm, July 27

If Lee Miller is watching from some other dimension, I am sure there is a wry smile on her lips. Man Ray once declared she could make more work for other people than anyone else he knew, and this talent has continued to make itself felt with undiminished strength. Since her death in 1977 people have been working continuously, printing her legacy of some 40,000 negatives, collating, cataloguing, and filing them in the Lee Miller Archive. There is still enough work to keep everyone busy for several years to come.

For those of us who have worked intimately with it, Lee's photographic estate has given more than the opportunity to enjoy fine material of historic importance. It has provided us with a unique opportunity to expand our own creativity. Susanna Penrose has used the experience as a springboard to a career in archiving and conservation. Carole Callow has become a fine printer of international standing. Others, more peripherally involved, have been inspired by Lee's work to start new careers of their own. As for me, I have had all the fun and gratification of writing the biography *The Lives of Lee Miller* and of making the documentary film of the same title, plus the enormous emotional satisfaction derived from discovering a true picture of the mother I never really knew. Ironically, before she died Lee had vehemently discouraged me from working on her material, maintaining that too close a study of her work would be detrimental to my own creativity.

In fact, quite the opposite has been the case. And the lingering effect of Lee's generosity of spirit is not confined to those who have worked directly with her material. It has nudged many others into taking firmer control of their own careers and making radical changes in their lives. Lee speaks to us all through her work and through her life. It is often more instructive to study a person's defeats than his or her successes and there is a certain type of defeat which belongs only to brave high rollers like Lee who constantly risk all and think nothing of it. In these moments of darkness lies the greatest learning, left behind like a precious gift for our benefit and enjoyment.

True to form, Lee's creative life has been as episodic after her death as it was in her lifetime, evolving in a further series of chapters. First there was the slow patient sorting of the material we discovered crammed in old boxes and trunks. Then came the thrill of assembling and piecing together her story. This led to the excitement of producing and launching *The Lives of Lee Miller,* and the first ever major exhibition of her work at the Photographers Gallery, London. And now it is as if Lee Miller the artist has come of age and is leaving home, entering a domain where her work will be judged and disseminated by others.

As Lee's work receives more and more attention, it becomes better understood and appreciated. This book and exhibition are landmarks in this process. My thanks and admiration go to Lyn Kienholz, longstanding friend of the Penrose family, who persuaded Jane Livingston to organize the Lee Miller retrospective and write this book, which is designed and produced by Alex and Caroline Castro. This team is one which I feel Lee would have heartily approved of. After all, she always chose her friends and colleagues wisely, as this celebration of her life and work surely attests.

Antony Penrose
24 October, 1988.

AFTERWORD AND ACKNOWLEDGMENTS

This book has been produced in connection with a retrospective exhibition of Lee Miller's work. Its opening is taking place at the Corcoran Gallery of Art, in Washington, D.C., in February, 1989; from there it will travel to New York, New Orleans, Minneapolis, San Francisco, Chicago, Santa Monica, California, and several international cities. The book and exhibition are, however, far from identical; the exhibition includes primarily vintage prints, ones actually printed by Lee Miller; the book includes many images that have been printed recently from Miller's negatives, and several that have never been shown or reproduced until now.

I want first to acknowledge the one indispensable source for this undertaking: the work done by Antony and Susanna Penrose in establishing the Lee Miller Archive. The materials in the Archive, both photographic and textual, were amassed by Antony Penrose and used extensively in the writing of his authoritative biographical book, *The Lives of Lee Miller*, 1985. I have drawn liberally both on this resource, and on Sir Roland Penrose's autobiographical book, *Scrap Book, 1900–1981*, 1981. I cannot overstate either my admiration for Tony's work, or my appreciation for his graciously sharing with me the whole resource of his knowledge and intuition. Susanna Penrose's contribution forms the underpinning for all of this; it was she who conceived, and has fostered, the Lee Miller Archive and its home in East Sussex.

The time-consuming job of printing the dozens of images we needed for the book has been carried out by Carole Callow at the Lee Miller Archive. Much of the clarity and subtlety of what we see in these pages is owing to her superb craftsmanship.

Second, my appreciation goes to Lyn Kienholz, President of the California/International Arts Foundation, who has made possible both this book and the exhibition of Lee Miller's photographs it accompanies. In a sense, Lyn began her involvement with this project long before she could have known it would materialize as it has, through her friendship with Lee Miller and Roland Penrose beginning in the late 1960s. Her devotion to her friend's legacy has found expression in this project. As it happens, Lyn and I first met in Los Angeles at about the same time her relationship began with the Penroses. My own familiarity and fascination with Lee Miller's work began in 1979, in the course of doing research for the book and exhibition, *L'Amour*

Fou: Photography and Surrealism, co-authored with Rosalind Krauss. Thus, a series of events begun twenty years ago have resulted in this collaboration.

Lyn Kienholz, through the California/International Arts Foundation, has obtained the critical support of the Samuel I. Newhouse Foundation; the National Endowment for the Arts, a Federal Agency; and the AT&T Foundation in supporting the development of the exhibition and its tour. The exhibition and book have been organized by the California/International Arts Foundation.

Our sincere gratitude extends to the Professional Photography Division of Eastman Kodak, and particularly to Raymond de Moulin, for their support of this book and its exhibition at the Corcoran Gallery of Art. Eastman Kodak's contribution to the artists in the medium of photography, like Lee Miller, who need attention and reassessment, is becoming a mainstay in our field.

Finally, as full partners in this endeavor, I wish to acknowledge Alex and Caroline Castro of CASTRO/ARTS, Baltimore. Alex and Carrie's interest in Lee Miller's work began as did mine, with the development of our book, *L'Amour Fou*. We resolved as early as 1980 to pursue the possibility of working together on a Lee Miller book. Alex and I, together with Lyn Kienholz, spent time at Farley Farm immersing ourselves in the work and refining our selection of images. Again, Tony and Susanna's unstinting generosity in giving us access to and information on the material, made this shared experience a privilege. Alex Castro has designed the book; Alex and Carrie have overseen its printing by the California press, Gardner Lithograph.

For clerical and administrative assistance in developing my text and coordinating the book production, I wish to thank Nancy Huvendick and Starr Figura of the Corcoran Gallery of Art; and for their editorial comments, Catherine Lamb of Thames and Hudson, London; Christina Orr-Cahall, Director of the Corcoran Gallery of Art; and Tony Penrose.

Jane Livingston
Associate Director and Chief Curator
Corcoran Gallery of Art

Lee Miller: Photographer is published on the occasion of the exhibition of the same name organized by the California/ International Arts Foundation, Los Angeles. Major funding for this book and exhibition has been provided by

The Samuel I. Newhouse Foundation
The Professional Photography Division, Eastman Kodak Company
The American tour is sponsored by the AT&T Foundation.

Additional funding has been provided by

The National Endowment for the Arts, a Federal agency

AMERICAN EXHIBITION TOUR

Corcoran Gallery of Art, Washington, D.C.
February 11–April 17, 1989

International Center of Photography, New York
May–June, 1989

New Orleans Museum of Art
July 8–August 20, 1989

Minneapolis Institute of Art
November 4–January 7, 1990

San Francisco Museum of Modern Art
February 2–April 1, 1990

The Art Institute of Chicago
May–June, 1990

Santa Monica Museum of Art, California
August–September, 1990

Designed by Alex and Caroline Castro, Baltimore
Printed in the USA by Gardner Lithograph, Buena Park, California